DREAMSCAPES

Creating Magical
Angel, Faery & Mermaid Worlds
with Watercolor

Stephanie Pui-Mun Law

IMPACT
CINCINNATI, OHIO
www.impact-books.com

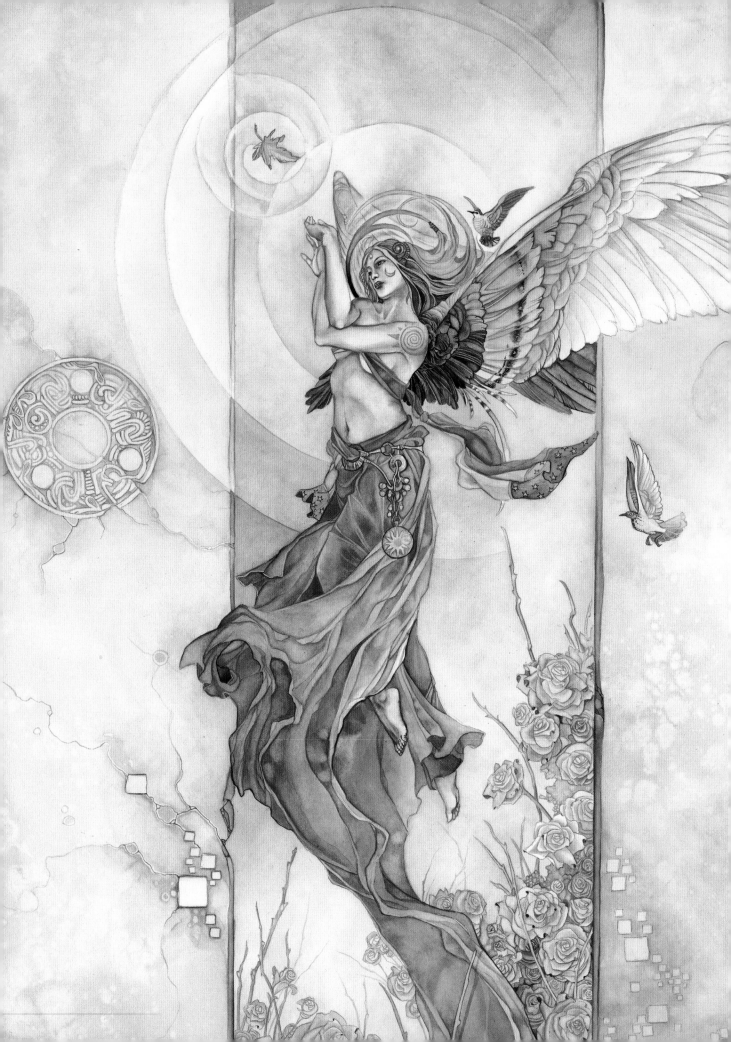

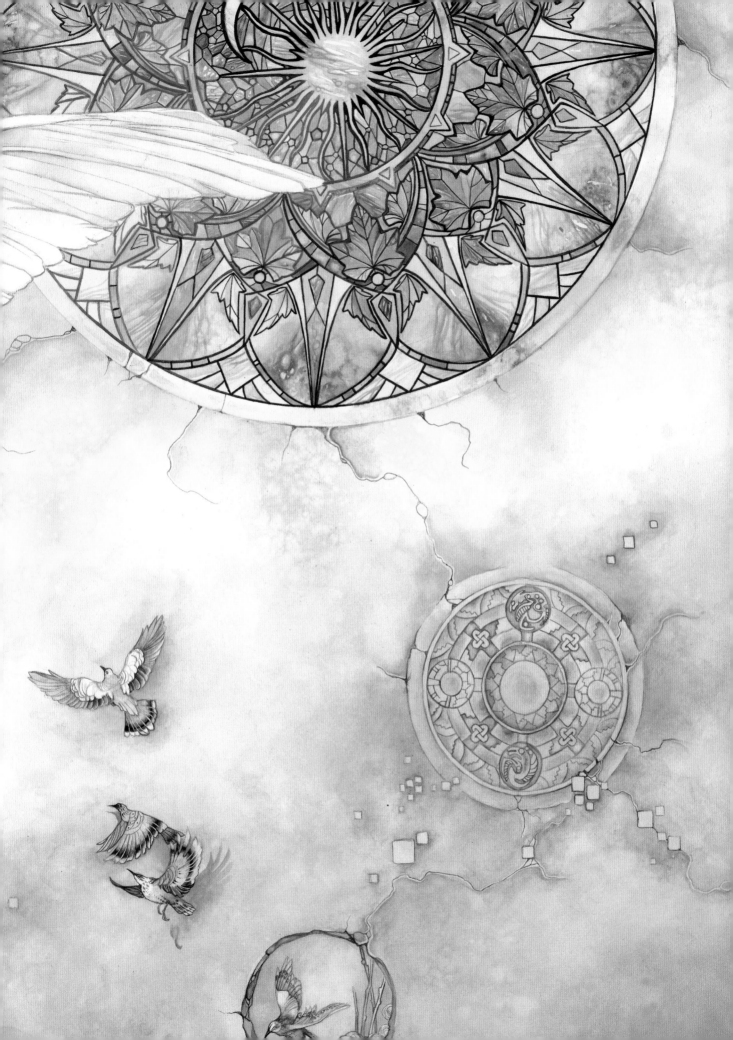

Dreamscapes: Creating Magical Angel, Faery & Mermaid Worlds with Watercolor. Copyright © 2008 by Stephanie Pui-Mun Law. Manufactured in China. All rights reserved. No part of this book may be reproduced in any form or by any electronic or mechanical means including information storage and retrieval systems without permission in writing from the publisher, except by a reviewer who may quote brief passages in a review. Published by IMPACT Books, an imprint of F+W Publications, Inc., 4700 East Galbraith Road, Cincinnati, Ohio, 45236. (800) 289-0963. First Edition.

These and other fine IMPACT books are available at your local art & craft retailer, bookstore or online supplier or visit our website at www.fwpublications.com

12 11 10 09 08 5 4 3 2 1

DISTRIBUTED IN CANADA BY FRASER DIRECT
100 Armstrong Avenue
Georgetown, ON, Canada L7G 5S4
Tel: (905) 877-4411

DISTRIBUTED IN THE U.K. AND EUROPE BY DAVID & CHARLES
Brunel House, Newton Abbot, Devon, TQ12 4PU, England
Tel: (+44) 1626 323200, Fax: (+44) 1626 323319
Email: postmaster@davidandcharles.co.uk

DISTRIBUTED IN AUSTRALIA BY CAPRICORN LINK
P.O. Box 704, S. Windsor NSW, 2756 Australia
Tel: (02) 4577-3555

Library of Congress Cataloging-in-Publication Data

Law, Stephanie Pui-Mun.
 Dreamscapes : creating magical angel, faery & mermaid worlds with watercolor / Stephanie Pui-Mun Law. -- 1st ed.
 p. cm.
 Includes index.
 ISBN-13: 978-1-58180-964-0 (pbk. : alk. paper)
 1. Fantasy in art. 2. Angels in art. 3. Fairies in art. 4. Mermaids in art. 5. Watercolor painting--Technique. I. Title.

ND1460.F35L39 2008
751.42'247--dc22 2007025939

Edited by Kelly C. Messerly
Designed by Wendy Dunning
Production coordinated by Matt Wagner

Metric Conversion Chart

To convert	to	multiply by
Inches	Centimeters	2.54
Centimeters	Inches	0.4
Feet	Centimeters	30.5
Centimeters	Feet	0.03
Yards	Meters	0.9
Meters	Yards	1.1

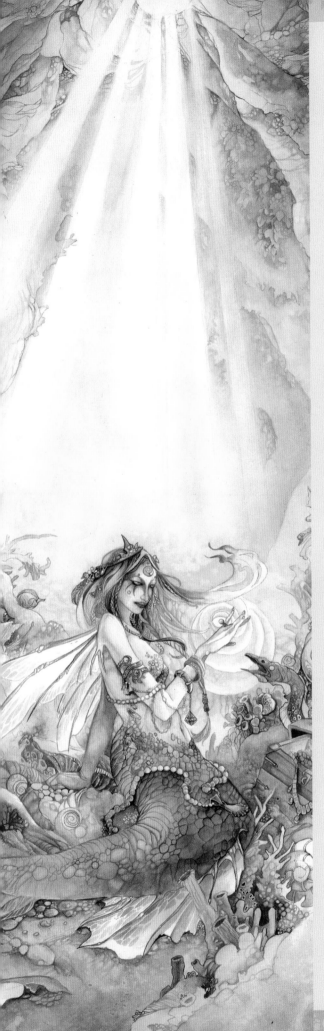

About the Author

Stephanie Pui-Mun Law has been painting fantastic otherworlds from early childhood, though her art career did not begin until 1998 when she graduated from a program in computer science. After three years of programming for a software company by day and rushing home to paint into the midnight hours, she left the world of typed logic and numbers for painted worlds of dreams and the fae.

Her illustrations have been for various game and publishing clients, including Wizards of the Coast, HarperCollins, LUNA Books, Tachyon Books, Alderac Entertainment Group and Green Ronin. In addition to the commissioned projects, she has spent a great deal of time creating a personal body of work whose inspiration stems from mythology, legend and folklore. She has also been greatly influenced by the art of the Impressionists, Pre-Raphaelites, Surrealists, and the master hand of Nature. Swirling images of sinuous oak branches, watermarked leaf stains and the endless palette of the skies are her signature. Her background as a flamenco dancer for over a decade is evident in the movement and composition of her paintings. Every aspect of her paintings moves in a choreographed flow, and the dancers are not only those with human limbs. What Stephanie tries to convey with her art is not simply fantasy, but the fantastic, the sense of wonder, that which is sacred.

While most of Stephanie's work is done with watercolors, she also experiments with pen-and-ink, intaglio printing, acrylic and digital painting.

Acknowledgments

Thanks to Dana for being the guinea pig for these tutorials. Mom, Dad, Dave, Beck and Hop for always being supportive of my art. You guys at #epilogue for letting me bounce ideas. Kelly Messerly and Pam Wissman for finding me and giving me this opportunity.

\mathcal{T}able of Contents

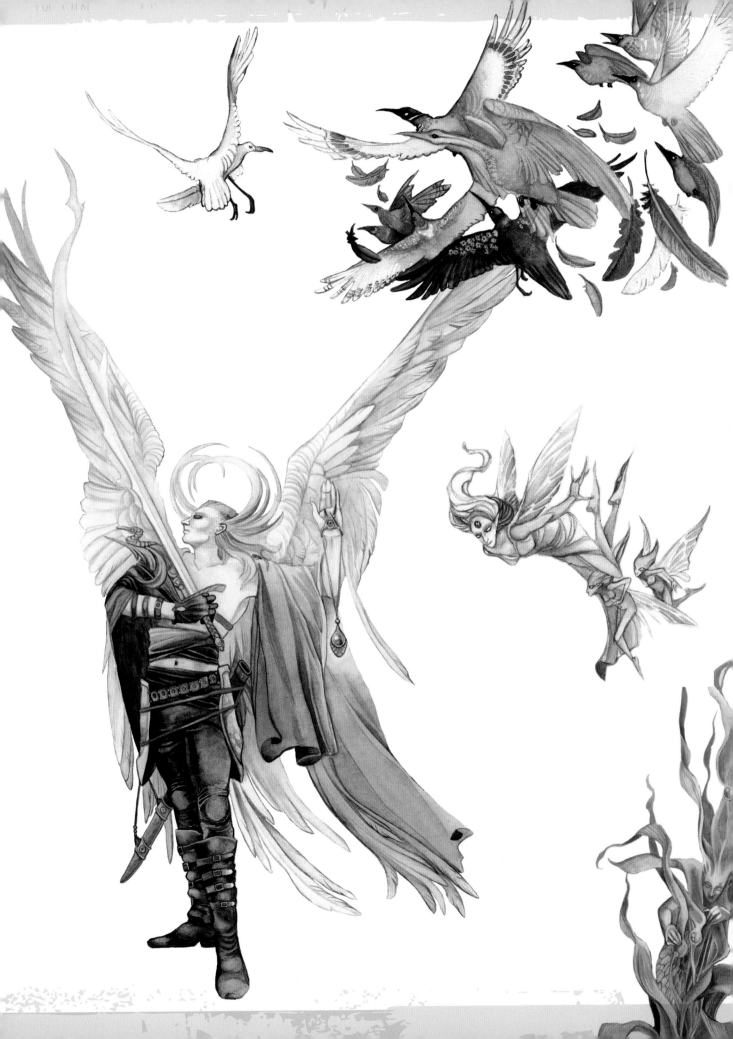

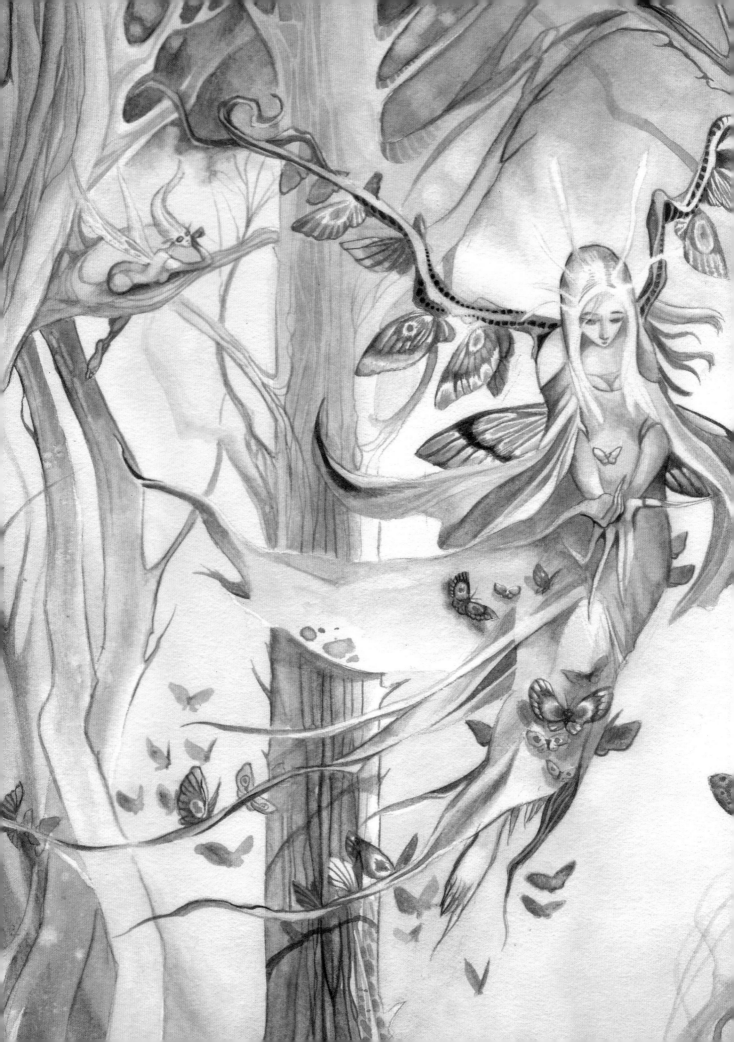

Part One
MATERIALS & TECHNIQUES

It can be a daunting task to sit in front of a blank sheet of paper with the expectation of creating something magical. Yet possibilities and inspiration are all around—from other artists and from nature. Even the "mistakes" that we can be so fearful of can be turned into unexpected and unusual results.

Being familiar with the basics and having a knowledge of the tools at your fingertips can help smooth the path from our nebulous imaginations to visual life on a sheet of paper. Practice is the only way to turn that obstruction of physical tools into a magical bridge that the legions of wonder can flit, swim and glide across into colorful realization on the once blank sheet of paper.

Pencils

IN THIS BOOK YOU'LL USE PENCILS IN YOUR studies of drawing ethereal fantasy creatures with the goal of a painted end result. Even though the focus here is on painting with watercolors, pencils are a viable tool for completed works of art.

8B
6B
4B
2B
HB
2H
4H
6H
8H

Lead Hardness
You can get leads in varying degrees of softness; 8B is the softest, while 8H is the hardest. HB is a medium hardness. The softer the pencil lead, the darker your mark. If you use too soft a lead, the pencil will easily smear and make your painted colors look dirty. If the pencil lead is too hard, you will have to press harder to draw your lines, creating indentations on your watercolor paper with the point. For this reason, HB and 2B pencils are good choices for sketches that are going to be painted over.

Selecting a Pencil
A traditional wood pencil is a good all-around choice. Mechanical pencils are consistent and convenient because you do not have to stop to sharpen them, and they can be purchased in a variety of lead thicknesses, from a very fine .3mm (for small details) to thicker .5mm and .7mm. The downside of a mechanical pencil is that you lose the organic flow that a uniform thickness of line cannot accommodate. A regular wooden pencil has an expressiveness that tends to get lost with mechanical pencils. An alternative is a lead holder. Lead holders can hold leads 2mm in thickness. They are similiar to mechanical pencils, but can hold a much thicker lead that you can sharpen to a point or draw with its edge.

If you are planning to paint on the surface afterward, do not use much shading if you wish to keep the colors pure. If you are just sketching for ideas or doing a pencil drawing, however, go all out. A lead holder is a particular joy to use in that case.

Traditional no. 2

Mechanical (.3 thickness)

Lead holder

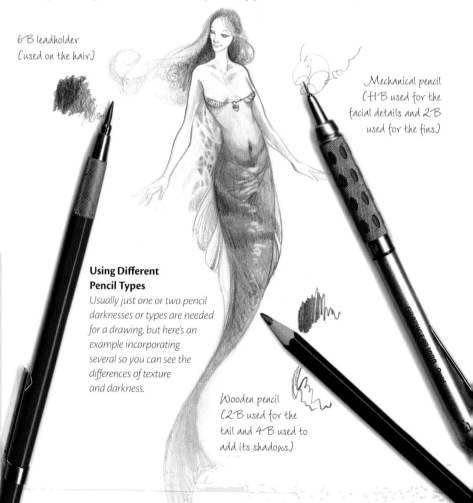

6B leadholder (used on the hair)

Mechanical pencil (HB used for the facial details and 2B used for the fins)

Wooden pencil (2B used for the tail and 4B used to add its shadows)

Using Different Pencil Types
Usually just one or two pencil darknesses or types are needed for a drawing, but here's an example incorporating several so you can see the differences of texture and darkness.

Selecting an Eraser
Vinyl erasers work fine for sketches, to clean up a piece after all the painting is completed or for removing bits of dried masking fluid. Kneaded erasers are only needed if your intent is to create finished pencil drawings because you don't want to be laying in heavy graphite under your watercolors—it will muddy the colors.

Brushes and Other Painting Tools

THE TWO MOST COMMON TYPES OF BRUSHES are flats and rounds. Flats are useful for creating large areas of even color. Rounds are great for shaping certain areas and adding details.

Items like salt and rubbing alcohol are great for adding unique textures to your painting.

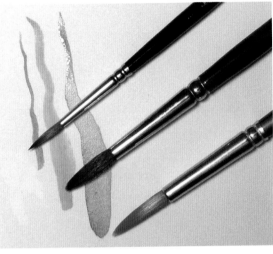

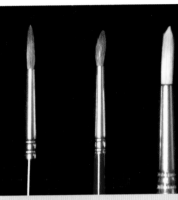

Flats
A ½-inch (12mm) flat is a good brush for doing washes in large areas. If you decide to work with bigger paintings in the future, you should eventually acquire bigger flat brushes that can cover more areas with one stroke. A ½-inch (12mm) flat is suitable for working in areas up to 11" × 14" (28cm × 36cm). But for surfaces larger than this, you'll need a larger flat to hold the necessary water and pigment.

Rounds
Having an assortment of brush sizes gives you a nice base of tools to work from. Rounds in nos. 0, 2, 4 and 8 are a good starter set. You can add to your collection as you gain more experience with painting and find yourself in need of a better selection. Sometimes you can purchase a starter brush set that includes three to five brushes of different sizes for a reasonable price.

Very fine work and details like leaves, eyes and scales require a small brush with a good point such as a no. 0 round, while a large round such as a no. 10 or bigger is useful for irregularly shaped washes.

Sable or Synthetic?
Brushes can range in quality (and price) from synthetic fibers to top of the line Kolinsky Sable hairs. If you are just getting started, you might not want to splurge on the most expensive brushes. There are many reasonably priced mixed synthetic and sable, or pure sable options that are of good quality. What you want to look for in a brush is the ability of the hairs to hold a point when wet (if the hairs all splay outward or don't stick together, the brush isn't good), and the resilience and bounce of the hairs (when bent, they should spring back to shape).

Cheaper brushes eventually lose their point as the hairs get splayed or bent, but do not just toss these old brushes out. They are good utility brushes to use when you need to lift paint or to apply masking fluid. When you don't want to spoil your nicer brushes with rough treatment, grab an older one.

Salt
Sprinkle salt into wet paint and the crystals pull the pigment as the liquid dries, leaving a random starlike mottled effect. Brush away the salt crystals after the painting has dried.

Rubbing Alcohol
Sprinkling rubbing alcohol onto wet paint causes the pigment to push away, leaving an interesting splotched effect.

Paints

WATERCOLOR PAINTS COME IN TUBE AND CAKE form. Don't feel like you are limited to pans or tubes however. You can always mix and match—get a pan set for a basic starter set, and then, when you need additional colors that are not included, purchase tubes.

Tubes or Cakes?

Advantages of tubes:

* *Offer more control over the intensity of color.*

* *Easy to acquire in a variety of pigments so you can custom select the array of colors.*

* *Easy to get the amount of pigment you need by squeezing a tube, rather than trying to work it up from a dried cake.*

Advantages of cakes:

* *Starter sets offer a good selection of pre-selected colors.*

* *Less cleanup is needed because a cake is more self-contained.*

* *Easy to take with you when traveling or painting on site—perhaps to a forest or garden for inspiration.*

Red Lake

Cadmium Yellow

Ultramarine Blue

Primary Colors

The primary colors (red, yellow and blue) are three basic colors to get you started. In theory, the entire spectrum of colors can be mixed from them.

White Gouache

Gouache is an opaque watercolor paint. When used sparingly, white gouache can be an effective way to go back over a finished area and paint in some white. However, the transparent quality of watercolor really makes a painting glow, and, when you apply opaque colors, you are stepping away from that look. The white of untouched paper will always be brighter and more pure than painting back with an opaque white gouache.

Payne's Gray

Burnt Umber

Brown Madder

Lamp Black

Alizarin Crimson

Sap Green

Viridian

Cerulean Blue

Cadmium Yellow

Naples Yellow

Expanded Palette

Having more colors gives you a brighter, more pure palette to choose from. You can mix a lot of shades from a limited set, but if you want a very bright and light color like pale pink, or a light shade of a primary color, you should purchase a tube or cake of that color.

In addition to red, yellow and blue, some additional recommended colors are shown above. Starter sets of cake paints will usually include most of these colors, though if you go with tubes you can individually select them yourself. As you gain more experience, you can add to your selection of colors.

xtras

Water Container

A bowl or cup of water is needed for washing off your brushes. Don't be lazy and let your water get too dirty and cloudy! It will make your colors look muddy, so take the time to freshen the water every once in a while.

Palette

A lot of cake paint sets have a built-in palette for mixing colors; therefore it may not be necessary to purchase a separate one. However, if you are using only tubes you will need a palette to set out and mix your colors.

Absorbent Paper Towels

Keep a supply of paper towels on hand for mopping up excess moisture from a painting.

Masking Fluid and Old Brushes

Also called liquid frisket, masking fluid is a liquid latex that you paint directly on your surface to retain white areas before applying paint. Never use a good painting brush for applying masking fluid. Save up old brushes for this purpose, and clean them with soap and water quickly after you finish. Once the frisket has dried on the paper, you can apply washes of color over it. When the paint is fully dry remove the masking by rubbing gently with your fingertip or eraser. The areas underneath will be white and unpainted.

Colour Shaper

These are rubber-tipped tools with either a chisel or pointed tip that are often used for sculpting or acrylic painting. Because a Colour Shaper has no individual bristles, dried liquid frisket will not harm it, and it can be used just like a brush to apply the masking fluid. When finished, simply wipe off the tip with a paper towel.

Mixed Neutrals on Your Palette

Although it is important to keep colors clean and separate (especially for pale colors like yellows, oranges, pinks and light greens), sometimes letting colors run together on your palette can create mixed neutral tones. Use them to paint subtle shadows and in-between shades, instead of a flat pure color. The less vibrant hues and neutral shifts lend a subtle realism to your painting.

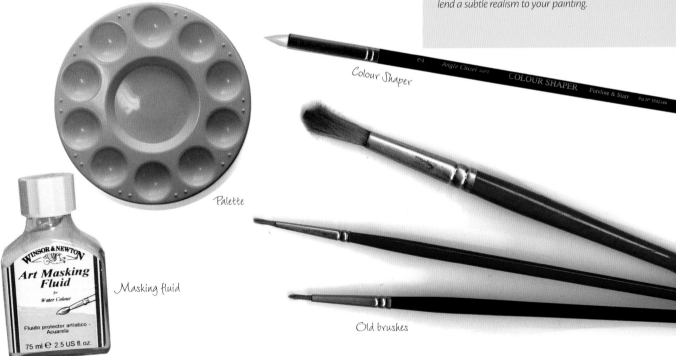

Colour Shaper

Palette

Masking fluid

Old brushes

\mathcal{P}aper

THE TYPE OF PAPER YOU CHOOSE TO PAINT ON is as important as your brushes and paints. Papers are usually categorized according to the surface texture (which is commonly referred to as a paper's tooth): rough, cold press or hot press.

Watercolors are usually most suited to rough or cold-pressed paper because they absorb the pigment quickly. Hot-pressed paper is better for more opaque techniques such as working in acrylics or gouache paints and drawing with inks and pencils.

Selecting a paper is also a matter of personal preference—whether you like a rough texture or a smooth, unbroken surface. I prefer to work on lightweight illustration board, but you should try out different textures and types of surfaces to see for yourself how the paints behave.

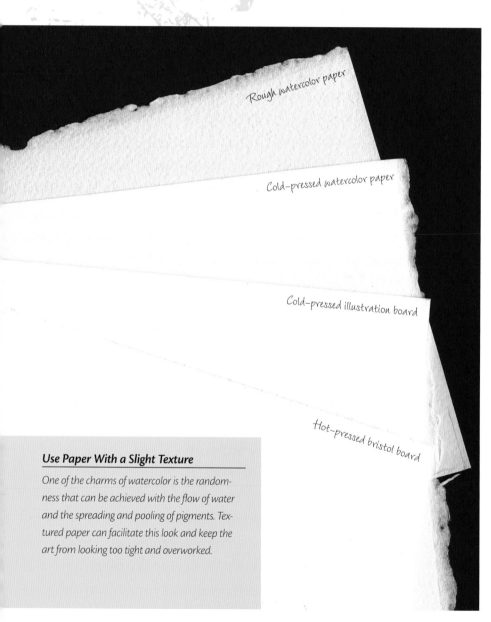

Rough watercolor paper

Cold-pressed watercolor paper

Cold-pressed illustration board

Hot-pressed bristol board

Selecting a Surface

- **Rough surface**. *This finish has the most pronounced peaks and valleys. It is not recommended for a beginner watercolorist because mistakes are hard to hide and paint can pool into the valleys.*
- **Cold-pressed surface**. *This surface has a medium tooth and allows the water and pigment to be absorbed quickly. The surface is also resilient to rough treatment and can handle lots of layering and lifting. Cold-pressed paper is a good type of paper to start out with.*
- **Hot-pressed surface.** *This surface is extremely smooth and nonporous. Watercolors tend to pool and bleed a bit more since the liquid isn't rapidly absorbed into the paper. However, this does make blending easier.*

Use Paper With a Slight Texture

One of the charms of watercolor is the randomness that can be achieved with the flow of water and the spreading and pooling of pigments. Textured paper can facilitate this look and keep the art from looking too tight and overworked.

An Alternative to Watercolor Paper

Illustration board can be a good alternative to watercolor paper. It can be found in cold- or hot-pressed finishes, though even the cold-pressed tends to be on the smoother end of the spectrum. Illustration board does not get as warped from repeated washes as watercolor paper does, and it does not need to be stretched. Tape it down to a Masonite board for easy transportation and to prevent damage to the corners.

You can also use bristol board, but it does not take water very well and will easily warp. Bristol board, however, is better suited for pencil or ink drawings with very little color.

Basic watercolor technique
STRETCHING WATERCOLOR PAPER

Unless you use prestretched watercolor paper or illustration board, you must stretch your watercolor paper to prevent it from becoming swollen with water and warped.

MATERIALS LIST

4 pieces of acid-free masking tape cut to the width and height of your paper, bowl of water, drawing board, paper towels, watercolor paper cut to size

1 **Wet the Paper**
Take the sheet of paper and soak it thoroughly in water.

2 **Remove Excess Water**
Wipe away excess moisture with a paper towel.

3 **Let the Paper Dry**
Take the paper by the corners and lay it flat on the drawing board. Tape down all four sides with acid-free masking tape. Let the paper dry completely. When it is dry, the paper is ready for you to paint. Do not remove the paper from the board until you have finished your painting.

olor

THE BASIC COLOR WHEEL CONSISTS OF THE primary colors red, yellow and blue. From these three basic colors, the rest of the spectrum can be created. The secondary colors are orange (mixed from red and yellow), green (mixed from yellow and blue) and violet (mixed from blue and red). The six tertiary colors result from mixing a primary with a secondary color.

Generally the reds, oranges and yellows are considered warm colors and purples, blues and greens are considered cool. Being aware of warm and cool colors can help you manipulate the mood of your paintings.

Mix Lively Grays and Blacks

Grays and blacks (but especially blacks) straight from the tube are often seen as "dead" colors. This is particularly true of black because it's completely neutral—neither warm nor cold—and, as a result, looks very flat and will draw your viewer's eyes toward it. Therefore, it's best to use black paint sparingly.

An alternative is to create a black mixture. Few things in the world are truly black; even a black object has light and shadows and is affected by the surrounding colors. Burnt Umber and Ultramarine Blue make a great combination for an artificial black. Add more Ultramarine Blue to the mixture for a cooler black or more Burnt Umber for a warmer cast.

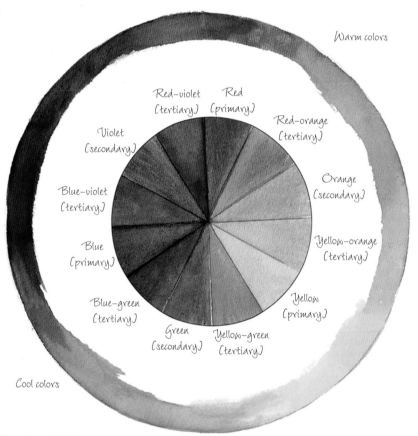

The Color Wheel
Being familiar with the color wheel will help you when it comes to mixing your watercolors and in determining the color schemes of a painting.

Complements and Color Mixing
Complementary colors sit opposite each other on the color wheel. Complementary pairs are red/green, blue/orange and purple/yellow. Mixing complementary colors together results in a muddy brownish-gray tone. The more colors you mix, the muddier the mixture becomes. Try to mix only two or three colors at most to get the color mixture you need.

Crisp Edges and Spilling

THE BEST PAINTINGS ARE A MIXTURE OF control and random accidents. Most artists evolve beyond the frustration of not being able to control the paint, to using an iron fist and killing all the spontaneity of watercolors, to finding a happy medium that uses the natural tendencies of watercolors, while maintaining knowledge and control over the results.

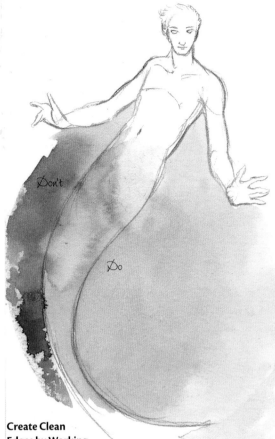

Create Clean Edges by Working Wet-On-Dry

When not enough time is left for a surrounding color to dry, it will bleed into the newly applied color next to it. On one side, the blue wasn't dry before the green was applied, so the blue spilled over into his tail. Be patient—a minute spent waiting now will save you much hair-tearing and regret later when trying to correct an error. This technique of working wet-into-dry can help you create crisp edges.

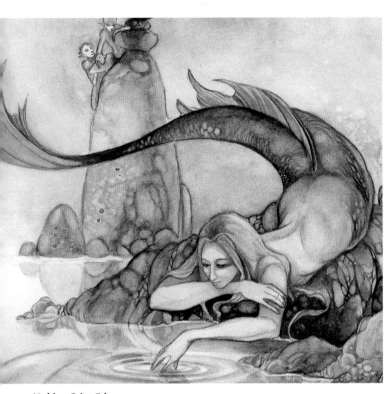

Making Crisp Edges

To create details or a crisp edge, do not paint an adjacent layer of color near another wet color or it will bleed from one section to another. You can only create fine-edged details with dry adjacent colors. When in doubt and something is wet, wait.

Take Advantage of Spills

Sometimes spilling color can be a good thing. You can use the effect purposely as a technique. Her hair blends right into the background in a cloudy haze that works quite well in this instance.

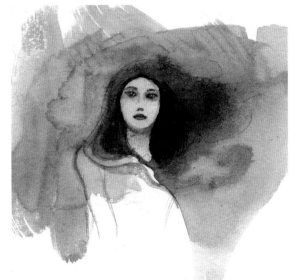

Basic watercolor technique
FLAT WASH

Washes are the most basic watercolor technique, and can be used to cover large, flat background areas, or for laying in basic colors on smaller elements of a painting.

PAINTS

Ultramarine Blue

MATERIALS LIST

½-inch (12mm) flat, acid-free masking tape, cold-pressed watercolor paper or illustration board, drawing board

1 Wet the Paper
Secure your surface to a drawing board. Position your paper at a slight angle toward you (prop some books underneath the top if you don't have a slanted drawing table). Use a ½-inch (12mm) flat to wet the entire area of the wash.

2 Add Pigment
Load a ½-inch (12mm) flat with Ultramarine Blue. Drag the brush horizontally across the top of the paper. Since the surface is at an angle, the paint will drip toward the bottom of the page.

3 Add More Pigment
Before the previous stroke dries, drag a second stroke right below and slightly overlapping the first stroke. Make sure you catch the drips from the first stroke for an even wash.

4 Create the Final Layers
Keep layering pigments, following steps 2 and 3 until you get to the bottom. If too much paint runs to the bottom edge, reduce the angle of your work surface. Avoid going back and retouching areas that you have already painted until the surface is dry, since small variations and inconsistencies will smooth themselves out as the paint dries and the water flows.

1

2

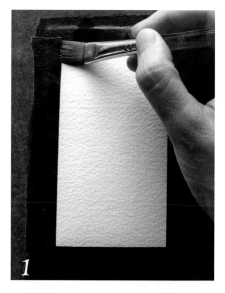

3

4

Basic watercolor technique
GRADED WASH

For a graded wash, dilute the paint with each consecutive stroke so that the pigment eventually fades into clear water and the white of the paper. Remember, it's important to let the paint dry on its own. Do not fuss with it too much or you may make inconsistencies more obvious.

Use graded washes for the changing colors of the sky's horizon or to create the vibrant edge of a rose petal fading to the pale pink heart.

PAINTS

Ultramarine Violet

MATERIALS LIST

½-inch (12mm) flat, acid-free masking tape, cold-pressed watercolor paper or illustration board, drawing board

1 **Wet the Paper and Add Pigment**
Secure your surface to the drawing board. Prop the surface up, angling it toward you. Wet the area with a ½-inch (12mm) flat, then load it with fairly concentrated Ultramarine Violet. Drag the brush across the paper's top with a horizontal stroke.

2 **Add Lighter Pigment**
For the next stroke, dilute the paint a little bit so that it is slightly lighter than the first stroke. Drag the brush across the surface, overlapping the first stroke.

3 **Continue to Add Layers**
Keep layering pigments, following step 2 until you get to the bottom. Remember, dilute the paint for each row.

4 **Let the Surface Dry**
After you've covered the whole area, don't fiddle with it because this will only mar the smoothness of the wash. Minor inconsistencies will smooth themselves out as the surface dries. Practice this a few times until you can create an even wash.

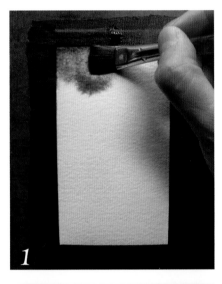

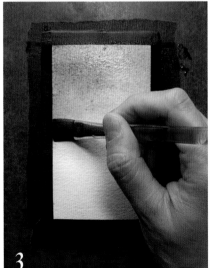

Applying a Graded Wash in a Curvy Area

Create graded washes in areas with curves and edges by slowly building a series of graded washes in the area. Start with a very pale wash; let it dry then keep building layers. Let the layers dry between applications so the pigment has a chance to build up. This method gives you much more control.

Mixing and Glazing

A GLAZE IS A TRANSLUCENT WASH ON TOP OF AN EXISTING layer. Each time you layer a color on top of another color it changes the tone in a way that is distinct from just mixing the wet colors directly before painting. Glazing gives a glowing gemlike quality to your colors and offers the subtlety of shifting colors that direct mixing can't accomplish.

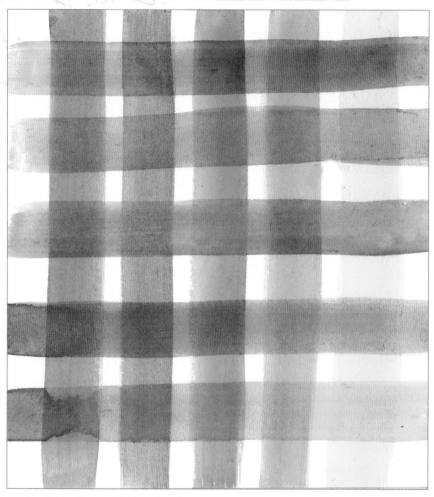

Glazing Colors Creates Different Results
Notice how a color's intensity is increased when another layer of the color is added to it. Layering complementary colors results in muted brown and neutral tones.

Creating a chart like this with your pigments will help you determine which colors to glaze because you'll be able to see how the colors look when one pigment is layered over another.

Working Wet-Into-Wet on Your Paper
Wet the entire surface of the area you will be working on with clear water and then take a brush and paint in the wet area with various colors. The water will dilute the edges of the painted areas and pull the pigment away from the center. This has a very organic look and is useful for painting leaves and flowers, for laying in the base colors of a mermaid's tail or a faery's wings.

Basic watercolor technique
GLAZING

A mermaid swims up from the dark depths of the ocean toward the sunlight on the surface, so a graded wash is a perfect background for her.

To achieve this background, create the graded wash so that the darkest part is at the top of your surface. Once it's dry, turn the surface so that the darkest part of the wash is now at the bottom.

PAINTS

Naples Yellow, Ultramarine Blue, Ultramarine Violet, Viridian

MATERIALS LIST

½-inch (12mm) flat, cold-pressed watercolor paper or illustration board, nos. 1 and 2 rounds, pencil

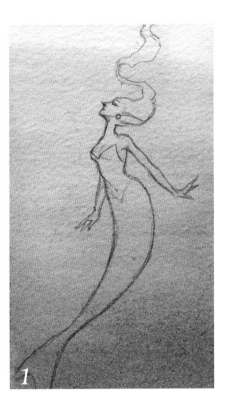
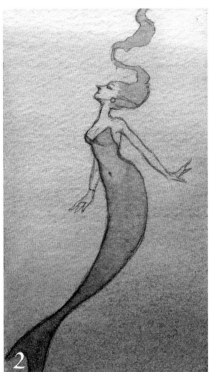
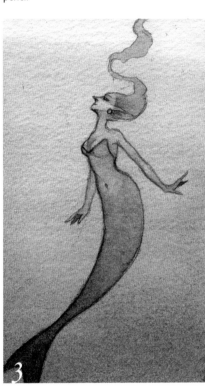

1 Begin With a Sketch and a Graded Wash
Sketch the mermaid with a pencil. Use a ½-inch (12mm) flat to apply a graded wash of Ultramarine Violet, so the top is almost white, and the bottom is the darkest part.

2 Glaze the Tail, Body and Hair
Apply a layer of Ultramarine Blue over her tail, body and hair with a no. 2 round. Since the previous layer is darker toward the bottom, the tail will seem to darken toward the shadows at the bottom.

3 Add the Final Details
Apply Naples Yellow to her skin with a no. 1 round. With a no. 2 round, add a layer of Viridian over the lower half of her tail to bring out more color. The brightness of the Viridian is subdued by the earlier layers.

Glazing Creates a Subtle Color Change

Here are the colors used in this demonstration in their pure form, that is, straight out of the tube. However, when they are layered on top of each other, they interact and mix differently, creating a much more subtle effect.

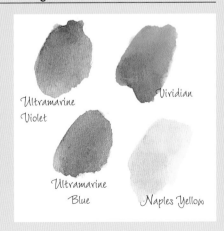

Ultramarine Violet

Viridian

Ultramarine Blue

Naples Yellow

ℒℳore Watercolor Techniques

1 Layered Graded Wash

By combining graded washes and glazing, you can create a multicolored melding of tones. Use a ½-inch (12mm) flat to apply a graded wash with one color. When that has dried completely, paint a second graded wash with a different color (or use the same color to intensify its appearance). Repeat this until you get the appearance you desire. Use this technique for complex backgrounds.

2 Drybrush

Load some paint on a brush, then dab it in a paper towel to get rid of excess moisture. Experiment with varying amounts and notice the results. With less moisture, the brush will skip over the texture of the paper and you will start to see the individual hairs of the brush in the strokes. With more water, you will get a very smooth, unbroken line similar to a wash. Drybrushing can be used to paint fine details in foliage, grass and hair.

3 Dry-on-Wet

Wet only the areas you will be working with using clear water (here, I painted horizontal lines of water). With a brush loaded with relatively dry paint, work through those wet areas. The wet parts will dilute the pigment, while the dry areas hold the paint still. This technique can be used for surface ripples of water.

4 Lifting From a Wet Surface

Lifting is when you remove pigment from the paper after it has been applied. You can lift from a wash that is still wet by taking a towel, tissue or sponge and dabbing at the paint. The drier the paint gets, the less color you can remove.

5 Lifting From a Dry Surface

To lift color from paint that has already dried, you must apply water. You can do this by dropping water onto the dried surface and letting it sit for a moment before lightly scrubbing it with a paper towel. You can also take a brush charged with water and use it to lightly scrub the surface. Using a smaller brush gives you more control over what is lifted. This technique is very useful for distant foliage, tree bark, stars, mermaid scales or for creating highlights.

6 Salt Texturing

Paint a wash, then sprinkle salt on the painting's surface while it's wet. After the surface has dried, carefully brush away the salt crystals. You will be left with a feathery texture of white stars. The salt crystals suck up the pigment from the surrounding areas, leaving a unique pattern. This is an organic texture that is useful for giving an element of randomness to your paintings. This is especially good for natural objects like rocks, background foliage or watery effects in the distance.

7 Plastic Wrap Texturing

Paint a wash, then, while it is still wet, lay a piece of plastic wrap on top. After the paint has dried, remove the plastic wrap. Use this technique for rock textures or stained glass.

8 Rubbing Alcohol Texturing

Paint a wash. While it is still wet, sprinkle it with rubbing alcohol. The pigment will push away from the rubbing alcohol and leave interesting speckled patterns. This texture is good for suggesting distant foliage or bubbles in an underwater scene.

Secrets to Successful Lifting

Certain colors respond very differently to lifting. Blues lift very easily (for this same reason, blues are sometimes difficult to glaze because the color insists on lifting as you apply a second wet layer). Reds, on the other hand, can be extremely stubborn and require much more force to lift. The paper also affects your ability to lift a pigment. Pigments on hot-pressed paper lift easily since the paint mostly sits on the surface. A very rough cold-pressed paper might be more resistant to lifting. Cheaper papers also have a tendency to suck up the pigment and very reluctantly release any of it.

Drawing on Inspiration

ANGELS HAVE BEEN THE SUBJECT MATTER OF many master artists. The Renaissance is full of paintings and sculptures devoted to angelic depictions. Faeries and mermaids have had their time in the spotlight as well in the movements of the Pre-Raphaelites and Victorian faery artists.

Copying from the past is a good way to learn. Study the traditional treatment of angels, faeries and mermaids as well as human figures.

Use a grid to transfer reference photos to your drawing surface or to transfer a drawing from sketch paper to the final painting surface.

Sources of Inspiration

Get ideas by looking at the works of masters. Some suggestions to get you started:

- *Michelangelo (his paintings and his sculptures)*
- *Leonardo da Vinci*
- *Edward Burne-Jones*
- *John William Waterhouse*
- *Richard Dadd*
- *Edmund Dulac*
- *Arthur Rackham*

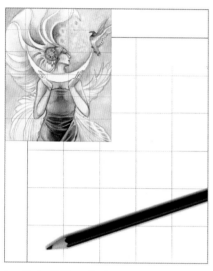

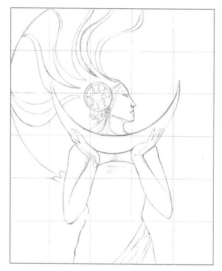

Begin to Map Out the Image

Using the gridded photo or study as a reference, draw small sections of the image at a time. If you have never done this exercise, concentrate on one square at a time and try not to think of the picture as a whole figure, but just focus on the lines and shadows. Block in the subject's outline; don't worry too much about shading—just focus on the basic shapes. The grid helps you break down the image and see it in an abstract way so that you can accurately transfer the figure. Relying on the preconceptions your brain has of the figure can lead to an inaccurate drawing.

Lay Out a Grid on the Image and Your Surface

Select a picture or study. Mark off a grid on the image with either a pencil or pen and a ruler. If you have a computer, you can scan the image and digitally mark off a grid.

Mark off your blank drawing paper lightly in pencil with the same number of gridded subdivisions. It does not need to be the same size as your gridded photo, but it does need to have the same proportions of width and height.

Complete the Sketch

Continue fleshing out the details and light shading. It's important to keep any shading light if you plan to paint over the sketch. If the pencil lines are too dark, they will make the paint's colors seem dirty. After you finish sketching, erase the grid lines.

Ideas From Around You

IT'S EASY TO START A COLLECTION OF REFERENCE images by taking a camera around with you. There are so many places from which you can take inspiration.

Explore Your Own Backyard or Visit a Botanical Garden

Step outside in the springtime when all the flowers are in bloom. Take snapshots of your own garden's blooms and trees or visit a nearby botanical or rose garden for more exotic flora and fauna.

Take a Trip to the Zoo or Aquarium

You can get ideas and references all over the place at any zoo. Fantastic horns and antlers can be used for faery headdresses or angelic instruments. Swans, cranes or exotic birds can be excellent for wing references. Take some photos of them when they spread their wings to stretch. Some zoos may also display insect wings that you can study for faeries.

Even a nearby tropical fish store will do for ideas if there isn't a nearby aquarium. Look at the colors and markings on the fish and the shape of the fins.

Respect Copyrights

Always be aware of copyrights when you use other people's images. It's fine to use photos as a reference to get ideas, to see how a swan's wing works or to study facial features, but, unless you have permission from the original owner of an image, it is not okay to copy a picture unless it is purely for learning purposes.

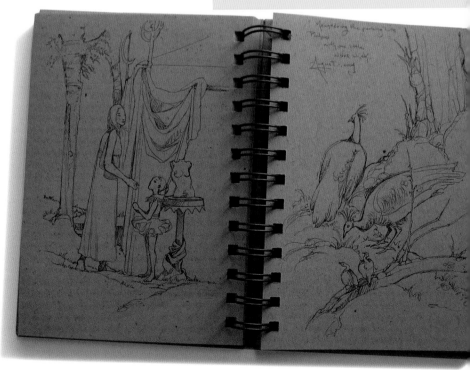

Imagery From the Internet

The Internet is a great reference tool for artists. Here are some resources for imagery:

http://www.corbis.com
http://images.google.com
http://images.search.yahoo.com
http://www.altavista.com/image
Additionally, there are sites that artists can subscribe to for use of reference imagery.

Keep a Sketchbook

It is hard to have a camera on hand at all times, but a thin pocket-sized sketchbook can be useful for recording what is around you, or for when sudden inspiration strikes!

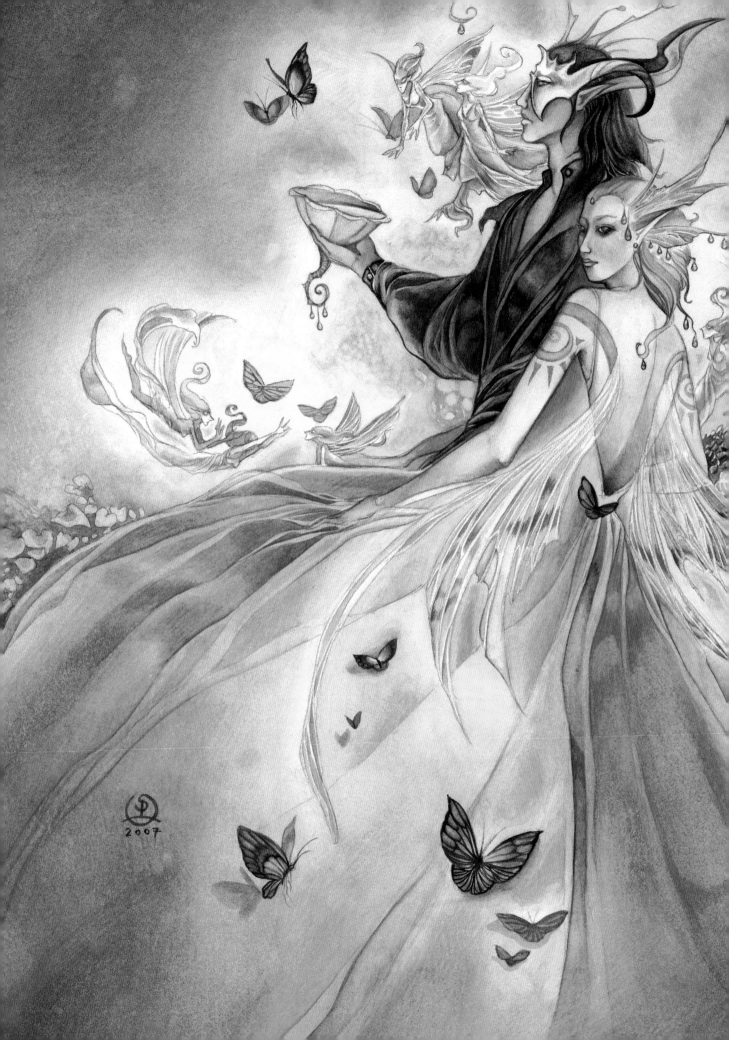

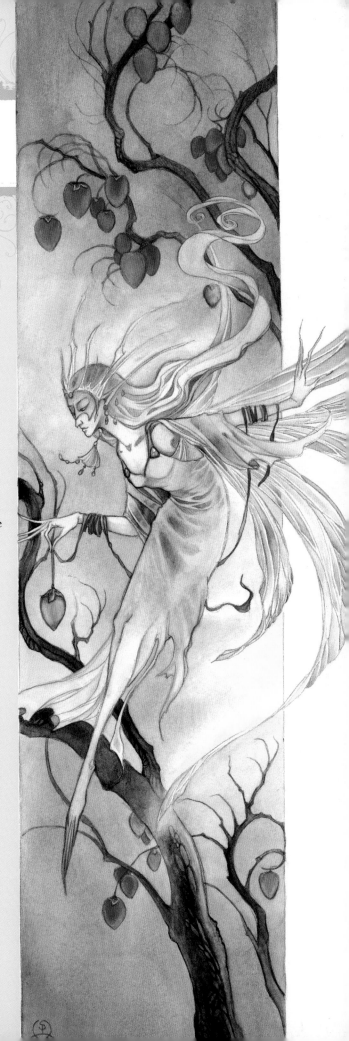

Part Two
FAERY LANDS

Come dance with me midsummer's eve.
Come brave the faery lights!
And nevermind what you might see—
of forbidden faery sights.
And nevermind the honeyed fruits,
the moonlit flows of faery wines.
And drink not of the liquid song
from faery flutes divine.
Come dance and let the weaving spell
flow through and braid around;
But do not dare forget you stand
upon a faery mound.

Faeries have danced through folklore for centuries. There are household fae like brownies, will-o'-the-wisps that slip through the dark nights, dryads and spirits of the trees and flowers, and seductive creatures that beckon mortals to join them in the moonlit faery rings.

he Faery Family

FAERIES CAN COME IN ALL SHAPES AND SIZES, from tiny pixies that could fit in your hand, to elegant Sidhe of the Seelie Court.

Tiny

Faeries drawn at very small sizes can dance around a mushroom ring or dance on a mushroom, spin through the night air or lie peeping from the underbrush. Draw them with normal body proportions, but only at a fraction of the normal size.

Child

Diminutive stature and a child's proportions (head being larger than the adult at 1/7 proportion) suggest a playful faery. Make the features more rounded with a less prominent bone structure for the face and with softer muscle definition in the arms and legs.

Adult

Faeries with adult human proportions have a more earthly nature because their proportions are so familiar. The average adult human proportion is about 6½ to 7 head lengths high. To distinguish faeries from humans, add wings, clothing and other accoutrements.

Tall

Exaggerated, elongated limbs make a very elegant figure and suggest an otherworldly nature. If you emphasize bone structure, especially in the cheekbones and chin, you will further enhance this effect.

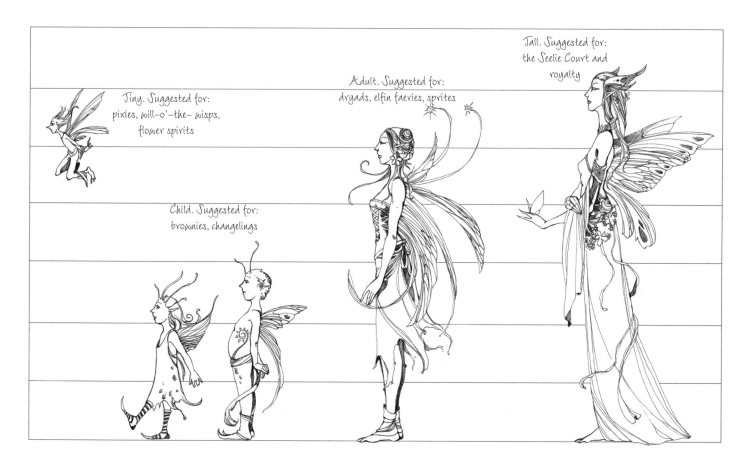

Tiny. Suggested for: pixies, will-o'-the-wisps, flower spirits

Child. Suggested for: brownies, changelings

Adult. Suggested for: dryads, elfin faeries, sprites

Tall. Suggested for: the Seelie Court and royalty

Emphasizing Tall

SOMETIMES YOU WANT YOUR FAERIES TO HAVE a humanlike beauty. Other times you might want to exaggerate certain features to highlight their differences from humans and to give them a more ethereal quality.

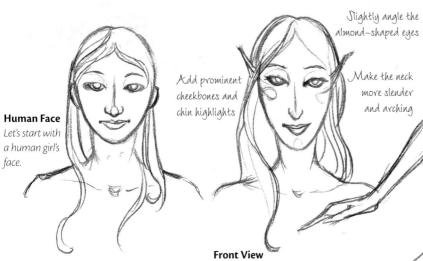

Slightly angle the almond-shaped eyes

Add prominent cheekbones and chin highlights

Make the neck more slender and arching

Human Face
Let's start with a human girl's face.

Front View
From here we can try elongating the face, stretching everything vertically.

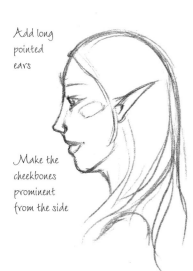

Add long pointed ears

Make the cheekbones prominent from the side

Arch the eyebrows high

Enlarge the eyes

Add long, trailing eyelashes

Make the nose and chin pointed and slender

Draw small, rosebud lips

Extend the slender point of the ear

Side View, Elongated Face
Profile view of the same elongated face.

Side View, Exaggerated Face
Take it a step further—exaggerate the features even more.

The Body
Apply the same ideas that we used on the face for the body: elongate the neck, arms and legs, add a willowy curved torso and emphasize musculature and joints—elbow, wrist, knee, shoulder and collarbone.

Emphasizing Small

YOU CAN EXAGGERATE CHARACTERISTICS THE other way for diminutive and cute faeries.

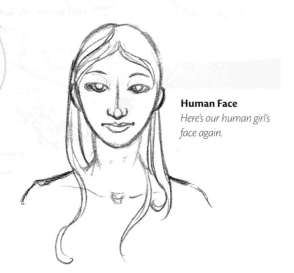

Human Face
Here's our human girl's face again.

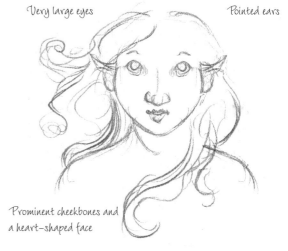

Very large eyes

Pointed ears

Prominent cheekbones and a heart-shaped face

Front View
Enlarge the eyes in proportion to the rest of the face and shorten the oval of the face (be sure to maintain the eyes at the midpoint of the face though). Add smaller rosebud lips, perky little eyebrows and an exaggerated mop of hair.

Emphasizing Small: Mushroom Pixie

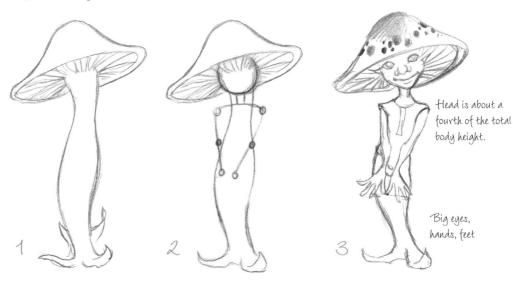

Head is about a fourth of the total body height.

Big eyes, hands, feet

Sketch the Basic Shape
Start out with a mushroom.

Add Details
It is a bit like looking for pictures in the clouds—look at the initial mushroom and try to imagine a figure fitting into the shape. Start with a sphere for the head, then work in the torso, arms and legs.

Finish
A cute mushroom pixie with a mushroom-cap hat.

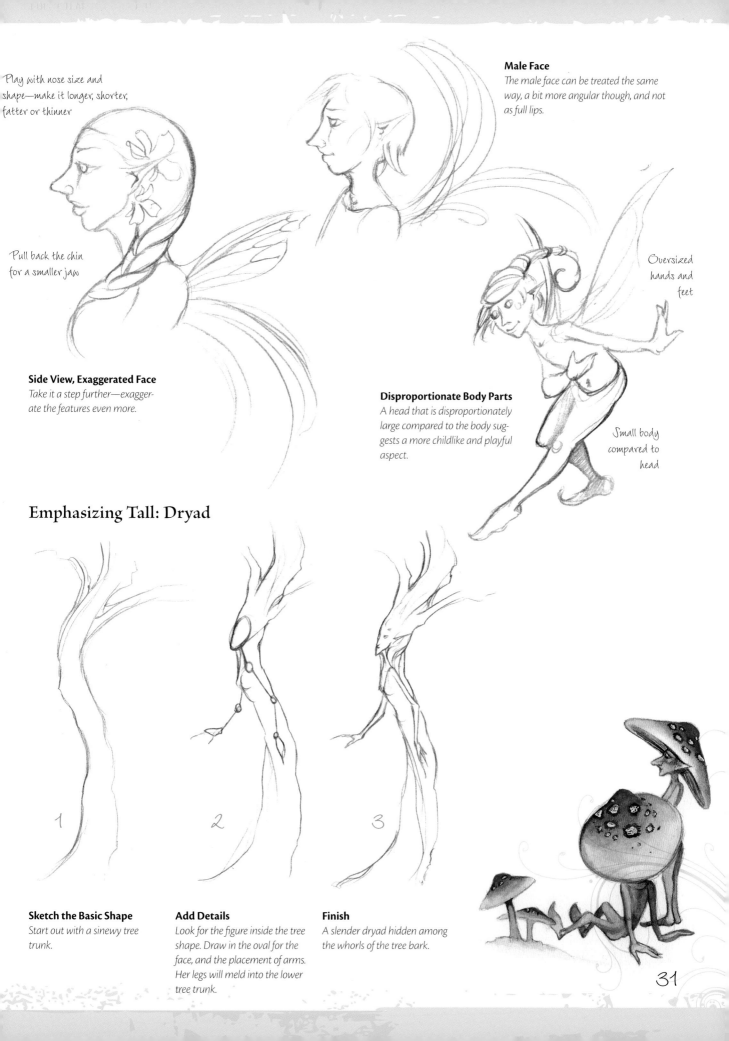

Play with nose size and shape—make it longer, shorter, fatter or thinner

Pull back the chin for a smaller jaw

Side View, Exaggerated Face
Take it a step further—exaggerate the features even more.

Male Face
The male face can be treated the same way, a bit more angular though, and not as full lips.

Oversized hands and feet

Disproportionate Body Parts
A head that is disproportionately large compared to the body suggests a more childlike and playful aspect.

Small body compared to head

Emphasizing Tall: Dryad

1

2

3

Sketch the Basic Shape
Start out with a sinewy tree trunk.

Add Details
Look for the figure inside the tree shape. Draw in the oval for the face, and the placement of arms. Her legs will meld into the lower tree trunk.

Finish
A slender dryad hidden among the whorls of the tree bark.

31

ℱaery Hands

HANDS ARE OFTEN THE MOST TERRIFYING part of the figure for beginning artists, and many are tempted to go the easy route and pick poses that conveniently hide the hands—behind a shawl, behind the back or tucked in a pocket. You can only go so far with that trick before it becomes a little too obvious to a viewer that you're just trying to avoid drawing the hands. So instead of fleeing from the prospect, meet it head on!

Lose the Fear of Drawing Hands

The best way to learn how to draw hands is to use your own hand as a model and examine the lines and curves as an organic whole rather than mechanical bits. Learn to see the hand. Draw, draw, draw your hand over and over in many positions. Fill up pages of your sketchbook with hand drawings, ten a day, until you lose the fear of all those fingers and joints.

Open Hand

1

2

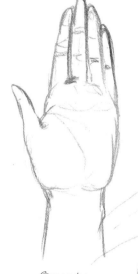

3

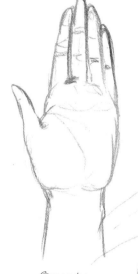

Open palm

Open palm from the back

Start With the Palm
Notice the slight point at the top where the middle finger extends.

Add Tendons
Tendons radiate from the wrist and from there extend out to the fingers. The length of the longest finger is the same length as the palm.

Line Up the Joints
The knuckles fall along curved arches you can draw as guides. Always think of these lines no matter what position the hand is in. They will help you keep all the joints lined up.

Closed Hand

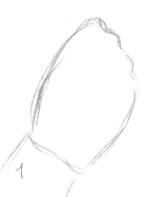

1

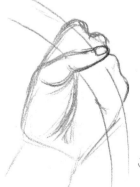

2

3

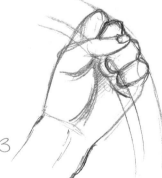

Holding a flower

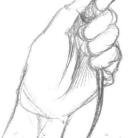

Start With a Rough Fist Shape
This should an approximation of the whole shape.

Add Details
Fill in the closer foreground lines. In this case the thumb overlaps the rest of the fingers. Add some of the creases of the palm below the thumb. You can roughly sketch in an idea of how the knuckles fit in. Use guidelines to map out the other knuckles.

Complete
Draw the rest of the fingers using the guidelines.

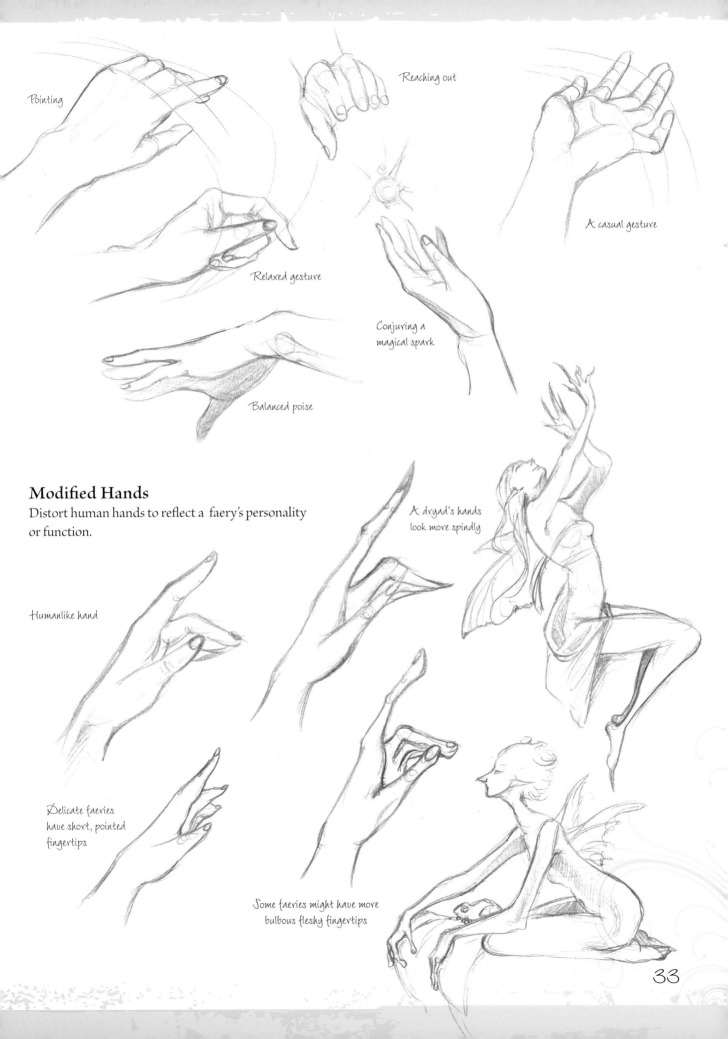

Pointing

Reaching out

Relaxed gesture

A casual gesture

Conjuring a magical spark

Balanced poise

Modified Hands

Distort human hands to reflect a faery's personality or function.

Humanlike hand

A dryad's hands look more spindly

Delicate faeries have short, pointed fingertips

Some faeries might have more bulbous fleshy fingertips

Faery Feet

Structure of the Foot

Feet are another tricky part of the body to draw. Some of the more vain faeries are fond of long skirts and dresses so you can on occasion hide those tricky toes and ankles behind swathes of silken flutter. However, even when you avoid actually drawing the feet, it is useful to know in your mind how they are placed and posed. The hint of a grass-stained toe peeking out from underneath a skirt grounds the figure.

Draw Feet Fearlessly

Just as with the hands, the best way to learn to draw feet is to sketch lots of them. Fill up at least three pages with drawings of your foot from all angles. Look at the curve of the ankle bones, the arch of the foot, the curved line of the toe knuckles.

Top view

The Top of the Foot
The structure of the foot is similar to the hand, only with a longer "palm." The tendons radiate out from the ankle and extend through to the toes.

Visualize the Basic Shapes
An easier way to think of the foot is in a series of ovals—the heel, the pads of the ball under the toes, and the toes.

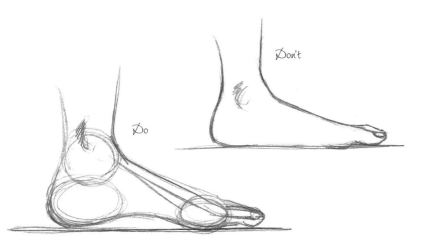

Don't

Do

Side View Dos and Don'ts
The arch of the foot shouldn't touch the ground. A totally flat foot looks artificial and as if it is in a shoe or glued to the ground. Keep the arch in mind whenever you draw a foot from the side.

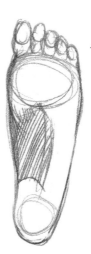

Bottom view

The Bottom of the Foot
The area on the inside of the foot, between the ball and the heel, is the arch. The arch does not touch the ground when the foot is flat, only the ball, the toes and the heel are on the ground.

Front view

Up on the toes

Standing front view

Dangling

Coyly twisted

Jucked under in
kneeling pose

Large flat
toes — more
earthy and
grounded

Standing back view

Modified Feet

Some variations to fit different
types of faeries.

Longer pointed
toes suggest
a more feral
aspect

Slender, almost fingerlike toes
suggest a sinuous creature.

And then there
are some faeries
whose feet are
not human at all!
Cloven hooves?

Wings

FAERIES HAVE AN INTIMATE RELATIONSHIP with the natural world, and their wings can reflect those natural ties. A good way to get ideas for faery wings is to look to their flying cousins. Butterfly and insect wings make great references.

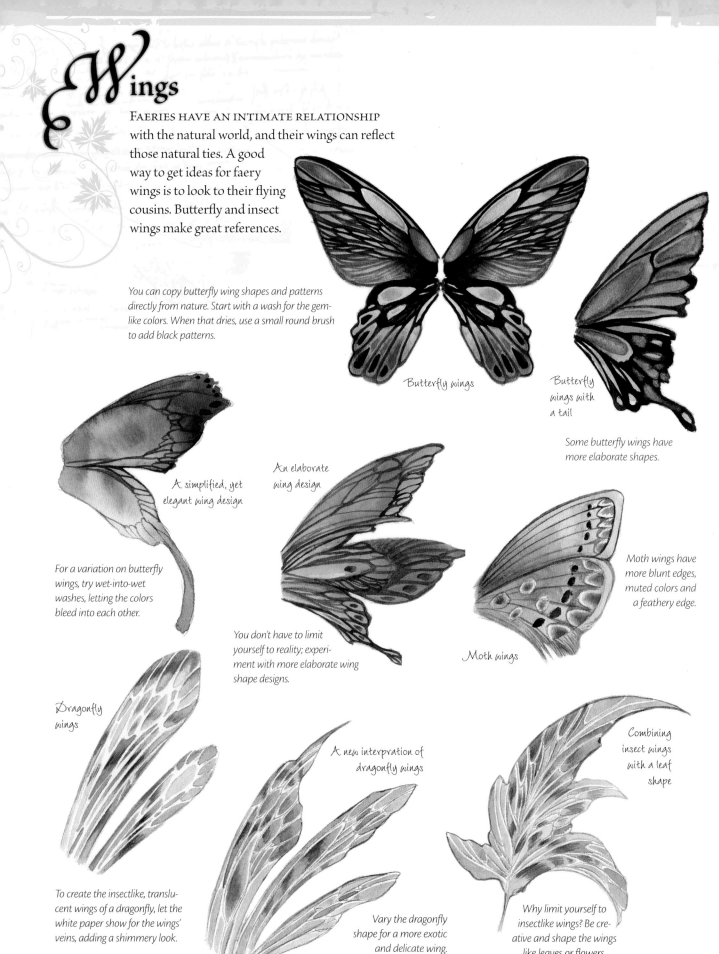

You can copy butterfly wing shapes and patterns directly from nature. Start with a wash for the gem-like colors. When that dries, use a small round brush to add black patterns.

Butterfly wings

Butterfly wings with a tail

Some butterfly wings have more elaborate shapes.

A simplified, yet elegant wing design

An elaborate wing design

For a variation on butterfly wings, try wet-into-wet washes, letting the colors bleed into each other.

You don't have to limit yourself to reality; experiment with more elaborate wing shape designs.

Moth wings

Moth wings have more blunt edges, muted colors and a feathery edge.

Dragonfly wings

A new interpretation of dragonfly wings

Combining insect wings with a leaf shape

To create the insectlike, translucent wings of a dragonfly, let the white paper show for the wings' veins, adding a shimmery look.

Vary the dragonfly shape for a more exotic and delicate wing.

Why limit yourself to insectlike wings? Be creative and shape the wings like leaves or flowers.

36

Wing Placement

WINGS SHOULD BE PLACED ALONG THE CURVE of the shoulder blades, from just below the shoulder and about three-quarters of the way down the back.

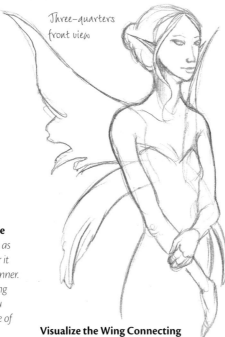

Three-quarters front view

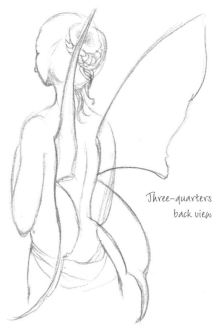

Three-quarters back view

Drawing a Wing's Profile

A wing in profile is flat, but as it comes toward the viewer it starts to look taller and thinner. If you were looking at a wing coming straight at you, you would only see the thin line of its edge.

Visualize the Wing Connecting to the Shoulder

Think of how the parts of the wing you can't see connect with the shoulder. Notice the foreground wing is almost at a flat angle to the viewer, while the farther wing points almost directly back from the viewer.

Sketch the Unseen Parts

This angle is tricky because the far wing is almost flat to the viewer and the closer wing points toward the viewer making it seem skinnier. To picture how the wings connect with the shoulder blades, lightly draw those unseen parts then erase them once you have the placement.

Side view

Back view

The Side View Doesn't Have Overlapping Shapes

A side view is easiest to draw because there are no tricky overlapping pieces. You can draw a side view of wings with the wings at an almost flat angle to the viewer, or angled slightly toward the viewer.

Wings Are Symmetrical in the Back View

Back view is also more simple than an angled view, as the wings will be symmetrically arrayed. Make sure you are aware of the arms and back hidden behind the wings.

Butterfly wings
INTROSPECTION

Faery wings often mimic the beautifully vibrant, patterned wings of their butterfly kindred. The wings of every faery are unique with patterns and colors as rich as their clothing (or more so). This little fae's gem-hued wings shield her retiscent and introspective nature.

She is the shy voice that wonders,
"Where does the sky end?" and,
"Who chose the palettes of the seasons?"
She hides behind her garnet wings
and gazes within.

PAINTS

Cadmium Orange, Cadmium Red, Cadmium Yellow, Lamp Black, Payne's Gray, Viridian

MATERIALS LIST

illustration board, nos. 0, 1, 2 and 4 rounds, pencil

1 Sketch the Wings

Roughly outline the wings and their pattern with a pencil. Since the viewpoint is from the back and slightly angled, her right shoulder is marginally closer to us than her left shoulder and should look like you took a regularly drawn wing and squished it vertically.

2 Add the Basecoat

Use a graded wash of Cadmium Red with a no. 4 round for the inner part of the wing. Keep the most intense color closest to her body, letting the color fade to the white of the paper toward the wings' edges. You can mix in some Cadmium Orange for variation along the bottom.

3 Darken the Wings

Mix Cadmium Yellow with Cadmium Orange and paint this along the fluted edges of the wings with a no. 4 round. Keep the color intense toward the center of each pocket, layering with more Cadmium Orange to intensify the color. Let the color fade to white on the outer part of each pocket of color. Intensify the parts of the wing closest to her body with layered washes of more Cadmium Red.

4 Define the Edges

Use Payne's Gray and Viridian along the edges of the wings with a no. 2 round. Since green is red's complementary color, this muted, grayish mixture makes the red and orange tones more prominent. Keep the edges sharp along the outer edge and blend into the red on the inner part of the wing.

5 Add the Finishing Touches

Finish off with Lamp Black for the patterns on the wings, using a no. 0 round for finer lines and nos. 1 or 2 for thicker lines. Use relatively undiluted paint for a more opaque and even tone. The harsh edges of the black pattern contrast with the soft blend of orange and yellow hues that melt into one another.

With a no. 2 round, run a light wash of Cadmium Yellow along the edge of her wings for more definition.

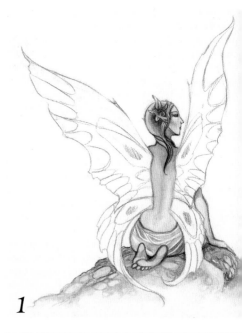

1

Overhead View

To understand the angles of the wings, imagine the faery from overhead.

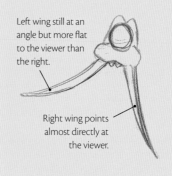

Left wing still at an angle but more flat to the viewer than the right.

Right wing points almost directly at the viewer.

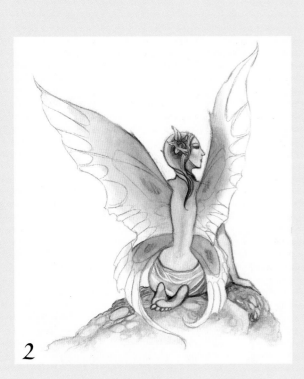

2

3

4

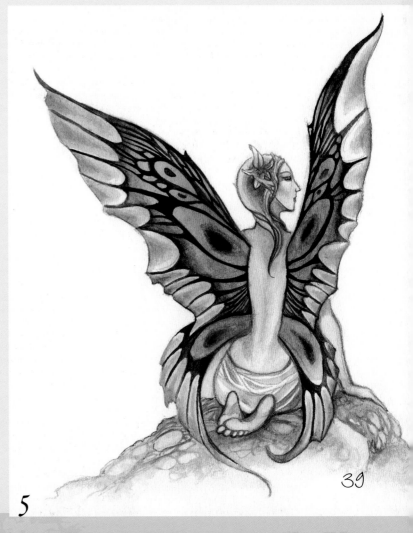

5

39

Translucent dragonfly wings
ELATION

While butterfly wings are opaque, a different type of wing would be like a dragonfly's translucent wings. These have a lighter, more airy quality to them and are more delicate in appearance.

Since these faery wings are translucent, their color should vary when there is something directly behind them. Because the wings are at different angles, light catches and reflects off the iridescence differently for each wing.

Wing skywards so sunlight glitters off
whisper-thin wings in rainbows of light.
She is the faery who causes the little skip and
leap in your heart when you hear good news;
she is responsible for the burst of unexplicable giddiness
when you spy a ray of sunshine after the rain.

O Joy! O Elation!

PAINTS

Cobalt Blue, Cobalt Violet, Lemon Yellow, Ultramarine Violet, Viridian

MATERIALS LIST

illustration board, nos. 0 and 1 rounds, pencil

1

1 Sketch the Wings
To encapsulate this joyful little faery as she leaps into the air, draw her from the side to show off her translucent wings. Sketch in her wings with a pencil.

2 Paint the Far Wing
Use Cobalt Blue, Ultramarine Violet and Cobalt Violet and a no. 0 or 1 round for the wings farthest from the viewer. Allow the white paper to show through for the veins in the wings. Make sure the white areas are dry to achieve this effect or else the colors will bleed and you will have a wet-into-wet blur instead of sharp defined edges.

3 Paint the Wing Closest to the Viewer
For the wings closer to the viewer, mix Lemon Yellow with a little Cobalt Violet for a yellowish-pink color and apply that to the areas that overlap her body. Use a mixture of Cobalt Blue, Ultramarine Violet and Cobalt Violet at the edges where they do not overlap.

4 Add the Finishing Touches
Using a no. 0 round brush and a mixture of Viridian and Ultramarine Violet, drybrush dark patches on the back wing using parallel strokes. Leave space between these lines for the base color to show through. This gives the wings more of an iridescent, shimmery look.

Use the same treatment on the closer wing, but use more Viridian in the paint mixture and drybrush in parallel strokes close to where the wings connect to her back for more shadowed depth.

Creating Shimmery Effects

You can mix an iridescent medium with your paints to give them a glittery sparkle. You can also dilute the medium with water and once the watercolors are dry, lay a glaze of the iridescent medium over the paint to give it more sparkle.

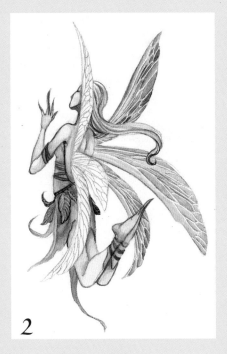

2

Drybrushing Wings

If you want to use drybrushing to create iridescent shadows on your faery's wings, your brushstrokes should follow the wings' contours. This will help create the smooth, shimmery look of translucent wings.

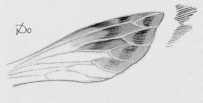

Do

Keep Brushstrokes Smooth and Even

See how the brushstrokes are almost parallel to each other and run along the wing lengthwise.

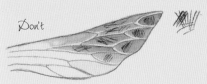

Don't

Avoid Uneven Brushstrokes

Don't make the strokes perpendicular to the wing lengthwise or have them crisscrossing. This makes the texture look sloppy and accidental.

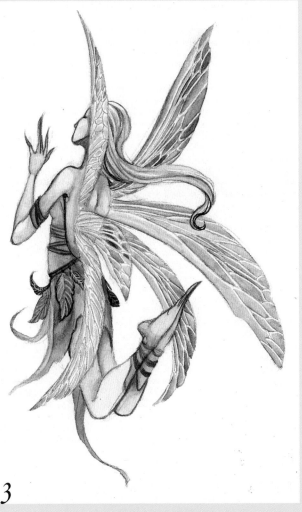

3

4

Faery Poses

WHETHER IN FLIGHT, STANDING, PERCHED ON the edge of a flower or playfully engaged in some activity, the poses you choose can say something of a faery's character. Start with basic frameworks to determine the positioning of limbs and distribution of weight. Once you have that, you can flesh it out and fill in details.

In the Air

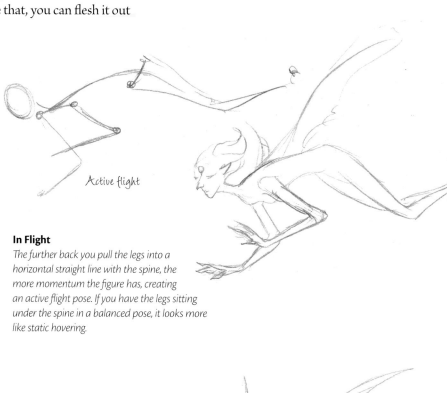

Active flight

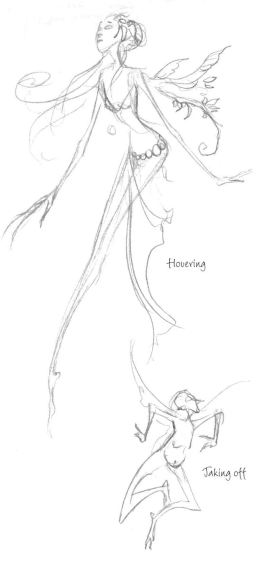

Hovering

In Flight
The further back you pull the legs into a horizontal straight line with the spine, the more momentum the figure has, creating an active flight pose. If you have the legs sitting under the spine in a balanced pose, it looks more like static hovering.

Classic pose

Taking off

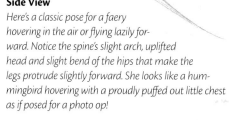

Launching Into the Air
If the elbow goes one direction, bend the wrist the other way for emphasis.

Side View
Here's a classic pose for a faery hovering in the air or flying lazily forward. Notice the spine's slight arch, uplifted head and slight bend of the hips that make the legs protrude slightly forward. She looks like a hummingbird hovering with a proudly puffed out little chest as if posed for a photo op!

On the Ground

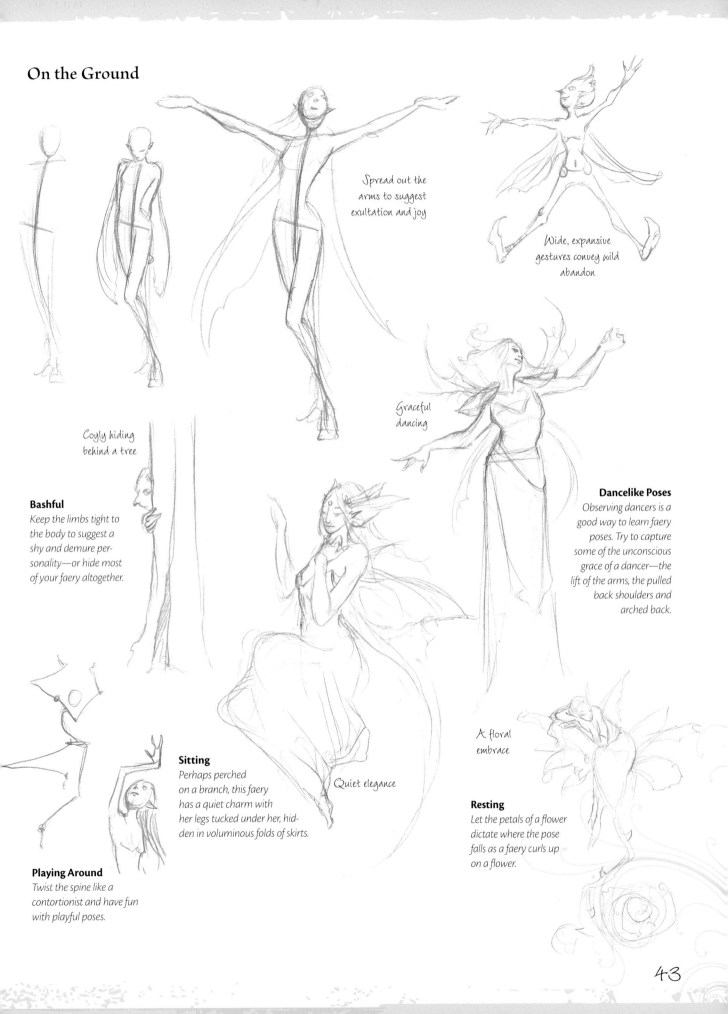

Spread out the arms to suggest exultation and joy

Wide, expansive gestures convey wild abandon

Graceful dancing

Coyly hiding behind a tree

Bashful
Keep the limbs tight to the body to suggest a shy and demure personality—or hide most of your faery altogether.

Dancelike Poses
Observing dancers is a good way to learn faery poses. Try to capture some of the unconscious grace of a dancer—the lift of the arms, the pulled back shoulders and arched back.

A floral embrace

Sitting
Perhaps perched on a branch, this faery has a quiet charm with her legs tucked under her, hidden in voluminous folds of skirts.

Quiet elegance

Resting
Let the petals of a flower dictate where the pose falls as a faery curls up on a flower.

Playing Around
Twist the spine like a contortionist and have fun with playful poses.

Clothing

What kind of clothing do fae creatures wear? They can be casual for ease of flight through the woods, or elegant, such as a ball gown for a midnight masquerade beneath the new moon.

Don't let yourself be limited by the ideas and faery personalities on these pages.

Pixies and Imps

The pixies that come scampering through your garden would be garbed in woodland casual wear—found bits of clothing from nuts and flowers and leaves. Imps and brownies are fascinated by humans so you may sometimes spy them wearing shoes!

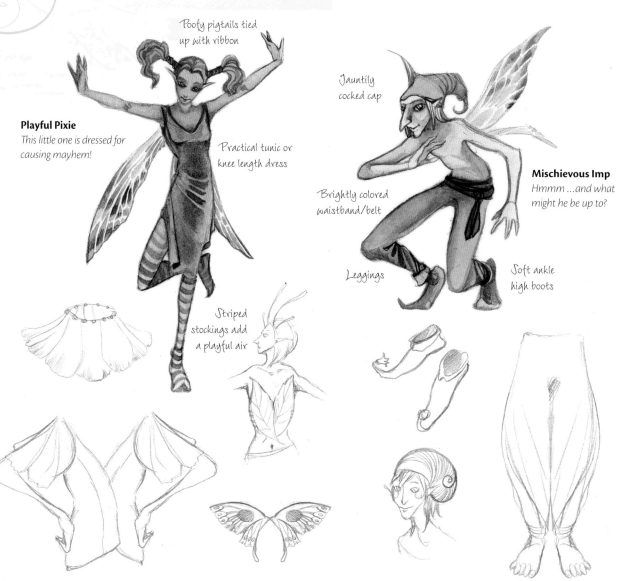

Poofy pigtails tied up with ribbon

Playful Pixie
This little one is dressed for causing mayhem!

Practical tunic or knee length dress

Striped stockings add a playful air

Jauntily cocked cap

Brightly colored waistband/belt

Mischievous Imp
Hmmm ...and what might he be up to?

Leggings

Soft ankle high boots

Clothing Variations for Pixies
Experiment with flower petal skirts and sleeves, tunics sewn of leaves, bare legs and feet or a butterfly wing mask.

Clothing Variations for Imps
Create unique outfits for your imps with different styles of footwear, caps made from an abandoned snail's shell, or loose pantaloons.

Sidhes, Dryads and Sprites

The elegant faery nobility might be found dancing round the mushroom rings in cloth spun of spider silk and embroidered with starlight and berry dyes.

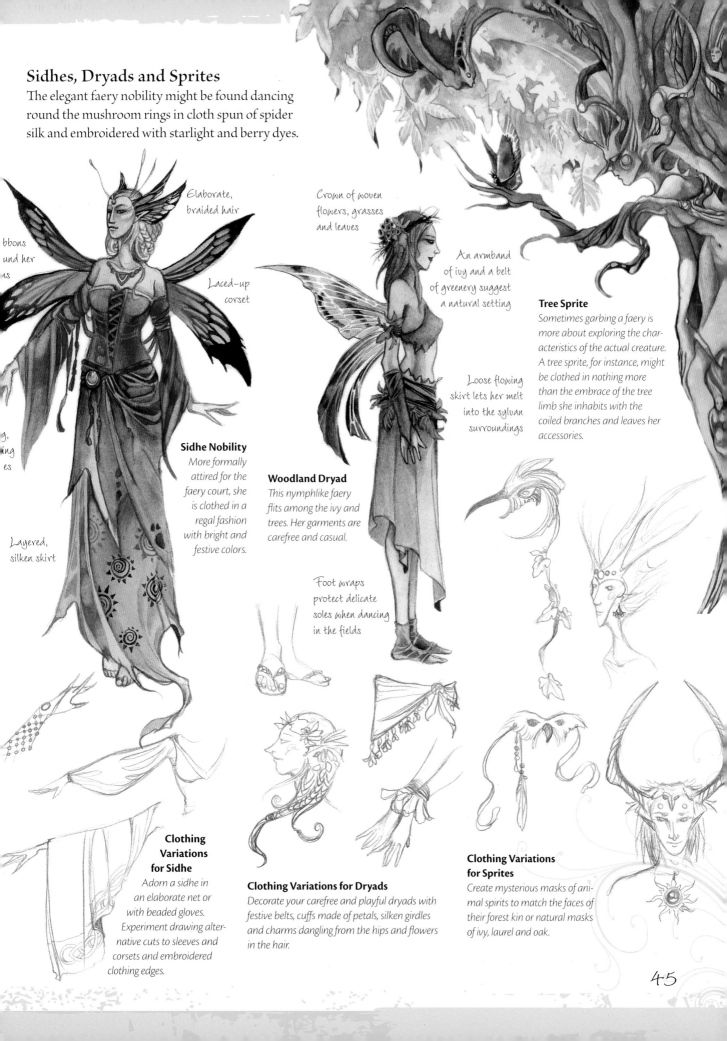

Elaborate, braided hair

...bbons ...und her ...us

Laced-up corset

...g, ...ing ...es

Layered, silken skirt

Sidhe Nobility
More formally attired for the faery court, she is clothed in a regal fashion with bright and festive colors.

Crown of woven flowers, grasses and leaves

An armband of ivy and a belt of greenery suggest a natural setting

Woodland Dryad
This nymphlike faery flits among the ivy and trees. Her garments are carefree and casual.

Loose flowing skirt lets her melt into the sylvan surroundings

Foot wraps protect delicate soles when dancing in the fields

Tree Sprite
Sometimes garbing a faery is more about exploring the characteristics of the actual creature. A tree sprite, for instance, might be clothed in nothing more than the embrace of the tree limb she inhabits with the coiled branches and leaves her accessories.

Clothing Variations for Sidhe
Adorn a sidhe in an elaborate net or with beaded gloves. Experiment drawing alternative cuts to sleeves and corsets and embroidered clothing edges.

Clothing Variations for Dryads
Decorate your carefree and playful dryads with festive belts, cuffs made of petals, silken girdles and charms dangling from the hips and flowers in the hair.

Clothing Variations for Sprites
Create mysterious masks of animal spirits to match the faces of their forest kin or natural masks of ivy, laurel and oak.

45

Using white gouache
WILL-O'-THE-WISPS

Will-o'-the-wisps dart about in the nighttime woods to lead travelers astray. Pixies hide in the underbrush or flit through the air. These smaller denizens of the fae realms can provide movement and flow to your compositions.

You will need Permanent White Gouache for this technique. Because gouache is opaque, this method can be done at any phase in your painting without premeditation.

PAINTS

Cadmium Orange, Cadmium Yellow, Lemon Yellow, Permanent White Gouache, Sap Green, Viridian

MATERIALS LIST

½-inch (12mm) flat, illustration board, nos. 0, 1 and 2 rounds

1 *Apply the Initial Wash*
With a ½-inch (12mm) flat, apply a wash over the area with the color of your choice (I chose Viridian). Let this dry completely.

2 *Add Spheres of Color*
These tiny will-o'-the-wisps will appear as colored lights. Using a no. 2 round and working wet-into-wet, paint spheres of bright colors of Cadmium Orange, Cadmium Yellow, Sap Green and Lemon Yellow fading into the background of Viridian.

3 *Paint in Some White*
Use a no. 1 round and dot in Permanent White Gouache (white gel pens also work remarkably well for this).

4 *Soften the Edges*
With a no. 1 round, blend the edges of the thick white paint outward so that the sparks have a softer edge and seem to glow. For starlike effects, you can use a no. 0 round and pull the wet edges of white outward.

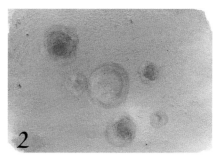

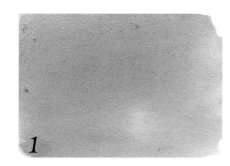

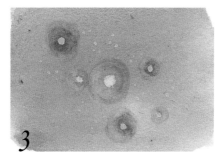

Using masking fluid
MAGIC SPARKS

The electrical charge of magic in the air can manifest itself as sparks of colored light. Here, you'll use masking fluid to save the white areas that will later represent these sparks, so you'll have to plan for these areas ahead of time.

Use inexpensive brushes to apply masking fluid because it will quickly destroy your brushes. Or, use a Colour Shaper (see page 13). Dip the brush in soapy water before dipping it into the masking fluid to keep the masking from sticking to the brush hairs. This makes cleanup easier and prevents the hairs from getting in your painting. As soon as you finish applying masking fluid, immediately wash the brush with soapy water. Do not wait or you will have a rubbery mess of bristles instead of a brush.

PAINTS

Ultramarine Blue

MATERIALS LIST

½-inch (12mm) flat, illustration board, kneaded eraser, masking fluid, paper towels, worn no. 1 round

1 Mask the Areas
Take an old no. 1 round and apply the masking fluid in a speckled pattern.

2 Apply a Wash
With a ½-inch (12mm) flat, paint a wash with the color of your choice directly over the entire area (I used Ultramarine Blue).

3 Remove the Masking
After the wash has dried, gently rub away the masking fluid either with a clean eraser or your fingertips. You will be left with hard-edged little white spots where the masking fluid protected the paper.

4 Soften the Edges
Wet a no. 1 round (an older or cheaper brush is adequate for this technique) with clean water and gently rub along the edges of the spots to soften the borders. Dab with a paper towel to lift out the wet color.

1

2

3

4

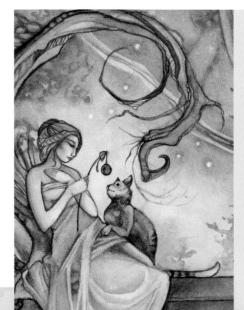

Masking Fluid Is Best for Small Areas

Masking fluid is best used in areas where a smooth wash is desired or to create the sparkle of a wing or stars. In general, use masking fluid sparingly. If you can paint around a spot instead of masking it, paint around it. Masked areas will have a very hard and noticeable edge. For large areas where it is necessary to preserve the white of the paper it is better to learn and practice painting around the area rather than relying on masking fluid.

Here, I used masking fluid to create the glowing sparks of white in the midst of a green background wash.

Glowing figures
PIXIES

Sometimes painting with a relatively monotone palette adds a more dramatic effect. For these pixies, limit the colors to a yellowish orange range to make the faeries glow with their own inner light. You could do the same with blue, purple or green tones.

PAINTS

Cadmium Yellow, Lemon Yellow, Light Red, Ultramarine Violet, Yellow Ochre

MATERIALS LIST

illustration board, nos. 0, 1, 2 and 4 rounds, pencil

1 *Sketch the Pixies and Apply a Background Wash*
Sketch the pixies with a pencil. Using a no. 4 round, start with a light wash of Lemon Yellow and Cadmium Yellow in the background. Be careful not to paint into the pixies because white paper will be very important for establishing their frail yet glowing appearance. If you need to use a smaller brush to do that, you can switch as you go to a no. 1 or 2 round in the tighter corners.

2 *Darken the Background*
Darken the background with a wash of Lemon Yellow, Cadmium Yellow and Yellow Ochre with a no. 1 or 4 round. Let the wash fade out to the areas right around the bodies and wings.

3 *Add the Shadows*
With a no. 0 round, use a mixture of Yellow Ochre, Cadmium Yellow and Light Red to paint the darkest shadows on the pixies and their clothing. Leave the outer edges white so they seem to glow. Dip a no. 2 round in clean water and run it down the center of each pixie to smooth out the shadow edges.

4 *Darken the Shadows*
With a no. 0 or 1 round brush , use Ultramarine Violet and Light Red to deepen some of the shadows and crevices such as the far arm of the male pixie, the eyes, the front of the female pixie's dress and under their chins.

5 *Add the Finishing Touches*
Use a Lemon Yellow and Cadmium Yellow mixture for the texture of the wings, making sure to leave white paper showing. Paint with a no. 0 round in a veined pattern.

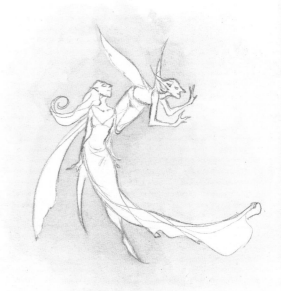

1

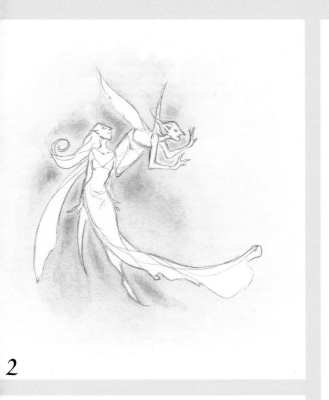

2

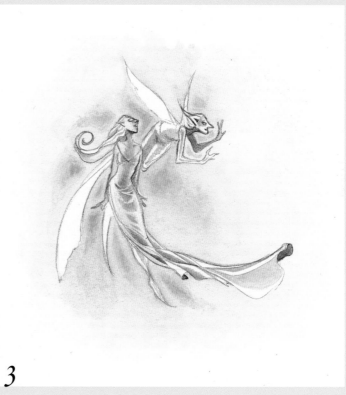

3

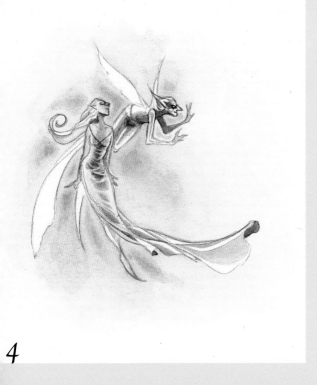

4

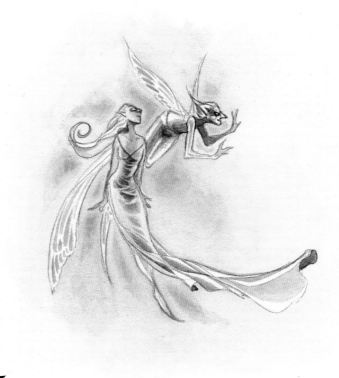

5

Glowing wings
THE SCENT OF JASMINE

Putting a glow to your faeries suggests an ethereal quality. It transforms what is just an insect wing into something glorious and magical. Glowing will-o'-the-wisps liven up a scene with enchantment.

Delicate as the scent of jasmine, this elusive little faery hides among the blossoms. Watercolors are ideal for glowing faery wings because of the translucent quality of the paints.

PAINTS

Cadmium Orange, Cadmium Yellow, Cerulean Blue, Cobalt Violet, Payne's Gray, Sap Green, Ultramarine Blue, Ultramarine Violet

MATERIALS LIST

½-inch (12mm) flat, eraser (any type), illustration board, nos. 0, 1, 2 and 4 rounds, pencil, salt

1 Sketch the Faery

Sketch the drawing, keeping the pencil marks light. This is very important when you're working with glows—you don't want the pencil lead to muddy up the colors. The white "glow" of the paper is more pure than any painted white you can achieve, and you don't want dirty paper that you will have to paint over with gouache in order to get the desired white.

2 Apply a Basecoat to the Background

In the background and in the shadows of the faery's body, lightly lay in a glaze of Ultramarine Blue, mixed with a little bit of Cerulean Blue for variety using a no. 4 round. Be sure to leave the wings white at this phase.

3 Establish Glowing Areas

To really play up a glowing area, the surrounding areas should be darker by comparison. With a ½-inch (12mm) flat layer more Ultramarine Violet, Ultramarine Blue and Cerulean Blue in glazes that fade into the lighter areas close to the wings and antennae. Do not add more glazes to the areas close to the wings; keep the light blue from step 2. Sprinkle salt into the background each time you layer a glaze to add texture and irregularities. Remember to let each glaze layer dry fully before adding the next layer.

4 Add Color to the Glowing Areas

With a small amount of Cadmium Yellow, apply a light glaze around the wings' borders with a no. 4 round. When adding the yellow glow around the wings, be careful not to extend too far into the blue surroundings or you'll get a sickly green glow instead of golden light! Use a more intense Cadmium Yellow and Cadmium Orange for the faery's hair and apply it with a no. 2 round. Notice how using the Cadmium Yellow in the hair reinforces the wings' glow. Glaze layers of Cobalt Violet and Cadmium Yellow onto the faery's skin with a no. 2 round, giving the skin a rosy flush. Layer shadows of Ultramarine Violet into her dress with a no. 2 round.

In the dry background areas, sketch in leaves and flowers with a pencil using the irregular patches left by the salt as guidelines.

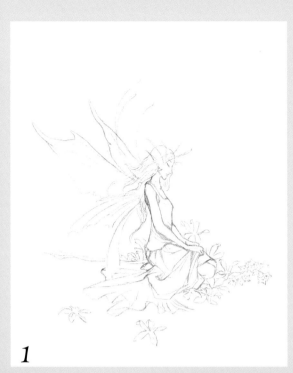

1

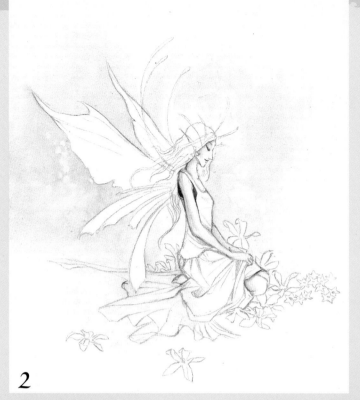

2

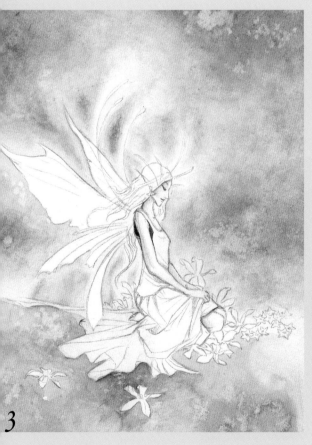

3

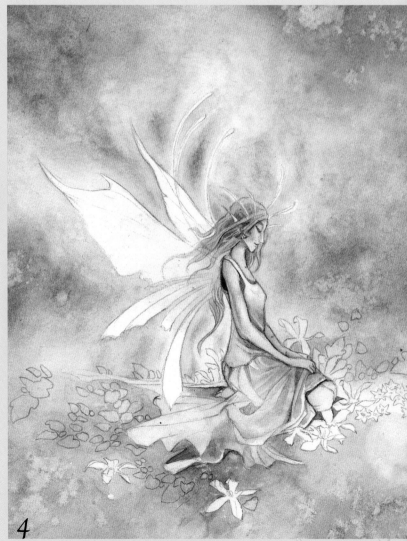

4

5 Paint the Wings

Being careful to leave areas of white veins, paint in a scaled pattern on the wings using Ultramarine Violet, Ultramarine Blue, Cerulean Blue and Cadmium Yellow with a no. 0 round. Notice how the pattern of colors fades from the blues and purples on the edges of the wings, to the lighter yellows and oranges closer to her body. Add some reflected yellow light to the back part of her skirt with a no. 1 round and Cadmium Yellow. With Ultramarine Violet, fill in the areas around the leaves and flowers, especially in the dark areas under the edges of her skirt. Add a final glaze of Cobalt Violet and Cadmium Orange to the shadows of the faery's skin with a no. 2 round.

6 Add the Final Details

Use a no. 0 round and a more intense Ultramarine Violet to apply some short, quick strokes through the edges of the wings' scales. Darken the yellow areas of the wings using Cadmium Orange.

Add a little bit of reflected golden light to the jasmine flowers with a Cobalt Violet and Cadmium Yellow mixture. Reinforce the darkest shadows under her skirt with Payne's Gray using a no. 0 round. Add tiny bits of Sap Green to the shadows to ease the monotony of blues and purples. Erase any pencil marks that might be left in the white areas using any type of eraser.

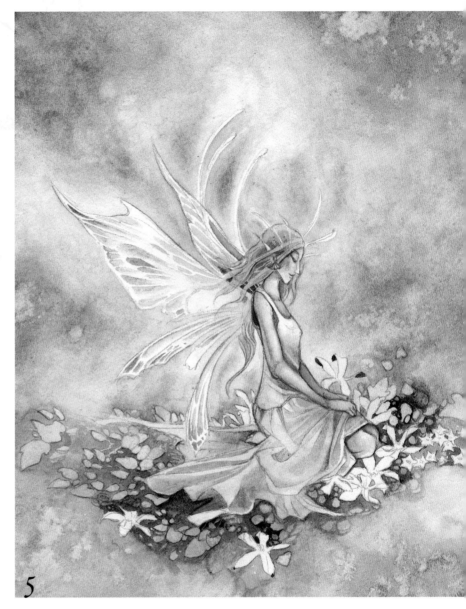

5

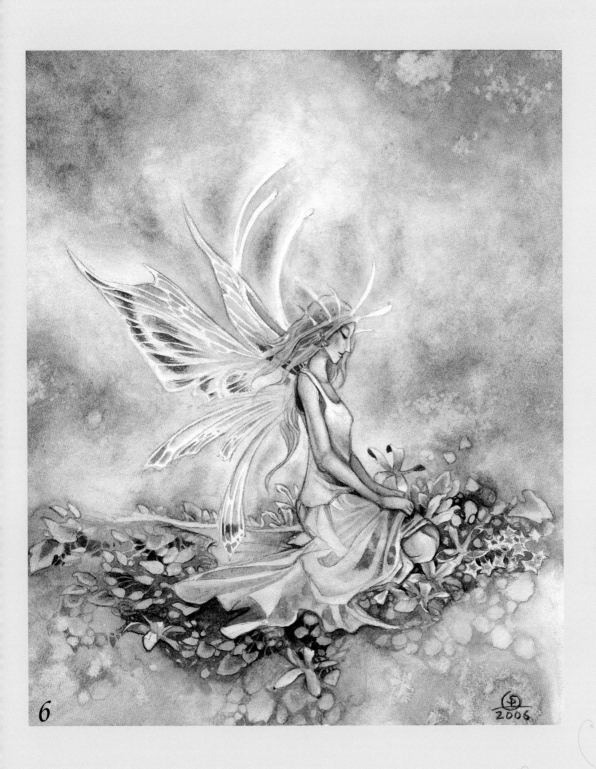

6

2006

Garden Details

LOOK NO FURTHER THAN YOUR OWN GARDEN to spy the fae folk in their natural environment. You'll find faery companions and inspiration in the springtime burst of blossoms, in the mushrooms that sprout after a damp rainy night or in the cathedral light of red and gold leaves in the autumn.

Ivy Leaf

Sketch and Add the Basecoat
Start with the leaf's basic shape, then mark out the main veins. For an ivy leaf, the veins branch out to five points from the stem's base. Apply a wash of Viridian with a no. 4 round and let dry.

Darken the Shadows
Mix Viridian and Sap Green and apply this over the initial wash with a no. 4 round. Leave the vein lines showing, so the veins will be lighter. For more distant leaves, leave it like this.

Add Details
For leaves closer to the viewer, add the smaller veins that branch off from the main ones. Apply a wash of Viridian and Payne's Gray with a no. 1 round. Keep the darker tones near the stem and fade out to lighter colors at the edges and top of the leaf. Again, paint around the veins.

Oak Leaf

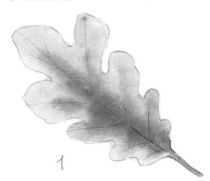 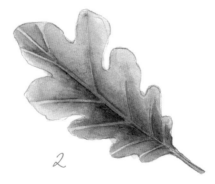 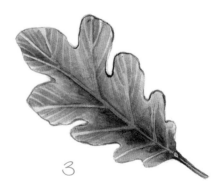

Sketch and Add the Basecoat
Draw the leaf's basic shape. Add veins that run up in pairs along the length of the leaf.

Wet the whole area with a Sap Green wash using a no. 4 round. While this is wet, touch in Cadmium Orange and Yellow Ochre, letting the colors spread out along the leaf's veined pattern.

Darken the Shadows
Paint around the veins of the leaf with Yellow Ochre and Cadmium Orange using a no. 4 round. Let the color fade out to the underlayer's paler tones and along the outside edges of the leaf, with the densest color right around the veins.

Add Details
Using a wash of Yellow Ochre, paint around the smaller branching veins of the leaf with a no. 1 round.

Roses

Roses can be daunting to draw with their myriad petals. They are actually a series of petals wrapped around a heart. If viewed from above, you mostly see the outer edges of those petals. When you break down the shapes, what you really see is a series of crescent-shaped edges. Faeries thrive in gardens and in the wild. The colorful profusion of flowers and petals can be used for both backgrounds and for creative faery garments.

Doodle

Draw a loosely scribbled spiral. Let your lines overlap and cross over each other.

Refine the Basic Shape

Lay a piece of tracing paper over your spiral. Trace over the lines that turn the spiral from a scribble to a real rose. Use the spiral as a guide, building petals out of the lines that crisscross.

Remove Extra Lines

When you lift your tracing paper up, you'll have your rose.

Poppy Petals

Start with a layer of Cadmium Orange on the outer edge of the petal and, working wet-into-wet, add Cadmium Yellow. Let this dry, then drybrush parallel lines of Cadmium Orange that run from the edge toward the center.

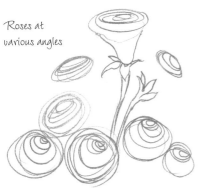

Roses at various angles

Refine the basic shapes into a bouquet

Rose Bushes

The same technique can be used to draw roses at various angles. In a profile view your spiral will be more flattened and closer to the upper edge of the rose while the petals that are closest to you are bigger and more spread out.

Hydrangea Blossoms

Working wet-into-wet, create a base layer of a pale Cobalt Blue on the outer edge that fades into Ultramarine Violet toward the center. Dot the center of the flower with Cadmium Yellow and add details to the petals with Ultramarine Violet.

Rose Petals

If you have a rose in front of you, examine how the petals are formed and how they curl and bend.

Iris petals

Working wet-into-wet, apply Ultramarine Violet to the outer edge of the petal, adding Cadmium Yellow toward the heart. Let this dry, then drybrush a ruffled texture with more Ultramarine Violet.

Forests

FORESTS ARE FREQUENT HAUNTS OF THE FAE folk. They are protected in the shadowy embrace of the trees. Different trees lend different moods to faery settings, and you can color them for the changing seasons—the lush explosions of purple blossoms in the spring or the bare, black branches of a cherry tree in the winter.

Oak

The meandering branches of an oak against the sky can be a comforting haven. An oak has a thick base trunk; the branches spread and divide out and twist and turn in a graceful growth out to the sides and upward forming a rather wide silhouette.

The rambling and haphazard pattern of growth provides ideal nooks and crannies for little faeries to hide. Oaks have more dense foliage than other trees, so the clusters of leaves should overlap each other in leafy globes when you draw them.

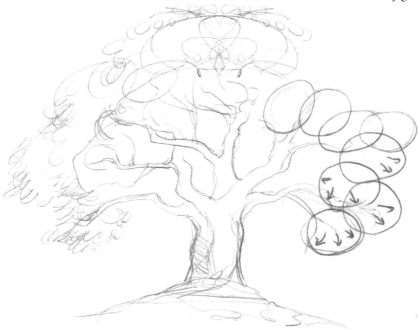

Foliage

Oaks have more dense foliage than other trees. The leaves mostly will be pointing outward in each of these leaf clusters.

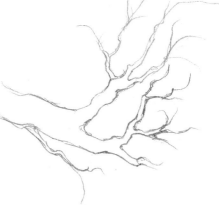

Branches

Every time a branch divides, the branches from the split are smaller than its parent. The divided branches keep getting smaller and smaller until you get to the little twigs at the end of the branch.

Shading Branches and Other Cylindrical Forms

When shading a cylindrical form, the brightest part is the edge facing the light source. Shading is gradated along the curve to be darkest just short of the opposite side. The opposite side from the light source will have reflected light on it and will therefore be a bit lighter as well.

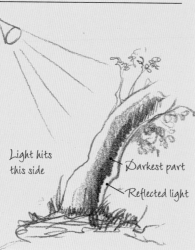

Light hits this side

Darkest part

Reflected light

Painting bark
OAK DRYAD

Painting tree bark (and indeed much of nature) is a good time to let loose of any overly-controlling tendencies you may have. The random flow and skip of paint texture on paper can effortlessly help you mimic the randomness of natural textures.

PAINTS

Burnt Umber, Light Red, Payne's Gray, Permanent White Gouache (optional), Raw Umber

MATERIALS LIST

illustration board, nos. 1 and 8 rounds, pencil, salt

1 Sketch the Tree
When you draw the oak's graceful, twisting branches, be sure that as you extend them out and up, the branches divide and become smaller than the lower parts. Sprinkle some salt in a background wash for the effect of light coming through leaves. For smaller branches or background branches, just paint directly over them with the base wash.

2 Drybrush the Base Texture
It's best to use a large round, like a no. 8, to drybrush in a base of Light Red. Drybrushing will leave behind white streaks for texture. Use drybrushing for background branches, too, with a darker color like Burnt Umber.

3 Smooth Out the Texture
After the drybrush layer dries, apply a wash of Raw Umber, Light Red and Payne's Gray to smooth out the harsh edges of the previous layer.

4 Enhance the Bark With Details
When the wash has dried, you can go back with a no. 1 round and Burnt Umber to pick out and enhance the random texture details. Outline the individual pieces of bark.

5 Adding Highlights
A no. 1 round works for lifting out some of the bark's color. Lift from the middle to make highlights. You may use Permanent White Gouache here as an alternative, but lifting gives a softer edge.

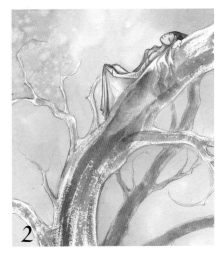

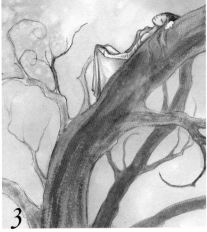

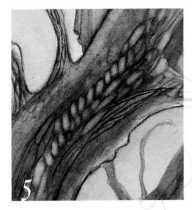

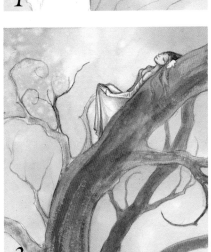

Painting bark
BIRCH DRYAD

The stark, black-and-white coloration and patterns of a birch grove lend an air of mystery. Birch trees have a mostly straight, smooth cylindrical trunk that extends vertically with smaller twiggy offshoots. The other notable characteristic of birch is that its white bark peels back in striated patterns horizontally along its length, revealing a darker inner heart.

PAINTS

Burnt Umber, Cobalt Blue, Payne's Gray, Ultramarine Violet

MATERIALS LIST

illustration board, nos. 0, 1 and 4 round, pencil, salt

Patterning Foliage Growth Along Branches

When drawing foliage on trees, try to see the underlying pattern of leaf growth. The leaves will be focused in clusters around branches. Depending on tree type, the density of branches and twigs results in the more or less dense leaf clusters. On birch trees, for example, the branches are sparse, so leaves are not thick and impenetrable bouquets, but sprinklings of greenery that feather out.

1 Sketch the Tree and Add the Background Wash
Sketch the birch's branches with a pencil. Work in darker areas with some shading. With a wash of Cobalt Blue, create the background using a no. 4 round, then sprinkle the wash with salt. Once this is dry, apply a glaze of Ultramarine Violet and Cobalt Blue for the branches in shadow. Avoid painting over the foreground elements.

2 Add Shadows to the Trunk
"White" is always a reflection of the surrounding colors. Since the background is a cool wintry color, the white tree bark will reflect those tones. Mix a little bit of Cobalt Blue and Payne's Gray and apply a light wash to shade the edges of the trunk and give it volume.

3 Add Texture
Mix Burnt Umber with Payne's Gray and paint the darkened exposed trunk areas with a no. 1 round. The rough texture of the pencil shading will help add texture to those dark patches. This is enough detail for the distant trees, but you'll need to add a few final details to the foreground trees.

4 Finish the Tree
Take a no. 0 round and add the final details with some more of the Payne's Gray and Burnt Umber mixture. Paint horizontal strokes along the white areas to add more striations. For the closest branches, detail the curling white bark around the darkened areas.

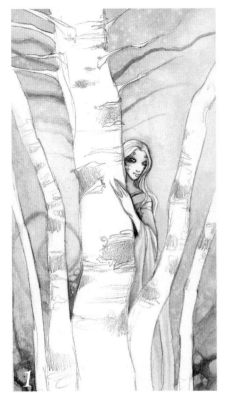

1

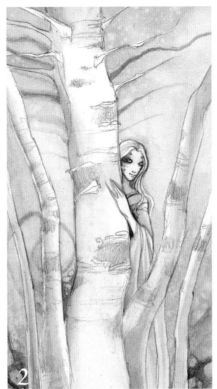

2

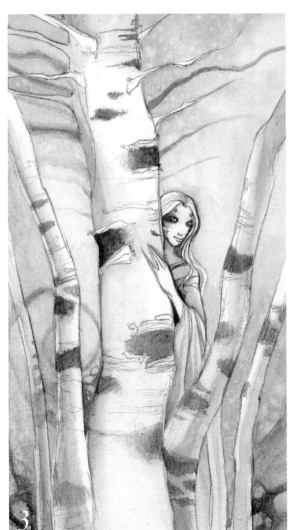

3

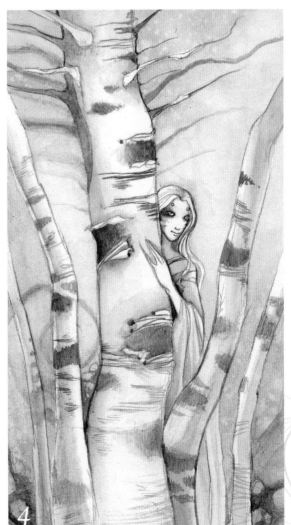

4

Suggesting Distance

To keep your background from drawing attention from the main focus of your painting, make elements that are farther away appear more hazy and less detailed.

Distant Foliage

If you had to draw and paint every individual leaf on a tree, a forest would take an eternity to depict! Instead you want to put detail only on select foreground aspects and leave the rest fuzzy.

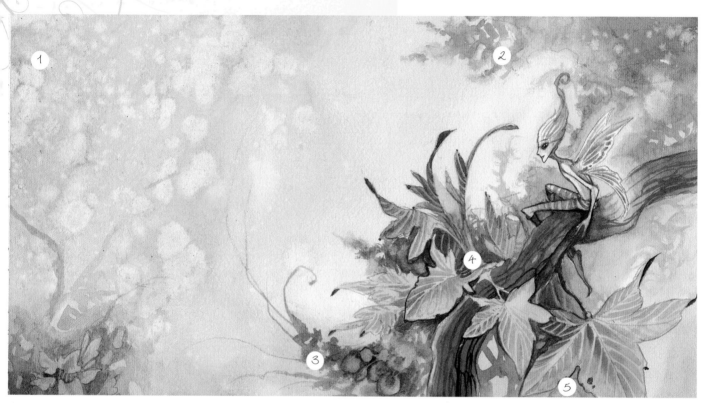

Distance

1 In the background, speckled salt can simulate dappled forest lighting.

2 Use hardly any detail, if at all, for the far leaves in the background.

3 For the midground, add minor shadows and highlights to the leaves.

4 The foreground leaves should have clear details and texture.

5 The focus of the painting should be the most detailed.

Middle Distance Leaves

For foliage in the middle distance, some detail-like shadows and occasional highlights hitting a select few leaves can be very effective.

Add the Basecoat

Build up from a base of more distant leaves. Begin with a wash to the background, and after it dries add a layer of a darker color for some distant leaves. Sketch in a few individual leaves for the midground.

Add the Shadows

Fill in the negative space (the area around the sketched leaves) with shadows, blending into the background wash by diluting the edges with water and dabbing with a paper towel.

Add Highlights

Add shadows to the leaves near their stems with darker shades of the same colors you used for the previous step, and maybe some contrasting tones like blues or purples. Let the basecoat show through the leaves' outer edges to suggest highlights.

More Techniques

You can paint distant leaves and other objects in several ways. Far distant foliage should only hint at leaflike attributes with very few details.

Technique 1: Wet-Into-Wet

Apply a large wet area of color, and while it's still wet take a no.1 round and dab the paint in a speckled pattern to suggest branches, leaves and far-off trees. You can build up layers of foliage like this with the farthest branches lighter than layers closer to the foreground.

Technique 2: Sprinkle Salt Onto a Wet Wash

Apply a wash and while it's wet, sprinkle some salt onto it. After that dries, the white salt spots will create highlights on distant leaves. Drybrush some shadows around the salt splotches to create a pattern of foliage.

Technique 3: Wet-on-Dry

Working wet-on-dry initally creates hard edges because you're applying wet paint over a dry surface. To soften the edges, blend them into the background color while the paint is still wet or let the paint dry and lift around the edges. Let gaps of background color show through for the light between the leaves. Think of the branches and leaves as silhouettes.

Backgrounds
FOGGY HILLS

Faeries exist in the places in between—in the moments when you blink, in the skip of frozen time at midnight when today teeters on the edge of tomorrow, in the fog shrouded transitions of dawn and dusk. Misted hills in the background provide this mystical environment for your faery scenes.

PAINTS

Cobalt Blue, Viridian

MATERIALS LIST

½-inch (12mm) flat, eraser, illustration board, no. 1 round, paper towels, pencil

1 Sketch the Landscape and Add the Background Wash
Sketch out the hills, letting the peaks and valleys overlap each other. Using a ½-inch (12mm) flat, wet the entire area with water. Paint a gradated wash with a mixture of Viridian and Cobalt Blue. Apply the most concentrated pigment at the top of the page and dilute with water as you work down. Let each new horizontal stroke slightly overlap the previous. Keep the painting tilted at an almost vertical angle, so the pigment can evenly disperse, leaving you with a soft, misty look. Let this dry.

With the same ½-inch flat (12mm), outline the contours of the hills at the top of the horizon with water, then wet the entire area below that line. While this is wet, do another graded wash with the same mixture. This time start at the top of the hills instead of the top of the page. Since the sky area is dry, the paint will not spread upward, only down from the top of the hills.

2 Build the Background Layers
Repeat the previous step with each layer of hills, moving top to bottom. In each successive layer, use more Cobalt Blue and less Viridian in the mixture so the colors of the hills change from a greenish tone in the far back to blue in the front. You will make a total of five gradated washes, including the first sky wash. Since the hills don't evenly overlap, the bottom of each layer creates a pale white area, appearing like foggy basins in the valleys.

3 Suggest Foliage
Using a no. 1 round, dot in foliage on the closest hills with a combination of wet-on-dry and drybrush strokes in Cobalt Blue.

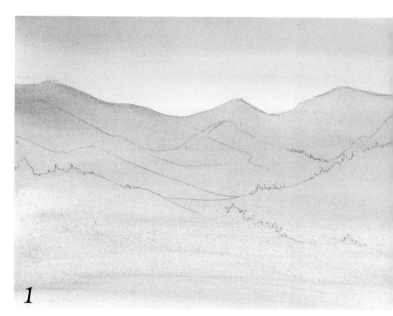

1

4 Add a Foggy Mist
Use an eraser to create horizontal zigzag streaks in the area of your final wash (the darkest bottom part). You can also paint streaks of clean water, then use a paper towel to horizontally rub across the page to lift up the pigment in streaks.

5 Refine Where Necessary
Paint back over the erased or lifted areas with Cobalt Blue to give the fog a little more definition. If you want the fog to seem more diffuse, you can skip this step and just finish it after the lifting phase.

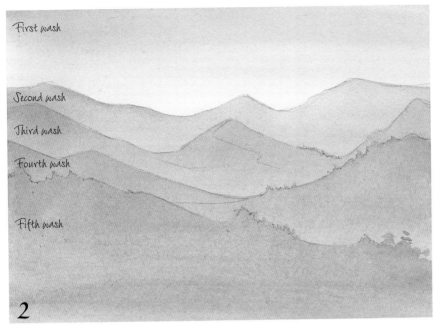

First wash

Second wash

Third wash

Fourth wash

Fifth wash

2

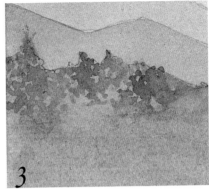

3

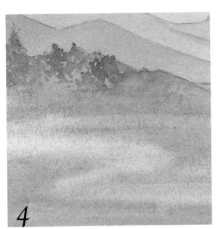

4

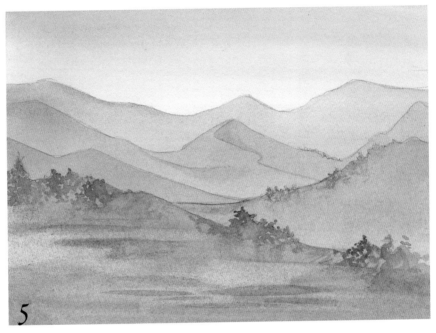

5

Pigments, Paper and Planning Are the Keys to Lifting Paint

The success of this lifting process will depend on the kind of paper and the pigments you use. Plan to use Cobalt Blue near the bottom of the page because it usually lifts easier than some other colors.

Faery with background
SPRING BOUGHS

The warmer turn of the seasons is heralded by the appearance in your gardens of hummingbirds and tiny fae come to taste Spring's delights.

Let's try a composition with a profusion of color and background elements.

PAINTS

Burnt Umber, Cadmium Orange, Cadmium Red, Cadmium Yellow, Cobalt Violet, Lamp Black, Lemon Yellow, Light Red, Naples Yellow, Payne's Gray, Sap Green, Ultramarine Violet, Viridian

MATERIALS LIST

½-inch (12mm) flat, illustration board, nos. 0, 2 and 4 rounds, paper towels, pencil, salt

1 Create the Pink and Green Mists

Once you've sketched in your drawing, start with a Sap Green wash on the bottom left, fading to Cobalt Violet on the top right. Use a no. 4 round to get into the corners and to avoid painting over details. Use a ½-inch (12mm) flat for larger areas. Sprinkle some salt into the green near the leaves. Add a little bit of Cadmium Yellow mixed in with Cobalt Violet near the butterflies.

2 Add the Leaves

Create shadowy distant foliage around the sketched leaves in the lower left corner using various concentrations of Viridian, Ultramarine Violet and Sap Green, working wet-on-dry with a no. 2 round. Dilute some of the edges with water and dab with a paper towel to blend these edges into the background. Paint around the irregularities of the salt-speckled Sap Green wash to hint at leaf shapes.

3 Establish the Foreground Leaves

Create a Cadmium Yellow and Lemon Yellow underlayer at the center of the foreground leaves. Add a Light Red undercoat on the branch using a no. 2 round.

4 Add Details to the Leaves and Branch

Fill in the details on the branch with a no. 0 round, painting the shadows with a mixture of Burnt Umber and Ultramarine Violet. Add details and texture to the foreground leaves with a mixture of Cadmium Yellow and Cadmium Orange using the no. 0 round.

Use Imperfect Washes to Your Advantage

It is difficult to get a smooth and unbroken wash near the foliage because of all the tight corners and contours, but don't worry about it too much. Irregularities will only add to the random foliage effect and can be taken advantage of in later layers.

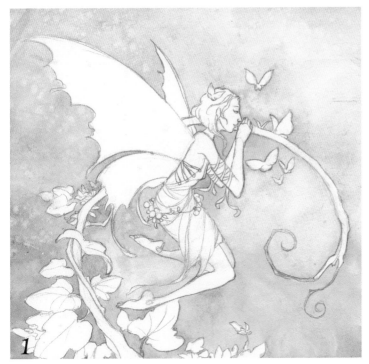

1

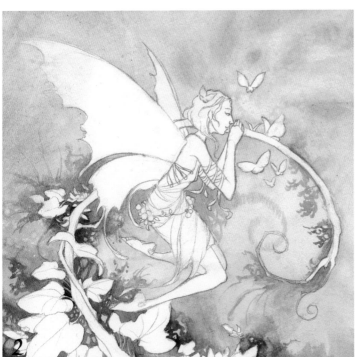

2

Detail of Foreground Foliage

3

4

5 Create the Skin Tone and Start the Wings

Lay in an undercoat of a mixture of Cobalt Violet and Cadmium Yellow for most of the faery's skin, but shade her back arm and leg with a mixture of Viridian and Payne's Gray using a no. 2 round. Sketch a light pattern on her wings with a pencil and add a wash of Cadmium Orange with a no. 4 round to the centers of her wings and the butterfly wings, making the color closest to her back the brightest.

6 Add Shadows and Bring the Wings to Life

Shade her skin with concentrated Light Red and a no. 0 round. Sparingly apply Viridian or Ultramarine Violet to create darker shadows in areas such as under her chin and around her eye. Paint the stark black pattern onto her wings, and do the same to the small butterflies only on a smaller scale, again using the no. 0 round and Lamp Black.

7 Finish Off the Wings

Add texture to the edges of her wings with a mixture of Ultramarine Violet and Cadmium Red and a no. 0 round. Be sure to leave plenty of white paper showing to suggest shimmery wings. To make the center stand out more, add a layer of Cadmium Red to the reddish-orange part of her wing that's closest to her back.

8 Add the Final Details

Paint her hair with streaks of Naples Yellow using a no. 0 round. Use Light Red for the lower tendrils in the shadow. Paint the shadowy folds of her dress Ultramarine Violet and a no. 0 round, then, after that dries, glaze it with a wash of Naples Yellow and a no. 2 round. Paint the ribbons on her arms and back Cadmium Red and use Viridian for the garland around her waist with the no. 0 round.

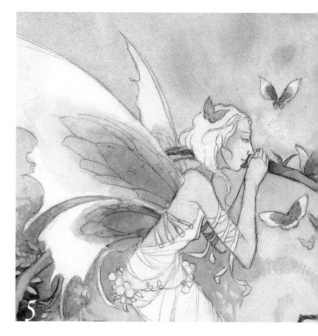

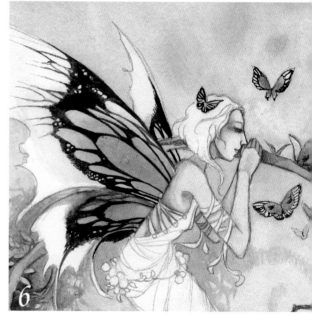

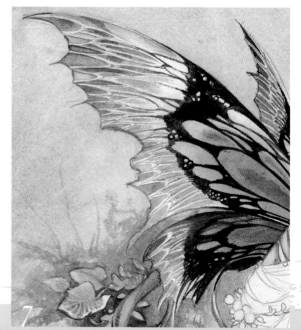

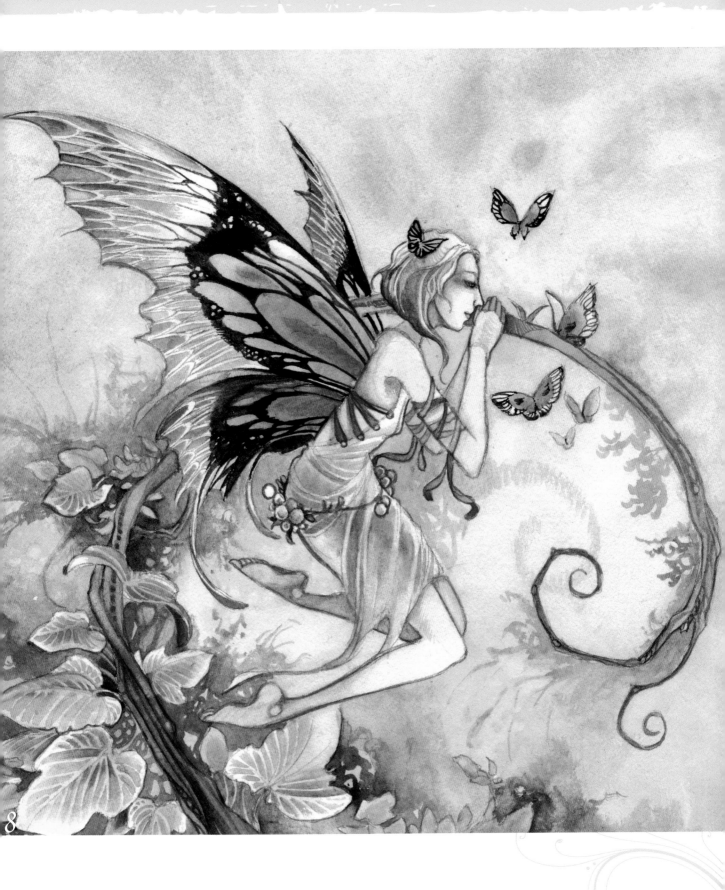

Composition

When sketching the subject for a painting, be aware of the composition. The foreground focus element is just one part of it. You want to capture the viewer's eye and keep the interest contained within the picture. Good composition keeps your audience looking at the art rather than looking for something else to see and do!

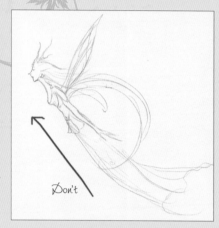

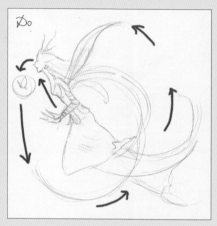

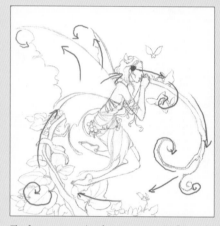

The lines for this sketch shoot off the page and take your viewer's interest with it!

With a slight modification to the composition you can pull the viewer back into the picture. Give the faery a focus for her gaze, and bring wisps of clothing curved up towards that focus so that the viewer's gaze follows her eyes and then back around and into the picture again.

The focus starts at her face, moves to the flurry of butterflies, then down along the branch and to the branch's tips, around the bottom to the leaves, then up the branch again and around her wings. The tips of the wings are self contained and curve slightly to keep the eye from jumping off the page, instead bringing your focus back up to her face. The arrows never point off the page—they always catch something near the edge and turn around.

Whenever you sketch a painting, try to map out the flow of the composition by following where your eye moves from one element to the next.

Background elements can be very helpful for pulling the viewer back from the corners and edges of your pictures. Spirals, circles of branches and foliage are naturals for this, although you don't want to overdo it and make your balance too boring. A perfectly centered circle is very self-contained. Your viewer won't be wandering off anywhere except through boredom! Move a circle slightly off center or break the perfect circle and make it a spiral instead. This makes the composition more active and engaging. This is not to say, "Never use perfect symmetry," just use with caution!

Bringing it all together
FAERY MUSE

We've gone over various elements that are tools you can use when painting faeries. Now let's bring it all together in a complex picture with many aspects. If you try to tackle everything at once it will be a headache, so break down a picture into its components and think of each part separately. In this sketch there are several pieces:

1 The main figures of the faery and the harpist.
2 The flying pixies in the air.
3 The background with the distant branches and leaves.
4 The more immediate background of the big tree and the roses and leaves.

Throughout this chapter we've approached how to draw and paint all of these elements as individual items. Seeing it all in one picture is no different, it just requires more planning.

PAINTS

Alizarin Crimson, Burnt Umber, Cadmium Orange, Cadmium Yellow, Cobalt Violet, Dioxazine Violet, Lemon Yellow, Light Red, Payne's Gray, Prussian Blue, Sap Green, Ultramarine Violet, Viridian, Yellow Ochre

MATERIALS LIST

½-inch (12mm) flat, illustration board, nos. 0, 1, 2, 4 and 8 rounds, pencil, salt

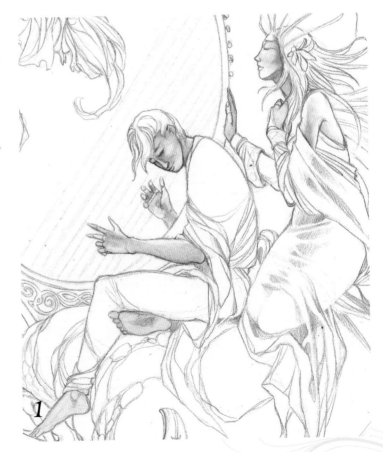

1 Apply Undercoats to the Main Figures' Skin

Sketch out the composition with a pencil then apply a pale mixture of Sap Green and Ultramarine Violet for the faery's skin with a no. 1 round. For the human's skin, use a mixture of Light Red and Cadmium Yellow. Apply a little Ultramarine Violet for his shadows also using a no. 1 round.

Emphasizing Otherworldliness

For very white skin, blues and greens make good undercoats when used sparingly, and though I use a warmer flesh tone for the human, you could just as easily use the same techniques on the faeries. By using mostly warm colors on the young man and cool colors on the faery, you can differentiate them and emphasize how unearthly she is compared to the human. His ruddy glow makes the contrast between the two more dramatic.

2 Build the Shadows and Underpaint the Clothing

Using a no. 0 round, deepen the shadows on her skin with Cobalt Violet and Cadmium Yellow. For fine details like her eyelashes and eyebrows, use Payne's Gray. Use Cobalt Violet for her lips.

With a no. 0 round, use Burnt Umber and Ultramarine Violet for shadows on the human's feet, the underside of his arm and the creases in his elbow and neck. Add details to his eyes and eyebrows with Payne's Gray mixed with Burnt Umber.

With some midsized brushes such as a no. 4 round, paint a basecoat for the shadows on their clothing with Ultramarine Violet and Viridian. Use Burnt Umber, Payne's Gray and Yellow Ochre for the basecoat on his pants.

3 Continue to Build the Main Figures

Working wet-on-dry, paint Light Red over the body of the harp with a no. 2 round. Since white reflects the colors around it, apply a bit of Light Red along the edges of his shirt, too. Add Viridian shadows under his elbow and where the cloth meets the harp with a no. 0 round. Paint a mixture of Burnt Umber and Yellow Ochre over his pants. Use Burnt Umber to push the darks further where his foot meets the underside of his knee with a no. 0 round. Paint his hair with Cadmium Orange and a no. 1 round.

Reinforce the contrast between the two figures by giving her white hair a cool cast with a mixture of Viridian, Ultramarine Violet and a faint hint of Yellow Ochre. Use a no. 0 round to paint the shadowy strands of her hair with this mixture. Add a touch of Alizarin Crimson on the flower in her hair with a no. 0 round.

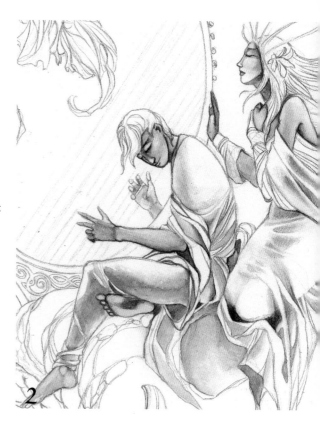

2

4 Add Details and Make the Faery Glow

Add details to the human's hair with a no. 0 round brush using a Light Red and Cadmium Orange mixture. For the harp's details, use Alizarin Crimson and Light Red mixture, painting a wash around the carvings with a no. 1 round.

Lay in a light wash for the glow around her wings with a no. 4 round. Use mostly Cadmium Yellow, but mix in a little Cobalt Violet for the areas closest to her back. Paint right over her skirt to make the light of her wings shine on her dress. Add a basecoat of Cadmium Yellow to her dress with a no. 4 round.

5 Finish the Dress

Since most of the shadows in her dress have already been established, just paint a layer of Alizarin Crimson over all of it with a no. 4 round, working wet-on-dry. For the lighter areas, mix in a little Cadmium Orange and some Cobalt Violet for the darker areas. In the darkest places, add Viridian.

6 Paint the Wings

Use a rainbow of colors to create her wing texture. Use Viridian, Ultramarine Violet, Lemon Yellow, Sap Green and Cobalt Violet and apply them to her wings with a no. 0 round.

Achieving Dark Tones With Complementary Colors

Add Viridian to his pants for some of the dark shadows even though the harp and pants are both reddish colors. Because green is the complement of red, you can achieve the darkest tones by layering the two (or any other two complementary colors like yellow and purple, or blue and orange). Also, by putting complementary tones side by side, you lend a vibrancy to the shadows.

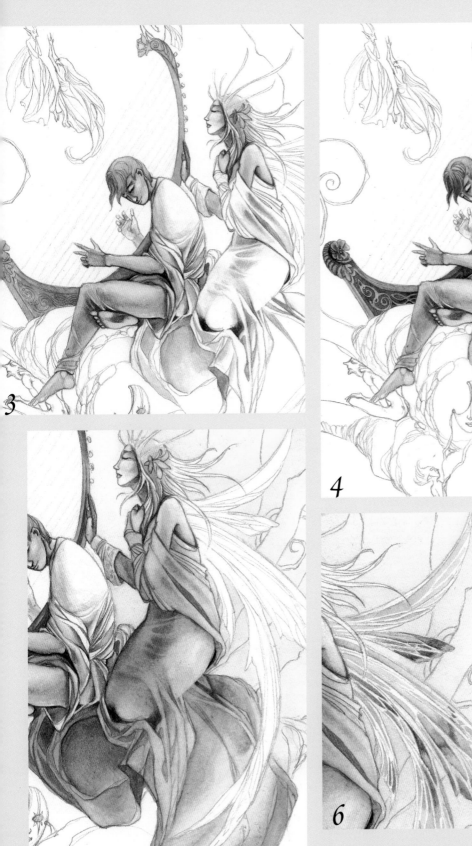

3

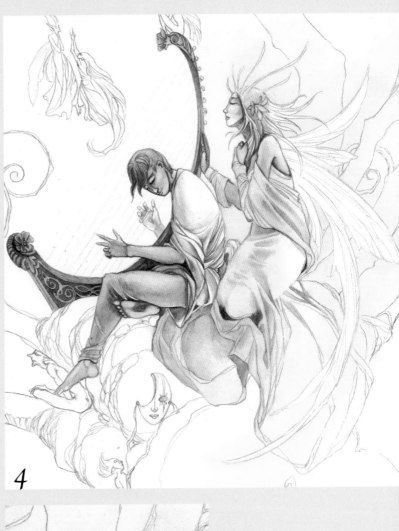

4

5

6

7 Add a Glow to the Pixies

Start with a wash of Cadmium Yellow and Lemon Yellow around the pixies. Use a no. 0 round to get into crevices, then switch to larger brushes for the outer areas.

8 Add Details

Mix Sap Green, Viridian and Lemon Yellow for the pixies' wings. Leave white areas in the wings to add sparkle and texture. Paint their hair with Yellow Ochre with a no. 0 round. Enhance the glow around them with a wash of more Lemon Yellow.

9 Finish the Pixies

Use Sap Green, Ultramarine Violet, Cobalt Violet and Cadmium Yellow for the pixies' clothing. Use a mixture of Cadmium Yellow and Cobalt Violet for their skin.

10 Lay In the Background Wash

With a ½-inch (12mm) flat, paint the entire background with a wash of Dioxazine Violet. Use your small rounds to paint the tight corners near the tree branches and the figures. Sprinkle salt in the corners where the foliage will be. Let the purple tones fade into the glow that surrounds the pixies and the main figures by diluting the paint on your brush near those areas.

Paint the gaps between the harp strings with a no. 2 round, leaving a thin strip of white paper showing through.

11 Deepen the Shadows

Add more Dioxazine Violet washes with a no. 4 round, pushing the corners back further. In the lighter areas, swipe on some water with a ½-inch (12mm) flat, smoothing out the colors in separate areas such as the harp strings and around the branches in the middle left area. This makes the washes in different areas look more unified. When all the washes are dry, start to pick out leaves in the areas around the tree with a pencil. Use the randomness of the salt to get ideas for the leaves' placement. Imagine you are looking for images in the clouds—look for random forms that the salt creates and visualize similarly shaped objects.

12 Add the Foliage

Use the foliage techniques on pages 60–61 to make the leaf clusters fade into the surroundings. Wet patches around the penciled leaves and paint a mixture of Dioxazine Violet, Prussian Blue and Payne's Gray, working wet-into-wet. When that dries, add trailing twigs with a no. 0 round. Push back the shadows at the centers of the clusters by drybrushing on more of the same mixture with a no. 0 round.

Keep some salt marks visible because they hint of more distant foliage. You don't want to pull everything into sharp detail—the further back something is, the less distinct and clear it should be.

13 Add Color to the Distant Leaves

Working wet-on-dry, add a mixture of Yellow Ochre and Viridian with a no. 4 round. This will give some color to the background leaves. Lift out the purple tones for the more hazy, distant leaves.

Painting the Harp Strings

If you are having trouble leaving thin gaps of white paper for the harp strings in step 10, it's okay to use masking fluid on the strings, or to go back and paint them with a no. 0 round and Permanent White Gouache at the end.

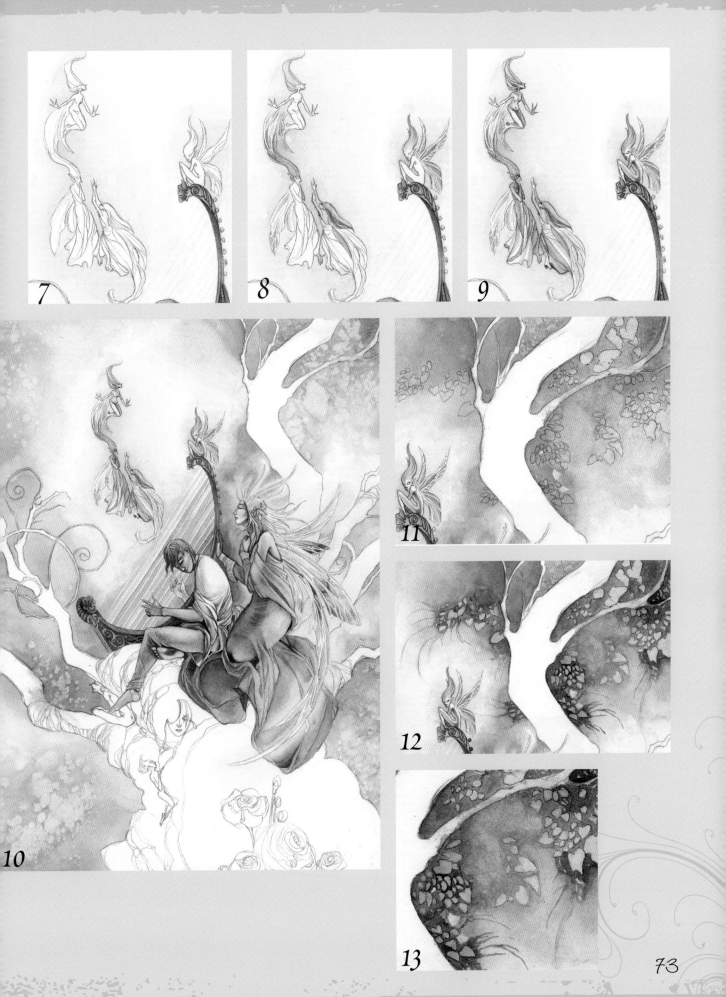

7

8

9

10

11

12

13

14 Finish Off the Leaf Details
Paint the leaves with Sap Green, Yellow Ochre and Viridian using a no. 0 round. Let the color bleed out toward the edges. Add some veins to the closer, larger leaves using the same colors and the no. 0 round.

15 Add a Basecoat to the Tree
Apply a wash of a Light Red and Burnt Umber mixture over the entire tree using a no. 8 round. Sprinkle it with salt.

16 Shade the Branches
Darken the central part of each branch with Burnt Umber, working wet-into-wet and using a no. 4 round.

17 Add Texture to the Tree Bark
With a no. 0 round, use Burnt Umber and Diaxazine Violet to paint in the texture of the bark. Use the salt texture to help your imagination as you work in the texture, outlining the weblike network of cracks along the branches.

14

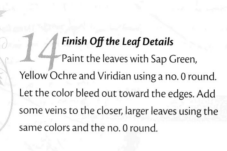

Detail of Foreground Leaf Veins

Detail of Background Leaves

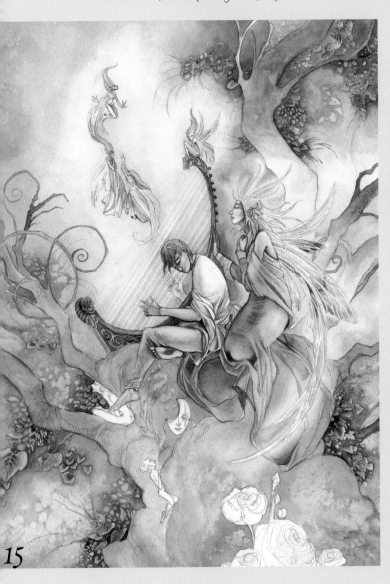

15

16

17

Tree Highlights

Tree Shadows

18

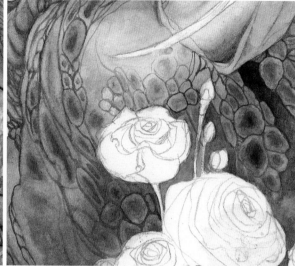

19

20

18 **Add Shadows and Highlights to the Bark**
For highlights, lift the color out from the texture in some pieces of bark with a wet no. 1 round. In other places, do the opposite and deepen the color with more Light Red or Burnt Umber. In the deepest shadows, add a wash of Dioxazine Violet with a no. 0 round.

19 **Create the Roses and Pixies**
Paint the pixies in the tree with Sap Green and a no. 0 round. Apply a wash of Cadmium Yellow in the center of the roses and Sap Green on the stems with a no. 0 round.

20 **Add Details to the Roses**
Finish off the roses by painting the petals with Cadmium Red and a no. 0 round, letting the yellow underlayer show through at the tips of the petals.

21 **Paint the Mask**
Using a no. 0 round, paint the details on the mask with Dioxazine Violet for the shadows. Use Alizarin Crimson for the ribbons and lips and Cadmium Yellow on the detailed pattern around the eye.

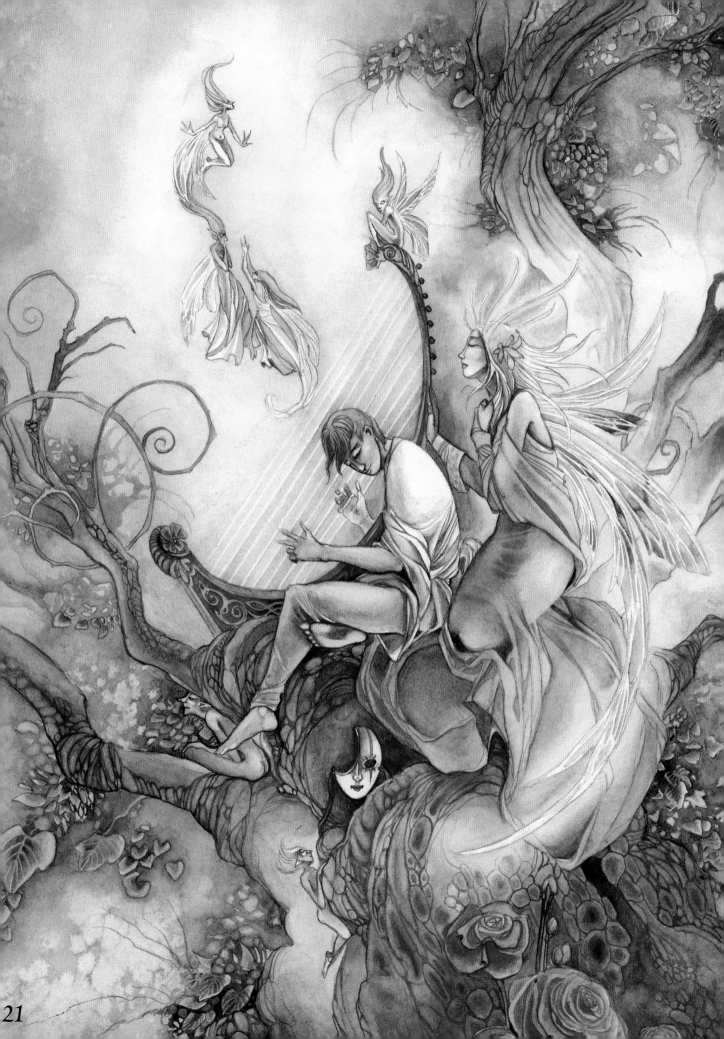

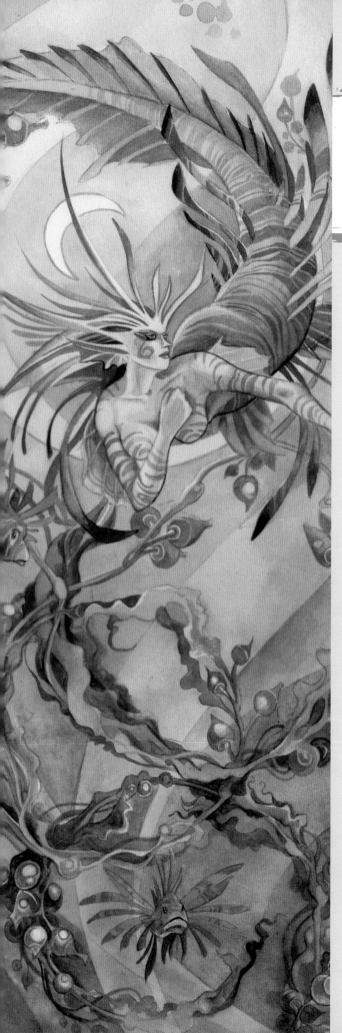

Part Three
MERMAID WORLDS

From lakeshore slips clear voices
sliding 'cross the mirror surface;
And laughter chiming from the deeps,
the faintest bell of resonance.

From river rushing, gushing flows;
burble, gurgle watery delight.
Slender hands clutch riverstones;
Playful eyes wink in the light.

From ocean surge of swell and ebb
in secret grottos no man has seen,
The sylphs of sea weave melodies
to tempt and taunt of hidden reefs.

From watery haunts,
From distant shores,
From silent depths
of ocean floor,
From hidden wellholes,
Sheltered springs,
Seep forth the songs
The seafolk sing.

Responding to the desires hidden in the hearts of those who sail upon the wild seas, mermaids slide through the silent depths. Half human and half fish, they part the waves with sleek bodies. Stories tell of deadly sirens whose achingly beautiful voices lure sailors to a watery doom. Ulysses braved death just for the chance to hear those voices lifted in seductive song. Faerytales speak of entire aquatic cities filled with lovely mermaids and mermen. How then to capture such an elusive presence within the bounds of pencil and paper and brush?

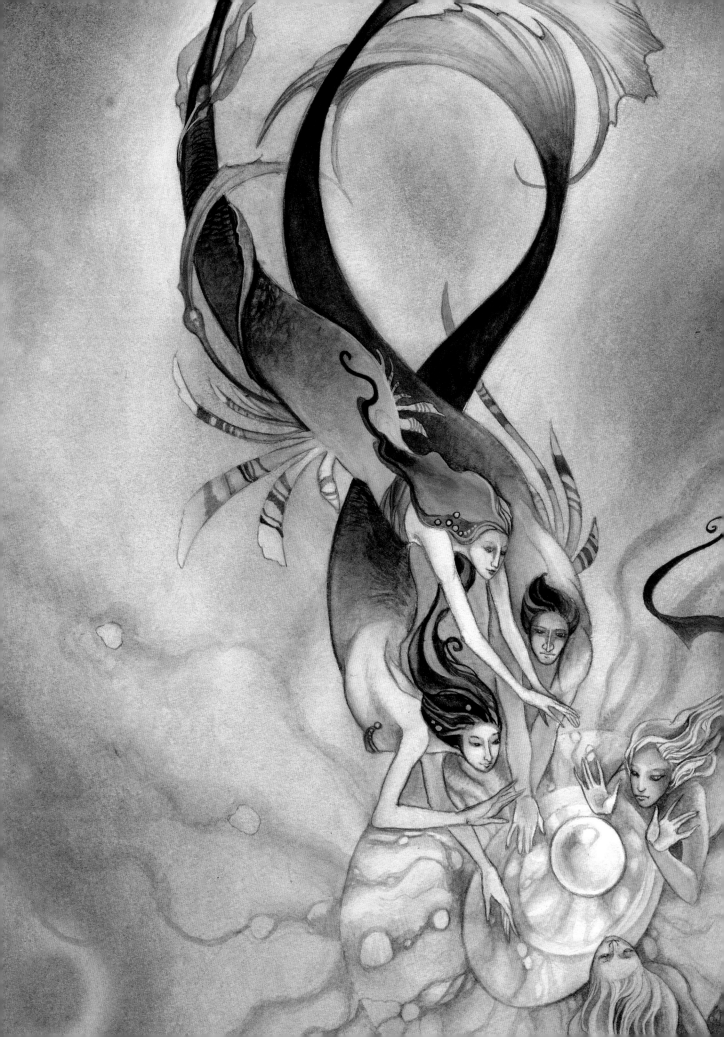

Melding Fish and Maiden

A MERMAID IS DESCRIBED AS HAVING THE upper body of a maiden, and the tail of a fish in lieu of legs. So how does one go about alchemizing the two forms? A good transition point is a curved line that sits low on the hips.

Where to Transition?

For the most classical mermaid look, the transition to the fish-half of the body should be at the hip bones, following the contour of the pelvis. From there, the tail can sweep out.

If the transition is too high, such as at the chest level, your mermaid will have an eel-like, ungainly look. Of course, if you are after a more alien or less idealized appearance this is perfectly valid. There is no single perfect way to draw creatures from legend. (As I have not yet spied a mermaid with my own eyes, I can't dictate "The Way" they must look!)

If the transition is too low, such as at her knees (or where knees would be if she had legs), it will give her an angular appearance. Her legs will look like they are glued together or like she is wearing a mermaid costume.

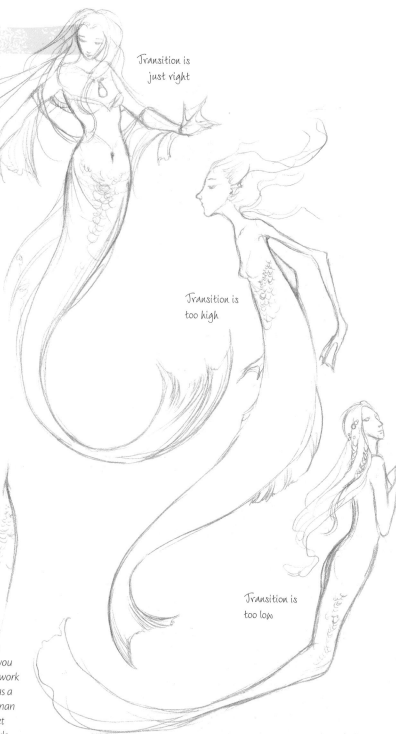

Transition is just right

Transition is too high

Transition is too low

Skin to Scales

When working on the initial sketch, draw a line where you want the transition to begin to give yourself a reference point. However, once you have the worked out the transition, erase any hard-edged lines and work a smooth and seamless melding of the skin to scales. If you leave it as a hard edge, it will look as if Dr. Frankenstein stitched a tail onto a human girl! You want the two parts to melt into each other. Let the scales get smaller along her abdomen and hips until they are just a faint sparkle.

Drawing Tails

When you are choosing the design for your mermaid's tail, nature is a good place to start. However, you need not be limited by the dictates of the natural world.

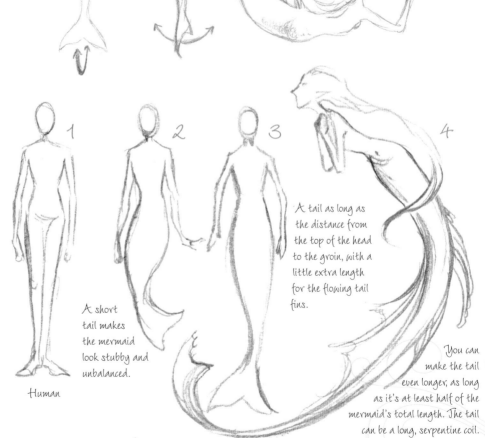

Dolphin: wide, round body

Guppy: flattened body

Direction of Tail Fins

Mammalian creatures of the ocean like whales, dolphins and seals have tails that move through the water in a vertical stroking plane. The more cold-blooded varieties of the ocean's denizens have tails that move in a horizontal plane back and forth. Mermaid tails can be modeled after either, though it can be easier to go for a more mammalian tail, since the width of the hips makes it awkward to flatten the body of the tail into a more two-dimensional plane of a fish.

Proportions

In a human figure, the groin is a good point of reference for the midpoint of the body. Use the same measurement for a mermaid. The tail length should be at least as long as the length of the top of the head to the groin.

Human

A short tail makes the mermaid look stubby and unbalanced.

A tail as long as the distance from the top of the head to the groin, with a little extra length for the flowing tail fins.

You can make the tail even longer, as long as it's at least half of the mermaid's total length. The tail can be a long, serpentine coil.

1 2 3 4

Capturing Movement
Positioning the Tail

A good way to capture the undulating form of a mermaid is to start by drawing the line of the spine because there is a natural balance to it. In the finished drawing, the tail's bottom curve counterbalances the upper body.

1 Start with a loose S-shaped curve. Mark off a midpoint for the hips, approximately at a 90 degree angle to the spine

2 Mark off the head and shoulders at approximately 90 degrees to the spine. As with the hips, there can be lift to one side or the other

3 Fill out the contours of the body and tail

4 Erase your guide lines and add more individualized details

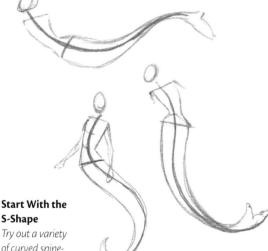

Start With the S-Shape
Try out a variety of curved spine-lines and work in a mermaid form around that.

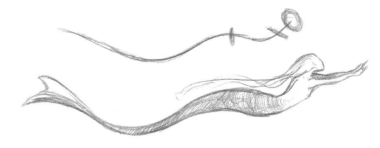

Build on the Basic S-Shape
You can get more complicated than a basic S-shape and create multiple undulating curves. If you make your curves too tight, your mermaid will look like a boneless contortionist. Keep at least the part of the spine above the hips relatively straight.

Types of Fins

Fins are both a functional and decorative aspect for your mermaids. They can be an individualizing feature and as fantastic as you wish to imagine.

Fins provide balance for your sea denizens, but can also be used to balance your compositions, providing flow and direction to a piece.

Rounded and smooth, like a lace frill

Shaped

Ribbed and spined, a bit more prickly and dangerous looking

Elegantly long and flowing

Fin Styles

There are many different styles of fins to draw. Long, flowing fins can have a more romantic character, while short, spiney fins suggest danger.

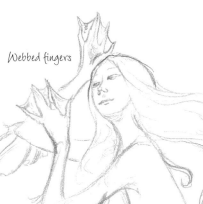

Smaller, rounded fins along the hips and tail

Ribbed spines along the side of the body connected to the arms like webbed wings

A double set of fins along the shoulder blades

Webbed fingers

Fins on the face or behind the ears

Fins rising in a kind of dorsal fin along the spine for balance

Fins along the backsides of the arm

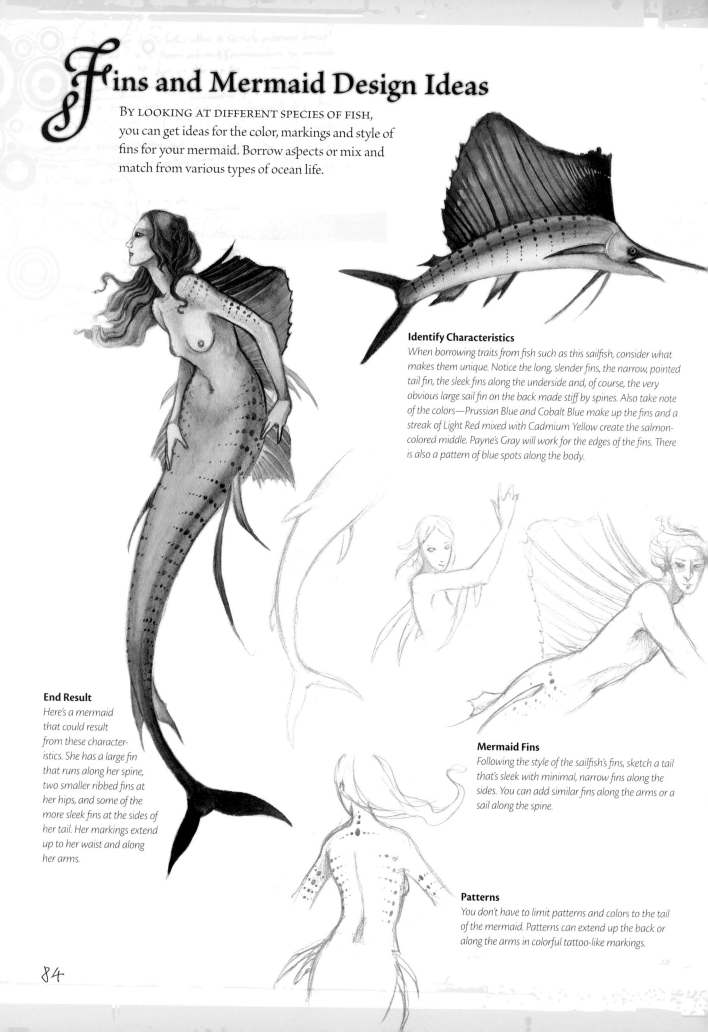

Fins and Mermaid Design Ideas

BY LOOKING AT DIFFERENT SPECIES OF FISH, you can get ideas for the color, markings and style of fins for your mermaid. Borrow aspects or mix and match from various types of ocean life.

Identify Characteristics

When borrowing traits from fish such as this sailfish, consider what makes them unique. Notice the long, slender fins, the narrow, pointed tail fin, the sleek fins along the underside and, of course, the very obvious large sail fin on the back made stiff by spines. Also take note of the colors—Prussian Blue and Cobalt Blue make up the fins and a streak of Light Red mixed with Cadmium Yellow create the salmon-colored middle. Payne's Gray will work for the edges of the fins. There is also a pattern of blue spots along the body.

End Result

Here's a mermaid that could result from these character-istics. She has a large fin that runs along her spine, two smaller ribbed fins at her hips, and some of the more sleek fins at the sides of her tail. Her markings extend up to her waist and along her arms.

Mermaid Fins

Following the style of the sailfish's fins, sketch a tail that's sleek with minimal, narrow fins along the sides. You can add similar fins along the arms or a sail along the spine.

Patterns

You don't have to limit patterns and colors to the tail of the mermaid. Patterns can extend up the back or along the arms in colorful tattoo-like markings.

84

Combining Fish Characteristics

You don't have to base your mermaid on one type of sea creature. Try combining characteristics of several different forms of sea life.

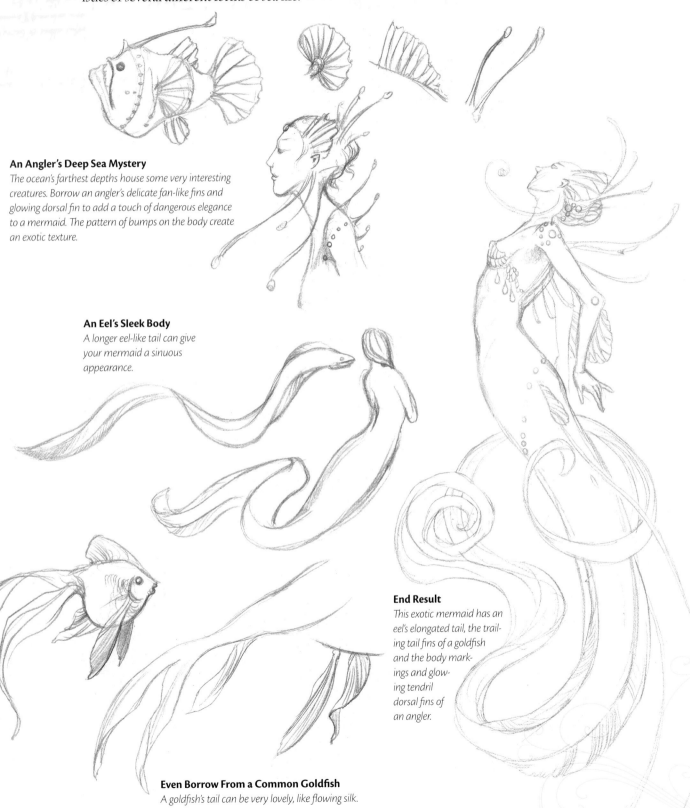

An Angler's Deep Sea Mystery
The ocean's farthest depths house some very interesting creatures. Borrow an angler's delicate fan-like fins and glowing dorsal fin to add a touch of dangerous elegance to a mermaid. The pattern of bumps on the body create an exotic texture.

An Eel's Sleek Body
A longer eel-like tail can give your mermaid a sinuous appearance.

End Result
This exotic mermaid has an eel's elongated tail, the trailing tail fins of a goldfish and the body markings and glowing tendril dorsal fins of an angler.

Even Borrow From a Common Goldfish
A goldfish's tail can be very lovely, like flowing silk.

Designing a Lionfish Mermaid

A LIONFISH HAS DISTINCTIVE FINS AND patterns that make it very elegant, with a dangerous edge. Most noticeable are the pattern of stripes along the body and fins and the spiny nature of the fins themselves with the translucent webbing.

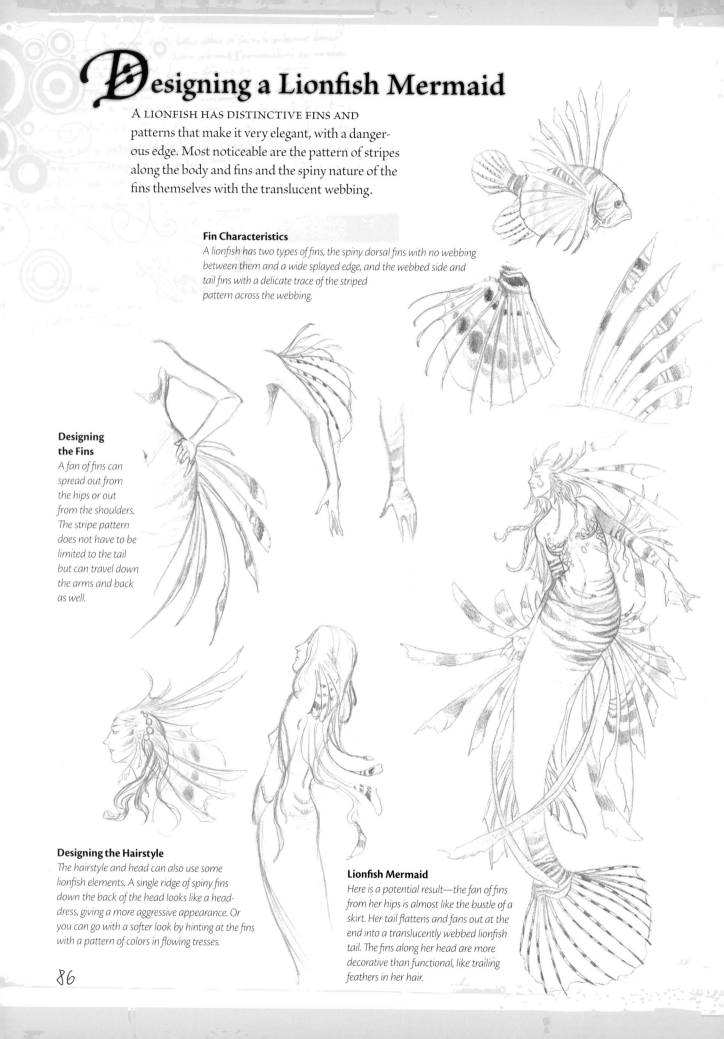

Fin Characteristics

A lionfish has two types of fins, the spiny dorsal fins with no webbing between them and a wide splayed edge, and the webbed side and tail fins with a delicate trace of the striped pattern across the webbing.

Designing the Fins

A fan of fins can spread out from the hips or out from the shoulders. The stripe pattern does not have to be limited to the tail but can travel down the arms and back as well.

Designing the Hairstyle

The hairstyle and head can also use some lionfish elements. A single ridge of spiny fins down the back of the head looks like a headdress, giving a more aggressive appearance. Or you can go with a softer look by hinting at the fins with a pattern of colors in flowing tresses.

Lionfish Mermaid

Here is a potential result—the fan of fins from her hips is almost like the bustle of a skirt. Her tail flattens and fans out at the end into a translucently webbed lionfish tail. The fins along her head are more decorative than functional, like trailing feathers in her hair.

Painting fins
LION OF THE SEA

After taking the time to design a lionfish mermaid, let's look at how to paint her. The array of elaborate fins offers a chance to look at how to approach both translucent and opaque fins. This mermaid's tail pattern extends up her back and shoulders, along her arms and even in a few playful swirls on her cheeks.

PAINTS

Brown Madder, Burnt Umber, Cadmium Red, Cadmium Yellow, Lamp Black, Prussian Blue, Viridian

MATERIALS LIST

illustration board, nos. 0 and 2 rounds, pencil

1 *Sketch Out the Design*
Use a pencil to sketch out your mermaid's design. As you work, shade all the stripes with pencil. Since the color you will paint over them is relatively dark, the pencil marks will be covered up.

2 *Add the Underlayer and Shadows*
Use Viridian to paint the shadows on her body and along her tail, working wet-on-dry with a no. 2 round. Blend the edges of the shadows with water to make them look smoother. Apply Viridian to her right arm and the fins on her right side since those are more distant and shadowed. Notice that the fin on her left hip overlaps the tail slightly. Since the fin's webbing is translucent, shade a blurry edge of Viridian to the tail that you can see through the webbing.

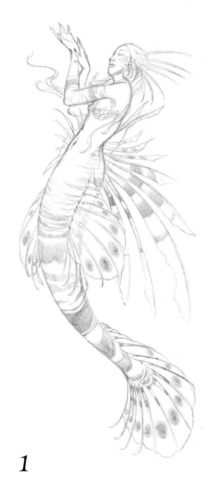

1

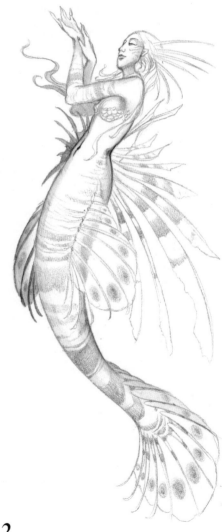

2

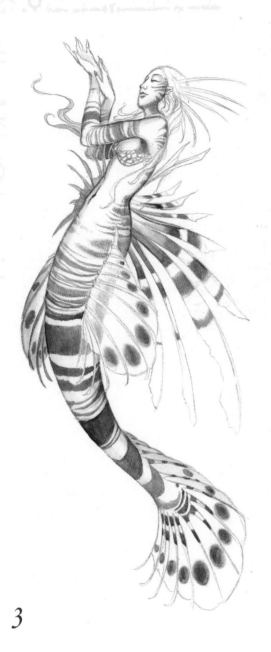

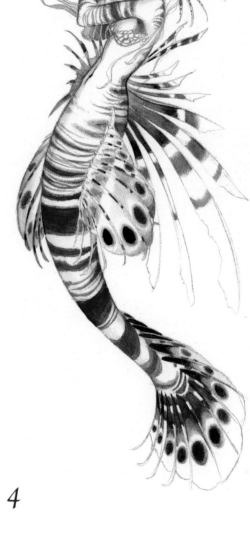

3

4

3 Add the Stripes and Dots

Paint in the stripes on her body and the dots on her fins with Brown Madder and a no. 2 round. You may want to use a no. 0 round for some of the thinner stripes. Add bits of Burnt Umber for variety in the shades of the stripes.

4 Add More Details to the Fins

Darken the spots on the tail and side fins with a mixture of Lamp Black and Burnt Umber using a no. 0 round. Use the same colors to shade the tail fin, along the spiny dorsal fins close to her back and on the stripes of the spines in her hair. Brighten the top of the tail stripes with a layer of Cadmium Red with a no. 0 round.

5 Add the Skin Tones and Hair

Mix Cadmium Red and Cadmium Yellow for a fleshtone and paint a thin wash of it over her upper body with a no. 2 round, keeping the pigments more concentrated in the shadows. Follow the pattern of shadows you already established with the Viridian shadows earlier. When you get to the striped area around her hips, leave a thin strip of white between the fleshtone and the Brown Madder stripes when you paint in those white areas. This attention to detail enriches the pattern on her tail. Mix Burnt Umber with Lamp Black and use a no. 0 round to add the details of her eyes, lips and little seashells in her bra. For her hair, lay in a base of Burnt Umber, then pick out individual strands for greater detail with more concentrated Burnt Umber and Lamp Black.

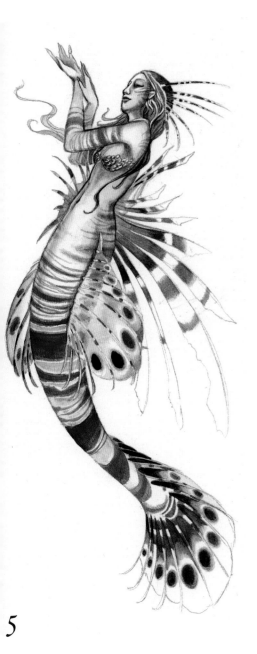

5

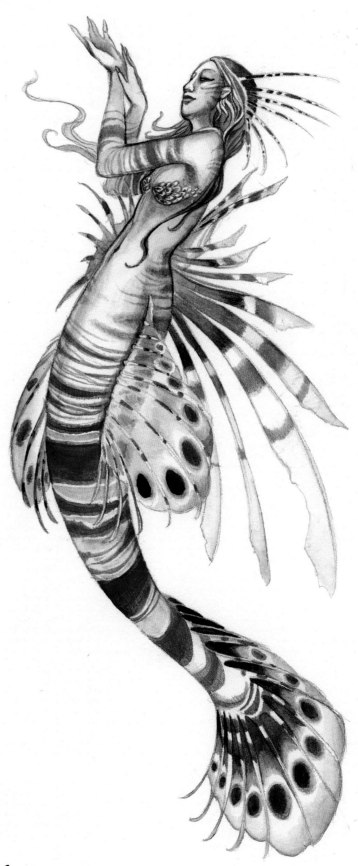

6 Complete the Painting

Mix Viridian with Prussian Blue and paint a light wash over the end of her tail and the tips of her dorsal fins using a no. 2 round. Since there isn't a background in this image, adding these colors to the white areas makes them visible. If there was a background for this mermaid, you could skip this last step and just leave those areas as the white of the paper.

6

Hair and Hair Styles

Long, flowing tresses and sinuous strands that trail their bodies in the water are the hallmarks of mermaids. When drawing hair, the key aspects are:

- The general shape and form of the hair.
- The highlights and shadows.
- The individual strands.

Don't get caught up drawing every single hair. Focus more on the overall shape and flow, then add the details of individual hairs for texture.

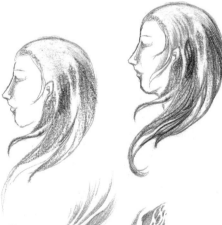

1 Random lines look messy and flat.

2 Define the hair by the negative space of shadows around it.

3 For curlier hair, the shadows will be more crescent shaped.

4 For straight hair, use just straight-edged shadows.

Watery Locks

Even though hair in water can swirl all about, generally you still want to keep some form to the mass of strands so that your mermaid does not look like a wild and demented creature lost in a frenzied cloud of hair. You can help yourself visualize it by drawing an outline for the shape of the hair around the head first. Remember that the hair will flow with the currents so draw a blob that goes mostly in one direction. After you do that you can fill in the details of strands and curls and even stray out of your initially drawn area. But keep it mostly within the area if you want to have some form and structure to the flow.

Sketching Hair

Start with the general shape of the head and hair. For short hair, use quick short pencil lines to fill in the shaded areas. Your strokes should go in the direction of the hair's growth.

For long hair, focus even less on the individual hairs. Start with the form, fill in the shadows, then go in and add more detail with the strands. Think of hair as groupings and clumps of strands. This will be especially important when you paint the hair instead of just drawing it in pencil. Remember—hairs are three-dimensional objects and have highlights and shadows like anything else. Define the hair by the shadows around it and the light on it.

Dry vs. Wet Hair

Hair flows and hangs differently when it's wet than when it is dry. Dry hair hangs loosely. If it is combed, it falls in a mostly orderly fashion, with the strands moving together in layers. The hair has body and its own volume.

Wet hair has less body and can tangle. Strands will crisscross and stick to each other and to the body. The tangles are full of negative space. Draw angular loops and whorls of shadow rather than the actual hairs.

Hair in water flows and moves with the currents and the figure's motion. Focus on drawing flowing clumps and strands of hair. Loose tendrils are not anchored by gravity, so they can swirl and flow in all directions.

Dry hair

Wet hair

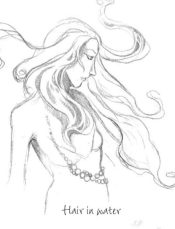

Hair in water

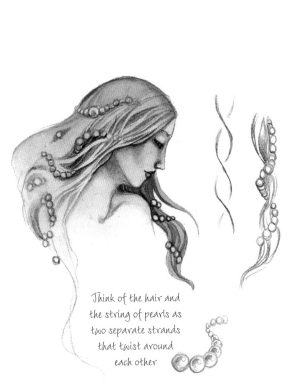

Think of the hair and the string of pearls as two separate strands that twist around each other

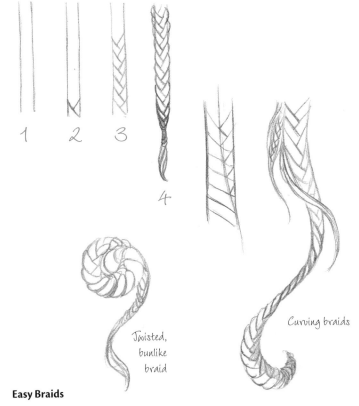

1 2 3 4

Twisted, bunlike braid

Curving braids

Flowing Locks

Long, loose hair for a mermaid is always fun to draw, particularly if she's swimming in the water. Then the tendrils of hair can flow in a cloud about her body. You can wind pearls or other jewels through the locks as well.

Easy Braids

1 Start with two lines to represent the width of the braid.

2 Draw one diagonal line from the bottom right corner up toward the left and a second that goes from midway along the first diagonal toward the right.

3 Continue this pattern up the length of the braid.

4 Give the basic structure form and curves by rounding out the sides and tying it off at the end.

You can also add curves and varying widths and twists to the braids. As a braid turns on its side, you'll see less of the crisscrossed pattern and more of the edge of one side.

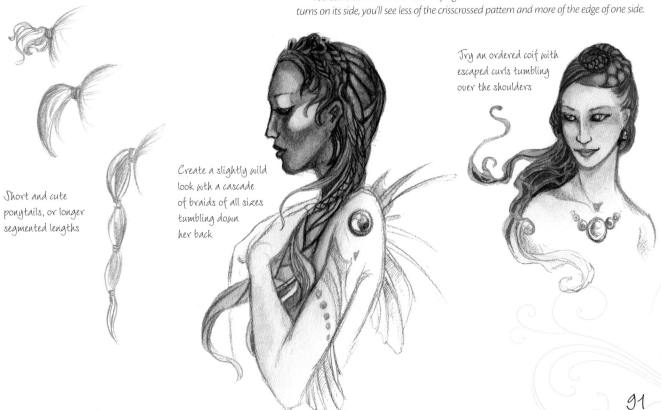

Short and cute ponytails, or longer segmented lengths

Create a slightly wild look with a cascade of braids of all sizes tumbling down her back

Try an ordered coif with escaped curls tumbling over the shoulders

Painting hair
IDLE PLEASURE

Oh, the tedium a mermaid must endure to unsnarl those knots and tangles every day after spinning through the waters and being tossed about by currents!

In watercolor you build up the darks and leave mostly unpainted paper for highlights and a more concentrated pigment for shadows. When painting hair, work on the shadows around the strands of hair. Avoid painting a line of uniform thickness to represent a strand of hair. Instead, think of the shadows the hair makes as it crosses over other strands and paint around them.

PAINTS

Brown Madder, Burnt Umber, Cadmium Orange, Cadmium Red, Cadmium Yellow, Cerulean Blue, Payne's Gray, Ultramarine Violet

MATERIALS LIST

illustration board, nos. 0, 1, 2 and 4 rounds, pencil

1 Sketch the Mermaid
With a pencil, sketch your mermaid, sculpting the hair's overall form. You can sketch a little bit of the shadows and general flow of the strands, but you don't have to be too detailed with it. The light source will be from the top right corner so her hair will be brighter there with more shadows under her hands and arms.

2 Add a Basecoat
Paint a Cerulean Blue wash for an underlayer of shadows on the skin with a no. 4 round.

3 Add the Skintone
Use Cadmium Yellow mixed with Cadmium Red (use more yellow than red) in a very pale wash over her skin. Darken the Cerulean Blue at her hips and tail with another layer using a no. 4 round.

4 Add Shadows and Details
Use a more concentrated Cadmium Yellow and Cadmium Red mixture (use more red than yellow this time) and a no. 4 round for the shadows and to neutralize the blue skin tones. Apply touches of Cadmium Red to the lips, then mix the red with some Burnt Umber for the details of eyes, eyebrows, ears and the deeper crevices and shadows with a no. 0 round. With a no. 0 round suggest some scales on her hips, lifting some of the blue out with a no. 1 round and creating a mottled texture.

5 Paint the Hair
Paint a wash of Cadmium Yellow for the hair with a no. 2 round. Keep the wash lighter toward the top right side where the light is coming from.

6 Add Shadowy Streaks
Use Cadmium Orange to lay selective washes in the more shaded areas of her hair, such as behind her right cheek, the strands winding below her arms and the strands she's braiding.

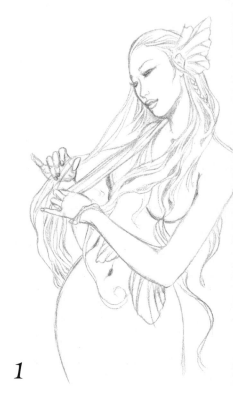

1

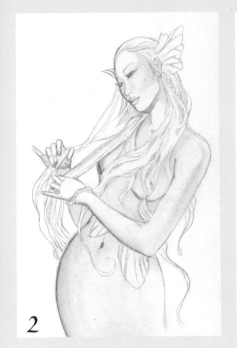

2

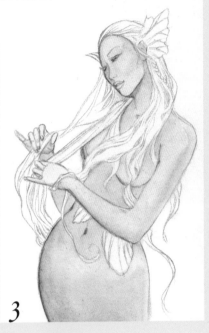

3

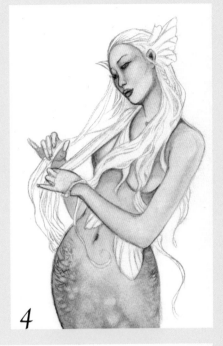

4

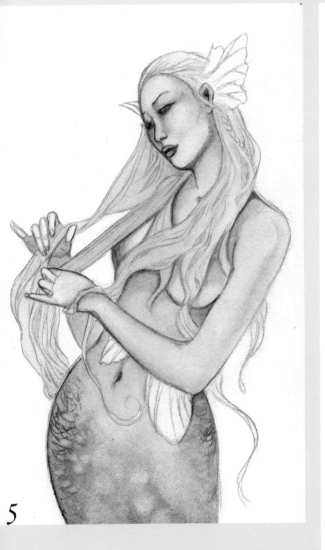

5

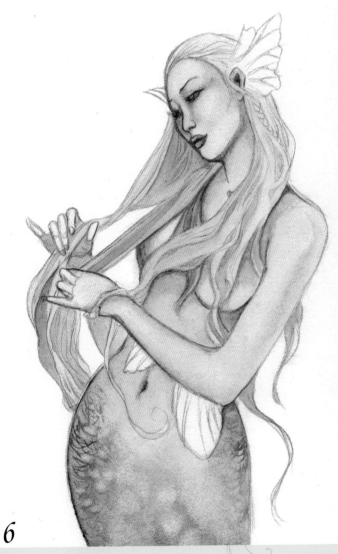

6

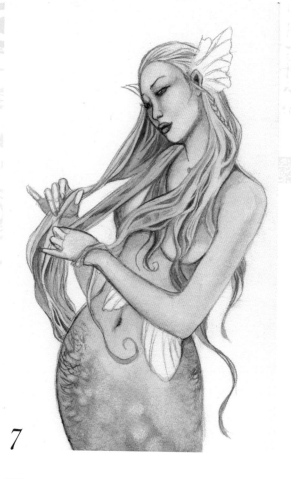

7

7 Detail Strands of Hair

Use Brown Madder and Burnt Umber to add more detailed shadows to individual strands of hair with a no. 0 round. The back and top of her head are mostly untouched after the initial wash of Cadmium Yellow and the minor touches of Cadmium Orange in previous steps. Glaze the top of her head with a no. 2 round and the Brown Madder and Burnt Umber.

8 Finish Up the Painting

Paint the fins with Cerulean Blue, outlining the outer edges with Payne's Gray using a no. 0 round. Darken the hair under her hands with a very pale layer of Ultramarine Violet and a little bit of reflected Cerulean Blue in the hair below the fins on her head using a no. 0 round. Add touches of Ultramarine Violet to the deepest shadows in her hair.

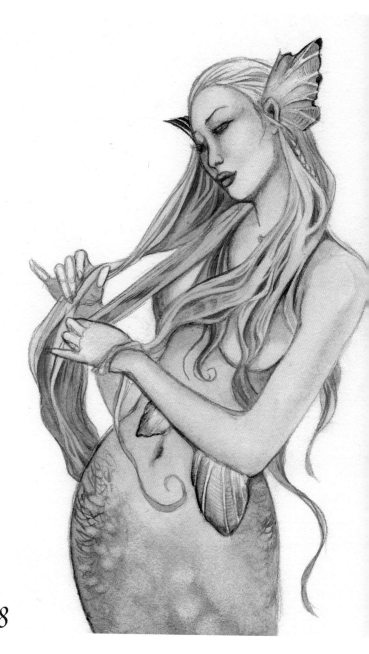

8

cales

SCALES ARE AN IMPORTANT TEXTURE WHEN painting mermaids. As with hair, don't create every single scale—do just enough to hint at them and let the viewer's imagination fill in the rest.

Drawing the Basic Patterns

 Scales can have different shapes

 Start with a row of scales

 Offset the next row by half a scale

 Think of scales like house shingles overlapping each other

 The darkest part of a scale is at the top close to where it's overlapped by the layer above. The lightest point is at the rounded edges of each scale

Curved scales

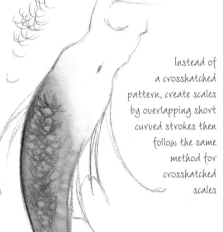 Instead of a crosshatched pattern, create scales by overlapping short curved strokes then follow the same method for crosshatched scales

 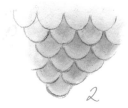 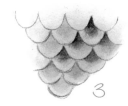

1 2 3

Painting Scales

1 Paint a base color to mold the scales' shape, working wet on dry. Keep the colors darkest where each scale is overlapped by the layer above it. Leave the rounded edges mostly unpainted.

2 After the initial layer dries, paint a wash of a lighter color over all the scales. This will help soften the edges of the shadows.

3 Re-emphasize the darkest shadows, but don't do this to every scale. Skip a few, making some darker or lighter for a variegated texture.

Tips for Painting Scales

* Keep a rim of a light wash or unpainted paper at the edge of each scale for a texture with more dimension.

* If your paint doesn't lift easily, try wiping the centers of each scale with a paper towel.

* If the paint won't lift, you can also paint highlights with Permanent White Gouache; however, lifting will soften the lines making them seem more like shadows than a grid.

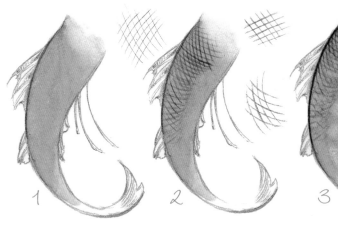

1 2 3

Painting Scales on a Mermaid's Tail

1 Wash the base color over the area where you will paint scales.

2 Paint a crosshatched pattern across the area with a darker color or a more concentrated version of the base wash.

3 Wet a small brush and lightly scrub at the center of each scale to lift out a bit of the color. Add a few more shadows where necessary.

 For a surface that's flat to the viewer, keep the crosshatched pattern straight. For a curved surface, curve the pattern creating diamond-shaped scales instead of squares.

Skin Tones

THERE IS NO NEED TO BUY PAINTS IN "FLESH" tones. You can easily achieve flesh colors just by mixing reds and yellows on your own. More red and brown gives a duskier skin tone, while more watered down washes create lighter skin. Use blue and green highlights on very pale skin to achieve an almost glowing white.

It's best to work in layers when painting skin. Layers add a subtle shifting of colors, reflections and highlights that really simulate the breath of life. Generally, you should start with a cool underlayer of shadows. Over that, lay on a wash of the main skin tone, then build up more shadows and add reflected light and highlights.

Dark and mysterious skin tones

Gleaming white skin tones

Light Skin
A mixture of Cadmium Yellow and Cadmium Red creates the rosy blush that's the base for lighter skin.

Extremes
What about more extreme dark or light skin tones? Some mermaids may have unusually pale and luminous skin, or they may be dark and mysterious.

1 Lay on an Ultramarine Violet underlayer for the shadows.

2 Mix Cadmium Yellow and Cadmium Red and paint a wash over everything. Don't go too heavy on the Cadmium Red or you will end up with a sunburned mermaid.

3 Add Naples Yellow to emphasize the shadows and add warmth. Let the lighter tones from the previous layer show through some highlighted areas.

4 Let bits of the underlayer show through for reflected light.

5 Create darker shadows with washes of Burnt Umber or Brown Madder.

Dark Skin
For darker skin, use a dusky brown base tone with a warm touch.

1 Apply a basecoat of Ultramarine Blue for the shadows.

2 Mix Burnt Umber, Payne's Gray and a bit of Brown Madder to paint a wash over all the skin. You may need to let the wash dry and lay in second and third layers to get an evenly rich and dark skin tone.

3 Apply Brown Madder glazes over some of the deepest shadows to add some more warm darks.

4 Lift out some areas for highlights or to define muscles.

For very white skin, start with a cool underlayer of either green or blue, then add a wash of Permanent White Gouache mixed with just enough Cadmium Yellow and Cadmium Red for a hint of color. Let some white paper show through for the brightest highlights, and drybrush Ultramarine Violet onto the darkest areas.

For very dark tones, wash Viridian or Prussian Blue over the skin. Once that dries, layer washes of Payne's Gray, Burnt Umber and some Lamp Black to the skin. Build more layers in the shadows. Pull back highlights, brush water over the areas and lift up the color by dabbing these areas with a paper towel to reveal the initial bluish-green washes.

Gems and Jewelry

MERMAIDS LOVE JEWELRY. SEA GLASS WORN smooth into rounded cabochons of color, strings of pearls harvested from the ocean's bounty, treasures scrounged from sunken ships and castoff tokens from sailors seeking blessings or luck from the spirits of the sea. The seductive glint of jewels set a sparkle to a mermaid's eyes as surely as the sight of the mermaids themselves set human hearts to longing.

The Effects of Light and Shadow

❧ **Cast shadow:** *The shadow cast by one object onto another.*

❧ **Highlight:** *The area where the light hits. Here, the brightest point on the jewel.*

❧ **Reflected light:** *Almost as bright as the top of the jewel where the light hits. Since the jewel is translucent, some light comes through the jewel into the shadow.*

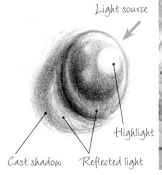

Light source

Highlight

Cast shadow Reflected light

1 2 3 4 5

Painting a Cabochon

1 Pencil in a sphere, mark out the shadow, the highlight and the crescent of reflected light.

2 Paint the light side of the jewel with Cadmium Yellow.

3 Add Sap Green to the darker side of the jewel. Keep the highlighted areas unpainted.

4 Darken the area between the highlights with Viridian and Prussian Blue. Drybrush these colors, then soften the edges by brushing water over them.

5 Add a bluish-green shadow of Payne's Gray and Ultramarine Blue.

Cabochons, Water Droplets and Light

Cabochon jewels and water droplets can be thought of in much the same way. The big difference is that a water droplet is completely clear so you might see a hint of background elements through it (that is, if it's a big enough droplet!)

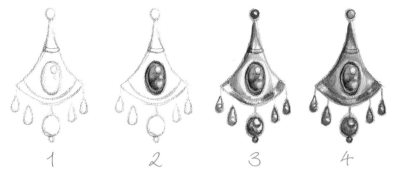

1 2 3 4

Painting Gold

Gold has a very reddish undertone cast to it. To emulate, start with a reddish undercoat.

1 Sketch a piece of jewelry a mermaid might wear—a pendant, an earring or a hair ornament.

2 Paint the cabochon in the center.

3 Working wet-on-dry, layer Cadmium Red mixed with Brown Madder. Leave lots of white for highlights and glints of light on the gold.

4 Paint various shades of Cadmium Yellow, Lemon Yellow and Naples Yellow on top of the red for a golden glow. Leave a little bit of white showing through.

Pearls and jewels
ADORNED

This mermaid clutches ropes of pearls to her chest, and her hair is adorned with jewels.

PAINTS

Brown Madder, Burnt Umber, Cadmium Red, Cadmium Yellow, Cerulean Blue, Lemon Yellow, Naples Yellow, Prussian Blue, Sap Green, Ultramarine Violet, Viridian

MATERIALS LIST

illustration board, nos. 0, 1 and 3 rounds, pencil

1 Sketch the Composition
You can drape ropes of pearls in a mermaid's hair or across her body.

2 Add the Background and Underlayers
With a no. 3 round, paint a layer of Cerulean Blue in the background and in the shadows of her body.

3 Paint the Skin, Tail and Hair
Lay in a wash of a Cadmium Yellow and Cadmium Red mixture on her skin and a wash of Viridian on her tail. Paint her hair with Burnt Umber, using layers of Burnt Umber and Brown Madder for the shadows. With a no. 1 round, paint shadows of the pearl ropes with Ultramarine Violet.

4 Refine the Jewels
With a no. 0 round, dot the center of each pearl with Naples Yellow. Avoid painting to the edge of each circle. Paint the highlighted parts on the jewels in her hair with Lemon Yellow. Paint a glow of Viridian around the outside of each jewel in her hair with a no. 0 round.

5 Add the Finishing Touches
Shade the pearls farthest from the light with various muted shades of blue, gray and green using a no. 0 round. If you would like more shadows around the pearls to define the white, use Ultramarine Violet and a no. 0 round to outline the shadowed side of the pearls against her flesh. Add color to the gems in her hair with crescents of Sap Green around the highlighted spot of light. For the larger jewels, add a bit of Prussian Blue to further darken the color.

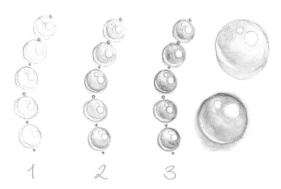

Painting Pearls

Pearls are similar to cabochon gems, but instead of being translucent, they are opaque and iridescently reflective. Since they are white, their colors are defined by the colors surrounding them. If they are nestled in flame red hair, there will be a hint of red to their edges. If, instead, they are draped by lush green fins, the shadows will be more greenish.

1 Draw the spheres separated by knotted string. Sketch in the highlights for each bead.

2 Paint a wash of yellow, avoiding the highlights.

3 Add shadows, with little bits of reflected color from the surroundings. Add hints of green for variety.

If the pearls are large, make them more iridescent by drybrushing in hints of other reflected colors, but keep the tones muted and the glazed washes very pale.

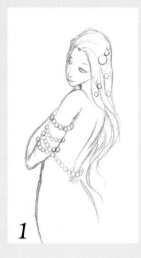

1

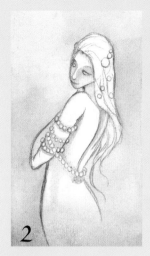

2

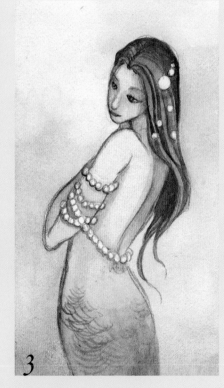

3

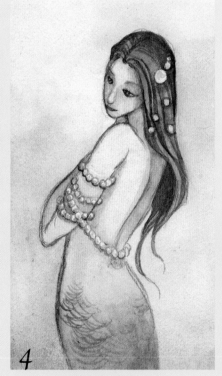

4

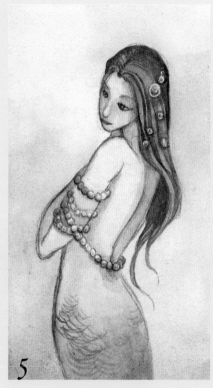

5

Small Pearls

Paint around the pearl with Cobalt Blue, then add a dot of color to each bead. As you move along the string, shift the color from gray, to green, to reddish yellow, to blue. Dilute the colors to keep them more neutral looking. Make sure you don't paint all the way to the edge of the circles when you dot the color in the middle. You can even leave some of them completely unpainted and white, depending on where your light source is coming from.

Underwater Surroundings

AND WHERE IN THE WATERY WORLD DO
mermaids spend their time luxuriating? Coral can
arch in fabulous structures and form the walls of
living grottos. Barnacles and limpids and tiny spiral
shells can decorate a rocky outcropping and turn
your mermaid's world into a beaded sculpture.

Coral and Creatures

*If you're lucky enough to scuba dive or snorkel in tropical locales, you can get a glimpse
of the elusive underwater world with your own eyes to gather ideas. Otherwise, an
aquarium or even a tropical fish store is a good place for inspiration. Take in the colors,
the alien shapes of spirals, the trailing leafy fronds and the delicate tracery of coral.
Incorporate these treasures into your mermaid paintings.*

First apply the wash

*Then apply the alcohol with a
brush for large bubbles*

*Use a toothbrush for
smaller bubbles*

Creating Bubbles With Rubbing Alcohol

*Like salt, rubbing alcohol can be used to create rounded speckled
textures that differ from those created from salt.*

*To create a bubble, apply a wash, then while the wash is wet, flick
rubbling alcohol at the wash so that sprinkles shower the paper. Use
a brush for large bubbles and a toothbrush for smaller sprinkles.*

Refining Large Bubbles

*After the wash and the rubbing alcohol dry, go
back with the same blue color you used for your
initial wash with a small round brush and pick out
bubble forms from the splotches. Leave a white-
edged border of unpainted paper around the
outside of each bubble and just fill in the middle
with a blurred blue.*

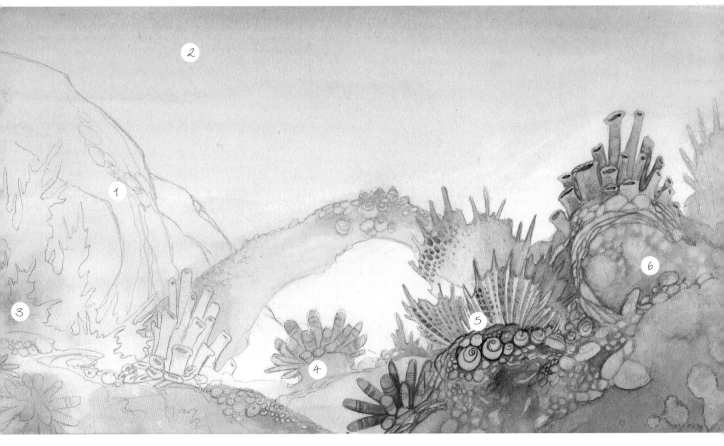

A Colorful Seabed

Let the randomness of these texture techniques give a splash of unexpected wildness to the seascape.

1 Pencil in a seascape. All the details do not have to be drawn right away, but get a rough idea for the structures.

2 Apply a graded wash for the background. Watery hues of Cobalt Blue, Viridian, Ultramarine Blue and Prussian Blue are all good options.

3 While the background wash is still wet, drop in colorful splotches for the coral, sea urchins and plants. Use bright pigments like Cadmium Yellow, Cadmium Red, Ultramarine Violet, Cobalt Violet and Sap Green.

4 After the initial washes dry, start to pick out the details. More distant elements need only a hazy definition of shadows painted in a second layer using the same color. Since I painted the background with a Viridian wash, I used a small brush and more Viridian to paint the shadows around the little shells and barnacles.

5 Layer the shadows. Build up layers of washes letting them dry individually before painting on top. This will make the colors brilliant. Pull out details like the little spiral shells with Burnt Umber and add texture to the coral by dotting it with a lacy pattern of Ultramarine Violet spots.

6 Add a softer, spotted texture to larger coral formations by lifting color. Use salt for a sharper pattern, or splash or sprinkle rubbing alcohol for a more bubbly texture. After a sprinkled wash dries, go back in and emphasize the effects by refining spots into rounded coral formations or a spattering of barnacles and shells.

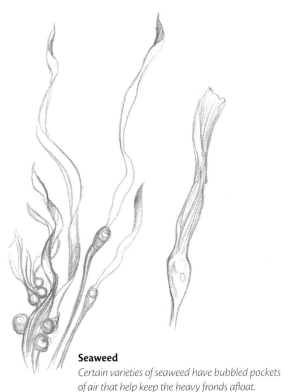

Seaweed

Certain varieties of seaweed have bubbled pockets of air that help keep the heavy fronds afloat.

Painting seaweed
AQUARIAN FRONDS

The forests of the sea sway in the currents—masses of kelp stretching up to the distant surface. The shadows can hide mysterious mermaid haunts.

PAINTS

Prussian Blue, Sap Green, Ultramarine Blue, Ultramarine Violet, Viridian

MATERIALS LIST

½-inch (12mm) flat, illustration board, nos. 0 and 2 rounds, pencil

1 Create a Layered Graded Wash

Apply an Ultramarine Blue wash, followed by one of Prussian Blue, then one of Virdian and one of Ultramarine Violet using a ½-inch (12mm) flat. Each wash should start a little further down the page than the last and be angled to create a brighter pocket of blue at the top right corner. Apply the Ultramarine Violet wash in the bottom left corner.

2 Add Distant Stalks

Sketch out some seaweed with a pencil. Mix Prussian Blue with Viridian and working wet-on-dry, paint the more distant stalks of seaweed with a no. 2 round.

3 Lift Out the Foreground

Wet a no. 2 round with water and rub along the closer foreground stalks to lift the pigment from the paper.

4 Paint the Foreground Stalks

Paint the whitened lifted areas with a diluted wash of Sap Green and a no. 2 round. With a no. 0 round paint a ruffled texture on the fronds with Viridian.

Mermaid suspended in water
PEARL OF THE DEEP SEA

This siren resides in the dark waters of the ocean's unfathomable depths. Her voice trails in a whisper of sibilant song that bubbles up from the hot fissures of the deep seabed, beckoning those bound to the surface, enticing them, like the hint of a forbidden fragrance.

The light source comes from the surface of the water at the top, so, as we progress lower in the painting, the light becomes more diffuse and the water murkier.

PAINTS

Cadmium Red, Cadmium Yellow, Cerulean Blue, Lamp Black, Lemon Yellow, Payne's Gray, Permanent White Gouache, Prussian Blue, Sap Green, Ultramarine Blue, Ultramarine Violet, Viridian

MATERIALS LIST

½-inch (12mm) flat, illustration board, nos. 0, 1, 2, 3 and 4 rounds, pencil, salt

1 Sketch the Mermaid and Add the Glowing Areas
Draw the mermaid and the pearl. With a no. 2 round, add Lemon Yellow to the glowing areas—the tips of all her trailing fins and the area around the pearl at the top. Blend it into the white of the surroundings by diluting with water.

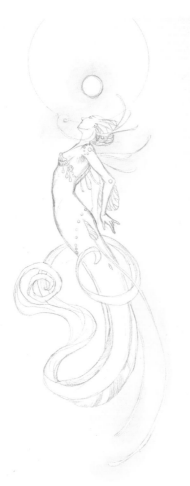

1

Composition Notes

Composition is a delicate balance that can be affected by the smallest changes. For example, this lone mermaid does not make a composition. No matter how beautifully painted, it could only be a free-floating rendering without a setting or purpose.

No focal point for her gaze here, just a mermaid floating in space.

Add some small background elements then the viewer's eyes follow the mermaid's gaze to the pearl. The glowing sphere draws the eyes back down toward the rest of the image.

2 Add the Background Wash

Mix Viridian and Cerulean Blue, then apply a wash to the background with a ½-inch (12mm) flat. Keep the color lighter around the glowing yellow areas. Sprinkle salt at the top corners.

3 Deepen the Colors

Continue layering in Viridian and Cerulean Blue washes to darken the edges, particularly toward the bottom. As you work toward the glowing fins at the bottom, apply layers of heavily diluted washes to gradually transition from the glowing yellow to a rich blue. Keep the layer from becoming splotchy by letting each layer dry before applying the next.

Soften the salt splotches at the top by brushing clean water over that area or by applying a light wash of Sap Green. Mix in a little bit of Ultramarine Violet as you work toward the bottom curve of the painting. To build up the darkness, add many layers of pale washes of Ultramarine Violet, letting each layer dry before doing the next layer to build up the pigment. Use a ½-inch (12mm) flat near the bottom edge and a no. 4 round in the areas near her body. Don't worry about making it perfectly smooth; you can take advantage of irregularities at a later stage.

4 Create the Glowing Watery Sphere

Start with a light wash of Cerulean Blue, then, working wet-on-dry, add wavy strokes of Lemon Yellow and Viridian with a no. 1 round. Keep building up the wavy texture in layers, letting each layer dry before painting the next. For the pearl at the center, paint the shadows with Sap Green muted by a touch of Payne's Gray.

5 Watery Textures

Continue darkening the sphere with wavy strokes of varying shades of Lemon Yellow, Viridian and Cerulean Blue. With a no. 0 round create texture to suggest smaller bubbles, letting the previous layers of color show through the center and painting around the little bubbles.

Use the nos. 1, 2, 3 and 4 rounds to add a bubbly texture to the watery areas outside the sphere. Enhance the random patches of washes and salt splotches by painting around them. Further exaggerate irregularities by lifting out color from the centers and along the edges of the textured waves, smoothing them out into the surrounding color.

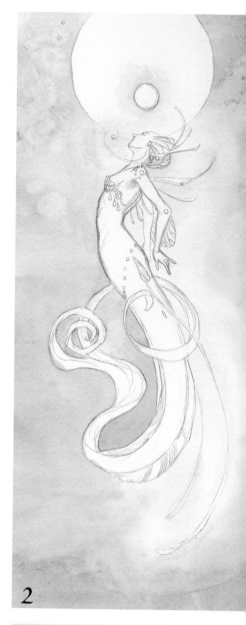

2

Minimize Mistakes With Masking Fluid

If you have trouble painting around the mermaid's long glowing tendrils, apply some masking fluid over the area before you apply any washes. Let the masking fluid dry completely before you start to paint. However, it is always better if you can pull it off without resorting to the masking because it will leave smoother borders that feel more natural than the hard and jagged edge masking fluid will leave.

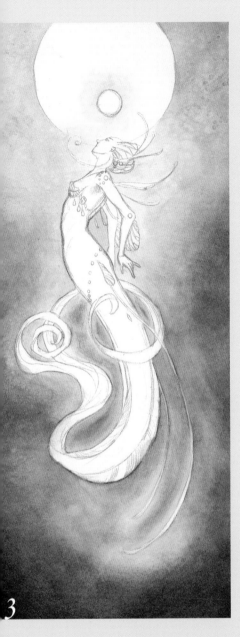

3

4

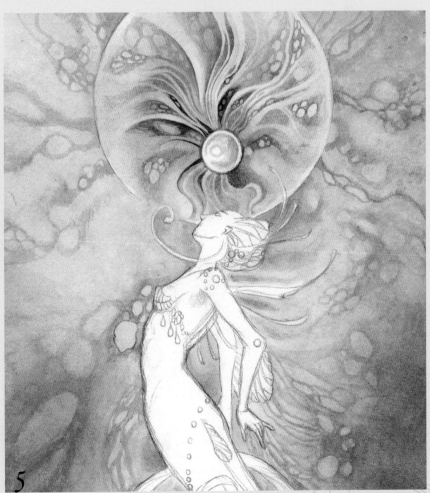

5

6 Create the Shadowy Underlayers

Working wet-on-dry, lay an undercoat of Ultramarine Blue on the shadows of her body with a no. 1 round. Blend it along the edges. Apply a wash of Viridian for the base color of the tail with a no. 2 round.

7 Building the Mermaid's Form

Darken the tail with a mixture of Prussian Blue, Viridian and Lamp Black. Apply darker and more concentrated color toward the tail's end, fading the color to a lighter bluish-green toward her hips with the no. 2 round. Add a hint of fleshtone to her skin with a no. 2 round and a mixture of Permanent White Gouache, Cadmium Red and Cadmium Yellow. Applying the opaque white over the underlayer of blue and green will give her skin an eerie chalky look. (If you'd rather give her skin a warmer look, leave out the white and just paint shadows with Cadmium Red and Cadmium Yellow.) Using Cadmium Yellow and Lemon Yellow, paint some of the jewelry details with a fine no. 0 round.

8 Add the Finishing Touches

With a no. 0 round, use feathered parallel strokes to paint the texture on the fins along the side of her tail with a mixture of Lamp Black and Viridian. Use the same mixture to paint the texture of scales along her tail, changing to Lemon Yellow for some highlights closer to her waist. Outline the fins along the side of her tail with Lemon Yellow to keep them from melting into the background.

For the trailing tail fins, start with a base wash of Sap Green, and then add textured streaks with parallel lines in Lamp Black and Viridian with a no. 0 round. Because the fins are translucent, add some darker streaks in the parts that cross on top.

Using a no. 0 round, finish off the fins on her head and arms with more of the Lamp Black and Viridian mixture. Let the white of the paper show through the spines of those fins.

Add a touch of Sap Green to the markings on her shoulder, arm and the jewels in her hair with a no. 0 round.

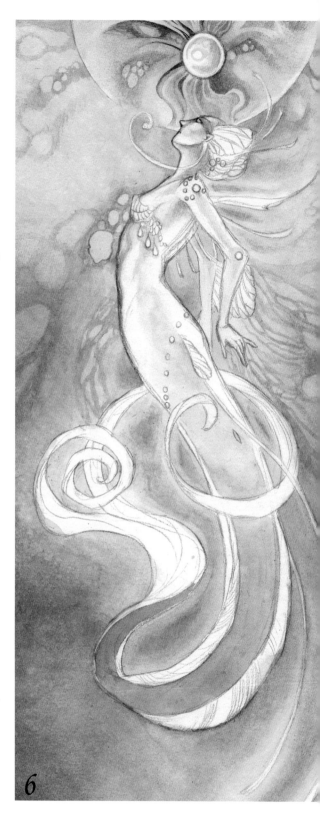

6

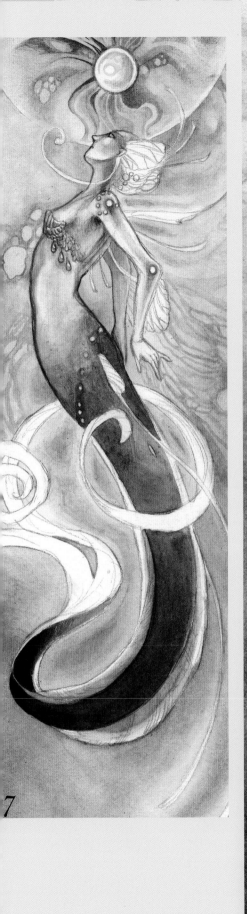

7

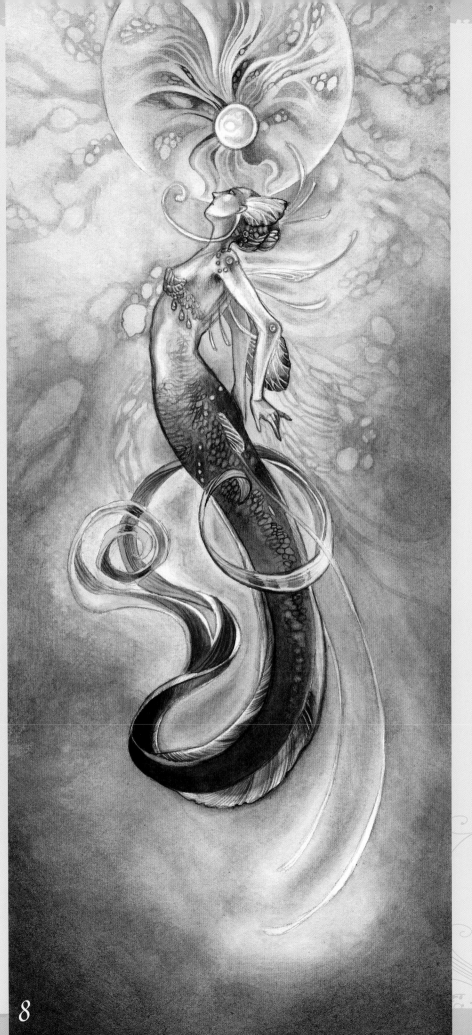

8

Mermaid on land
WHERE THE SEA MEETS THE SKY

Even in paintings where the surface is not visible, the sky far above is a presence that looms beyond the world of the sea denizens. Sometimes we only hint at the sky by the glow of light suffusing from above. Other times, for a more defined presence, we create the actual water's surface viewed from far below, or the waves from above as a mermaid slips up from the depths to the air and sky of the world beyond her element.

PAINTS

Brown Madder, Burnt Umber, Cadmium Red, Cadmium Yellow, Cerulean Blue, Cobalt Blue, Naples Yellow, Prussian Blue, Sap Green, Ultramarine Blue, Viridian

MATERIALS LIST

½-inch (12mm) flat, illustration board, nos. 0, 2 and 4 rounds, pencil, rubbing alcohol, toothbrush

1 Sketch the Drawing and Establish the Sky and Sea

Sketch the composition with a pencil then paint a graded wash of Cobalt Blue in the sky with a ½-inch (12mm) flat. Darken the upper corners with extra layers of Cobalt Blue, letting each layer dry before applying the next. Working wet-into-wet, paint the water's surface with Cerulean Blue with a no. 4 round. Let the white of the paper show through on the ripples for reflected light. For the underwater portion, apply a wash of Ultramarine Blue. Create the initial texture of bubbles and the rock and coral formations by speckling the wet wash with rubbing alcohol from a toothbrush.

2 Add the Surface Ripples and Underwater Murkiness

Add ripples to the water, working wet-on-dry to create patches of reflected blue sky with Cerulean Blue and a no. 2 round. Leave lots of white for the concentric rings of ripples flowing out from her body and the rock she clings to.

For the underwater portion, paint a graded wash of Prussian Blue from the bottom with a ½-inch (12mm) flat. Sprinkle rubbing alcohol with a toothbrush over the underwater area. Add more texture along the upper part of the rocks with a smaller round, working wet-into-wet. Avoid creating sharply defined edges so the underwater portion seems more hazy and murky than the clear, upper-half of the painting.

3 Add the Coral and Rock Textures

Mix a little Brown Madder with Prussian Blue and paint around the bright spots created by the rubbing alcohol with various sized round brushes. Use a combination of drybrush and wet-on-dry techniques with a small brush to add detailed textures to the underwater rocks.

Mix a basecoat of Cadmium Red and Prussian Blue and paint this on the rock the mermaid is clinging to, working wet-on-dry with a no. 4 round. The application of the paint does not have to be smooth. Let the paint overlap dried areas, leaving bits of white for sparkle and highlights.

4 Add More Rocky Details

Add details to the rock with a more concentrated mixture of Cadmium Red and Prussian Blue. Take the nos. 0 and 2 rounds and paint the shadows with a combination of drybrush and wet-on-dry techniques to emphasize the texture.

1

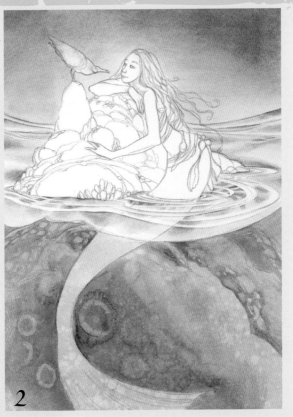

2

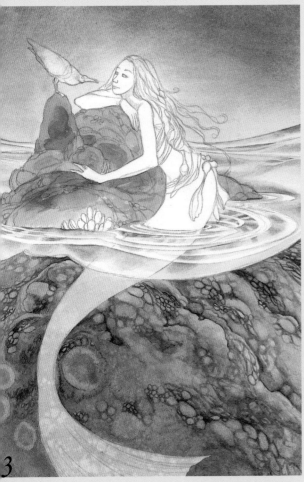

3

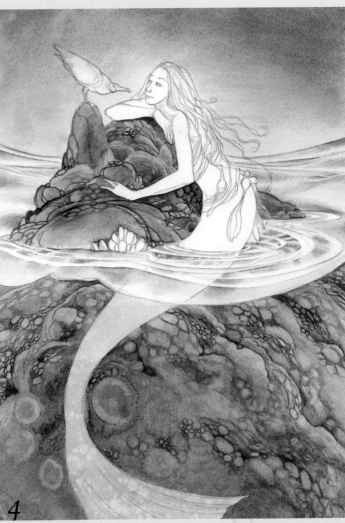

4

5 Add Hints of Greenery

With a ½-inch (12mm) flat, drybrush Sap Green over the upper parts of the rocks so they don't look so barren. Add bits of green reflection in the ripples. When that layer has dried, add detailed mossy bits with a no. 0 round and Viridian.

With a ½-inch (12mm) flat, drybrush Viridian to the upper parts of the underwater area so a little bit of the surface colors are echoed below. This helps to pull together the separate elements of the picture.

6 Add a Basecoat to the Mermaid

Paint a layer of Sap Green on the shadows of her body and along her tail with a no. 4 round. You can use smaller sizes as you work up her body and in narrower areas. You don't need to avoid the seaweed on her hips because they will also be greenish in tone. Adding just a hint of the sea to her skin will keep her from looking sickly. Do this by diluting the colors in her upper body and using more concentrated colors in her tail. Leave some of the blue showing through on the tail layers.

7 Create the Skin Tone

Apply a very diluted wash of Brown Madder over most of the skin of her upper body. Apply a more concentrated Brown Madder wash with a no. 2 round for the shadows of her skin. Let the Brown Madder fade into the darker greens below her hips so that there is a smooth transition of colors. Work in the details of her eyes and eyebrows with Burnt Umber with a no. 0 round.

8 Refine the Tail and Add Scales

Mix Viridian with Prussian Blue and add shadows and details to her tail with a no. 2 round. Where her tail is above the water's surface, make the colors lightest toward the sides and deepest in the middle. Let the colors blend outward to avoid hard edges and lines. Define the scales by drawing in their shadows with a no. 0 round and Viridian. Pull out the highlights by lifting the color from the edges of the scales.

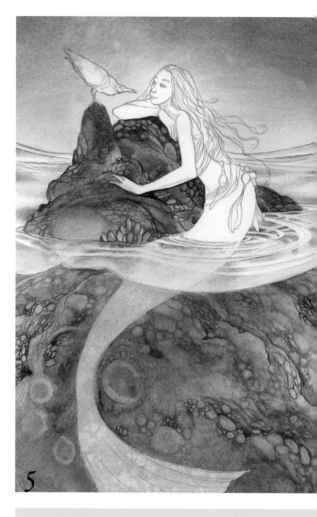

5

Tips for Seated and Reclining Poses

Even though a mermaid doesn't have the bones of human legs in her lower half, it's still helpful to imagine them there as guidelines for your design. To sit upright is a very human posture. Ideals of human aesthetic beauty are programmed in our brains. To adapt a mermaid to such a pose you have to keep these human norms in mind. For example, you don't have to draw her as if she has knees, but if you make the tail bend at a sharp angle close to where she's bending at the waist, her tail will look boneless and snakelike.

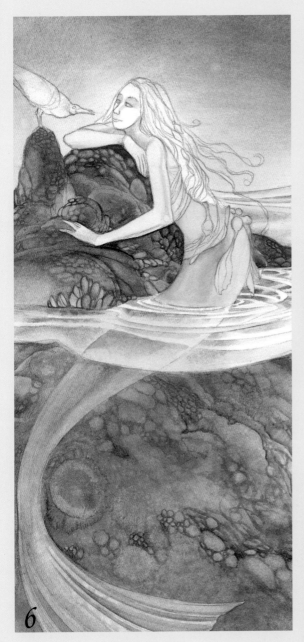

6

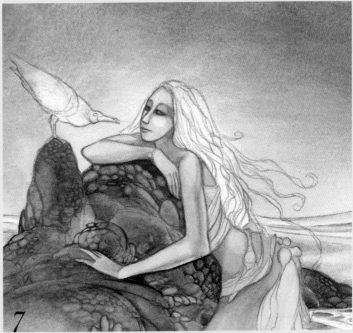

7

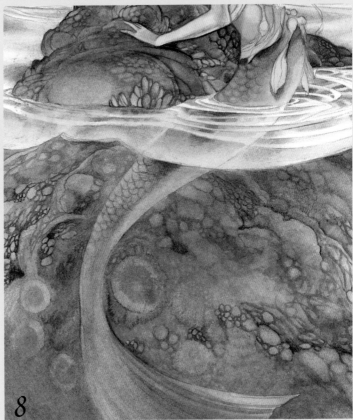

8

9 Detail the Mermaid's Upper Body

Use Prussian Blue to add more shadows and definition to the scales on the portion of her tail above water. Add details of the seaweed around her body with Naples Yellow using a no. 0 round.

10 Create Her Hair's Shadows

Paint shadows in her hair with Brown Madder and a no. 0 round. Don't paint the strands themselves, instead paint the darker areas in the curls and locks between the strands.

11 Add the Final Details

With a no. 0 round, paint a wash of Cadmium Yellow over her hair to give her golden locks. Finish off the seagull with a Cadmium Yellow beak and legs. Add shadows to its body with Ultramarine Blue. Add a very diluted wash of Cadmium Yellow across the top of the seagull's body.

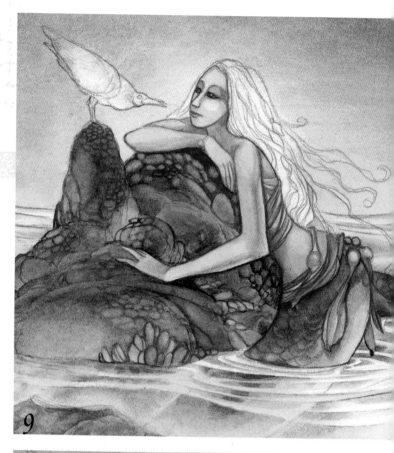

9

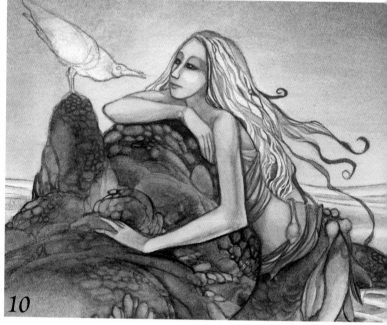

10

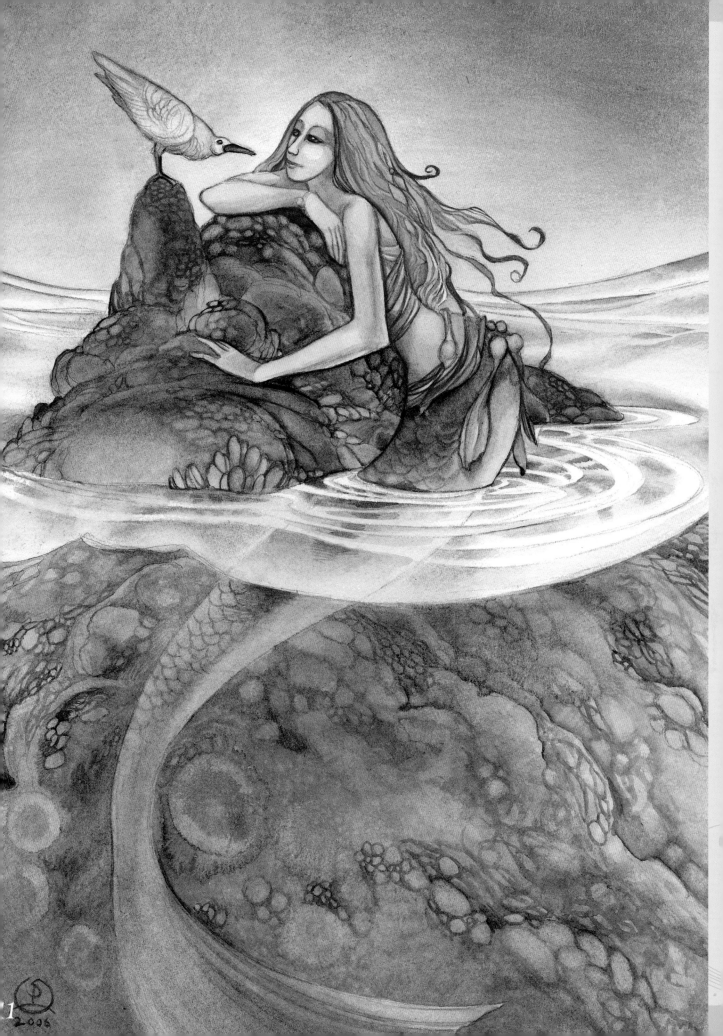

Bringing it all together
SEA VAPORS

From her cavern, she weaves her deep sea magic. She is a guardian of the deep. Her songs protect the denizens who live far from the reach of those who walk on land.

PAINTS

Brown Madder, Burnt Umber, Cadmium Red, Cadmium Yellow, Cerulean Blue, Cobalt Blue, Cobalt Violet, Dioxazine Violet, Lemon Yellow, Naples Yellow, Prussian Blue, Sap Green, Viridian

MATERIALS LIST

½-inch (12mm) flat, illustration board, nos. 0, 1, 3 and 4 rounds, pencil, rubbing alcohol, toothbrush

1 Sketch and Add the Glows

Sketch the composition with a pencil. Use a no. 4 round to lay in a wash of Lemon Yellow around the mermaid's upper body and the wispy bits from her bowl. Keep the paint very diluted so that you can let it fade to white at the edges.

2 First Layer of Blues

Mix Cerulean Blue with Prussian Blue and wash in the background water with a ½-inch (12mm) flat. Paint directly over the seaweed, but keep it lighter around the fish and near the glowing areas. It may take several layers of very pale washes to build the color without showing hard edges. Don't worry about irregularities in the smoothness of the wash especially near the seaweed. In fact, toss in some splashes of rubbing alcohol with a toothbrush to add more bubbled textures across the background.

3 Build Up the Blue Waters

Keep working in layered washes. Mix Cerulean Blue and Viridian for a more verdant tone and lay in more color toward the edges with a ½-inch (12mm) flat. Keep it lightest in the area near the yellow glow around her upper body.

4 Darken the Corners

Darken all the corners with a wash of Dioxazine Violet using a ½-inch (12mm) flat. Let the wash extend into the coral in the lower areas.

5 Begin the Seaweed

Mix Prussian Blue, Burnt Umber and Viridian and work wet-on-dry to create the seaweed masses in the background with a no. 3 round. Once some of the more distant seaweed has dried, run clean water on a ½-inch (12mm) flat and brush over the seaweed to soften and fade it into the background.

1

Color and Composition Tip

Composition dictates how a viewer looks at a piece, but another vital part of guiding your audience's eye is with color. Placing complementary colors adjacent to each other will make the contrast more obvious. In this painting, by keeping the background confined mostly to cool blues and purples, the warm, golden tones of the mermaid and the foreground elements really draw her forward so she becomes the focus of attention. Purple/yellow are complementary colors, as are blue/orange. Once you have the viewer's eyes on your focal point, you can use compositional placement of shapes and forms to guide the path of interest through the picture and give the whole piece a flow.

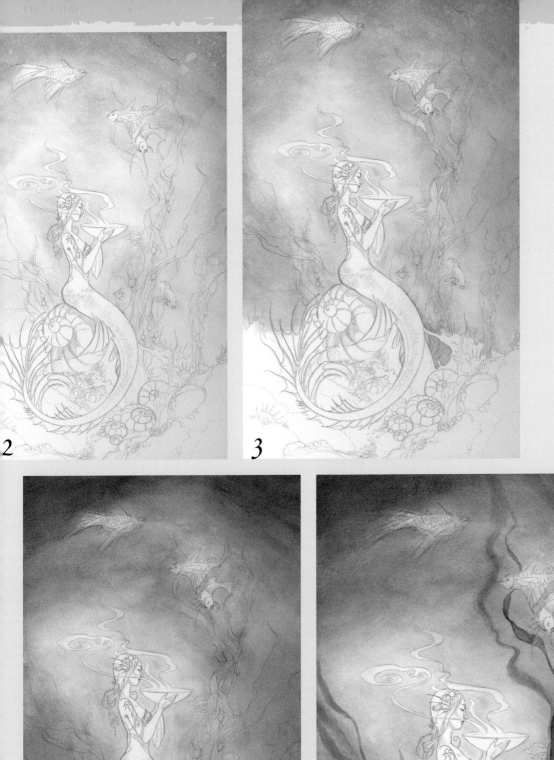

2

3

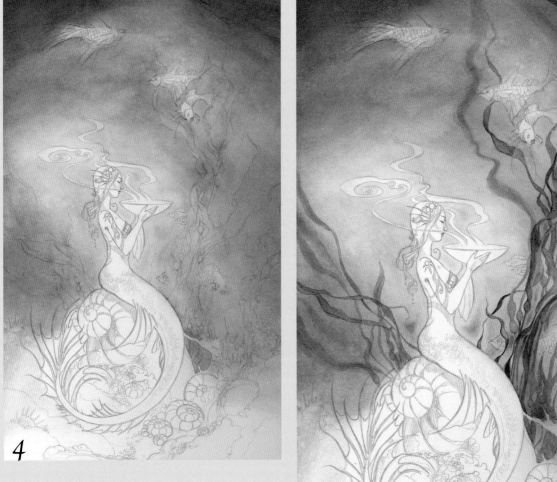

4

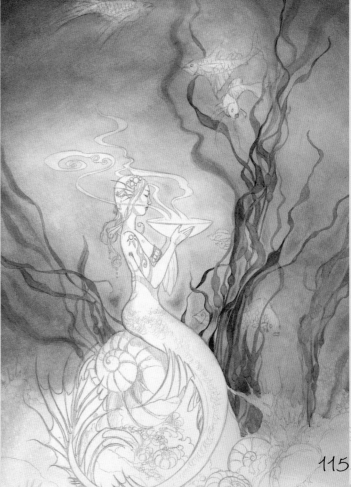

5

6 Finish the Seaweed

Darken the seaweed that's closer to the foreground and make the edges more distinct by painting them with varying mixtures of Prussian Blue, Naples Yellow and Viridian using a no. 1 round. With a wet, clean no. 1 round, lift out some color to form highlights.

7 Apply the Basecoat for the Coral

Paint a wash of Dioxazine Violet in the lower coral and rocks with a ½-inch (12mm) flat. Liberally splatter rubbing alcohol for texture with a brush and toothbrush. Keep the colors darkest toward the corners.

8 Add Texture to the Coral

Mix Viridian and Dioxazine Violet and use a no. 4 round and a combination of wet-on-dry and drybrush techniques to create the coral's texture. For variation and a more greenish tone, add a bit of Naples Yellow and Sap Green in some places. Paint around the little barnacles, shells and pebbles. Darken the shadows under her tail and the larger shells.

9 Keep Adding Details to the Coral

Continue picking out the details in the foreground. The closer the coral is to the foreground, the more fine detail you should show.

10 Add Some Contrasting Color

To add some spice to the background, apply Naples Yellow to the seashells' spirals with various small sized rounds. Make the color more intense towards the center of the shells and fading to white at the edges. Since yellow is the complementary color of purple, the shells will pop out from the coral beds.

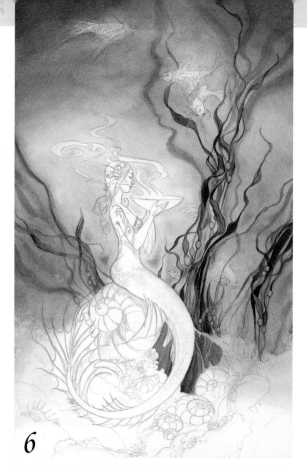

6

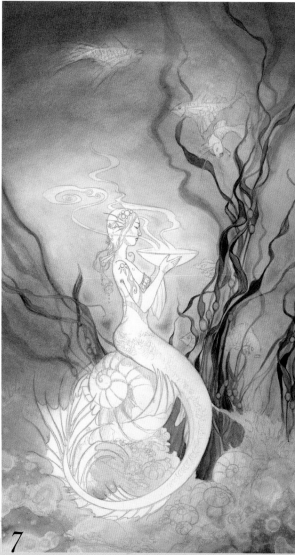

7

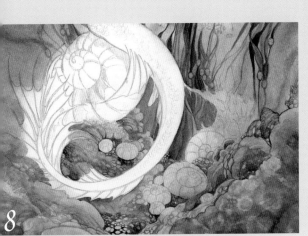

8

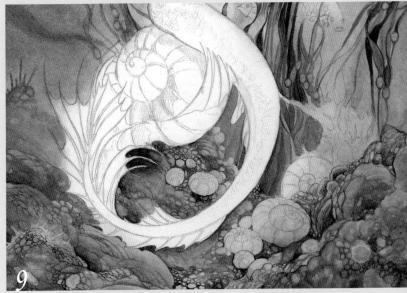

9

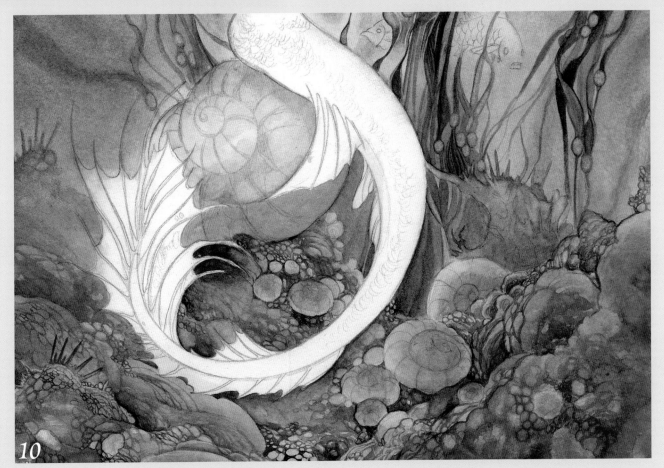

10

11 Add Shadows to the Seashells

Add Brown Madder to the shadows on the spiral seashells with a no. 0 round. These reddish shadows will help blend in the seashells and make them jump out a little from the purple coral beds while remaining part of the image. With a no. 0 round, trace a thin line of Viridian along the line of the spiral. Since green is the complementary color of red, this adds a little jolt of sharp contrast to the shadows.

12 Add Details to the Seashell

Continue filling out the details on the seashells with more concentrated Brown Madder and Naples Yellow and a no. 0 round. For the shadows, swipe a layer of Dioxazine Violet with a ½-inch (12mm) flat under the big shell the mermaid is seated on.

13 Create the Fish Scales

Paint the scales on the fish with a no. 0 round and Cobalt Blue.

14 Finish the Fish

After the scales dry, run over them with a no. 2 round and a very pale wash of Cobalt Blue to soften the edges of the scales' shadows. For the fish closer to the mermaid's glow, use a wash of Naples Yellow.

15 Apply the Mermaid's Basecoat

Apply several underlayers for the mermaid. For her skin, paint the shadows with diluted Cobalt Blue and a no. 2 round, keeping the paint pale. Lay in a wash of Naples Yellow on her tail and fins with a no. 2 round. Let it fade out to the white of the paper at the fin's edges. For her gold jewelry and bowl, apply a mixture of Cadmium Red and Brown Madder with a no. 0 round and leave plenty of white showing through. Add a little bit of Cadmium Yellow to the back of her hair for a reflected glow with a no. 0 round.

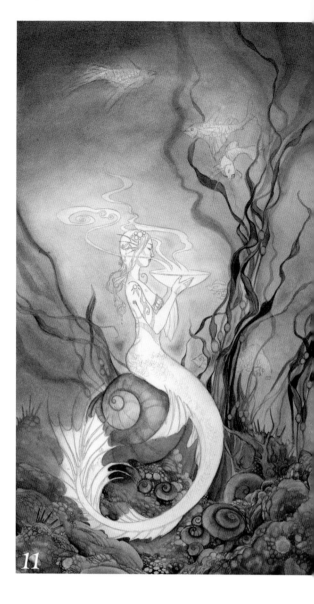

11

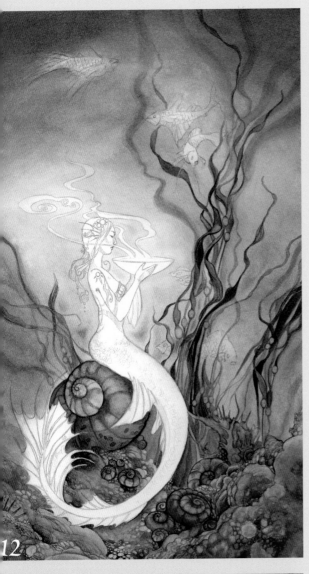

12

13

14

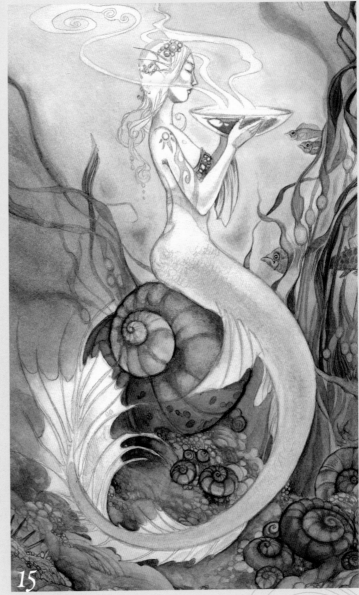

15

16 Complete Her Skin

Paint a wash of Cobalt Violet mixed with Cadmium Yellow over her skin with a no. 2 round. Keep the highlighted areas such as her cheekbones, shoulder and upper arms very light. Darken the end of the tail with a mixture of Dioxazine Violet, Prussian Blue and Burnt Umber. Let the color fade up to the Naples Yellow area toward the top. You may need to do about three layers (letting each layer dry before applying the next) to build up the intensity of color. Use a concentrated version of this mixture and a no. 0 round brush for the dark spines of her tail fins.

Emphasize the skin's shadows with Brown Madder. Use a no. 0 round to line certain edges and create the deep shadows at the back of her neck, under her chin, arm and elbow. With a no. 1 round paint the markings on her back and arm with a wash of Cadmium Yellow. Work wet-into-wet to add variations, making some areas warmer with a hint of Cobalt Violet and Brown Madder.

17 Add Texture to the Tail and Fins

Add texture to the scales of her tail by painting a crosshatched pattern with a no. 0 round, following the rounded contour of the tail. Use Burnt Umber for the upper areas near her waist and use a more concentrated mixture of Burnt Umber, Dioxazine Violet and Prussian Blue for the lower parts of her tail. When the lines have dried, lift out some of the color from the center of a few scales with a no. 1 round to make them shimmer with light.

Darken the inner parts of her fins with more Naples Yellow washes with a no. 1 round. With a no. 0 round, add some detailed lines with more concentrated pigment to give them texture. Add hints of Dioxazine Violet to the wash at the tip of her tail where the fins overlap the seashell. Keep the edges of the fins white.

18 Paint the Gold and Hair

Apply a wash of Cadmium Yellow over the red areas of the bowl and jewelry with a no. 1 round, leaving the white highlights at the edges. Paint her hair with the same black mixture used for her tail with a no. 0 round. After the initial layer dries, lift out a few strands of highlights.

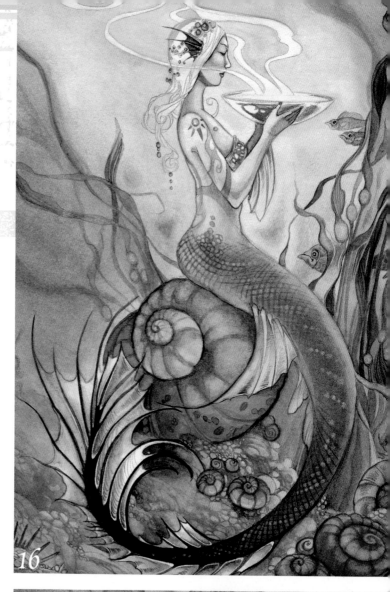

16

17

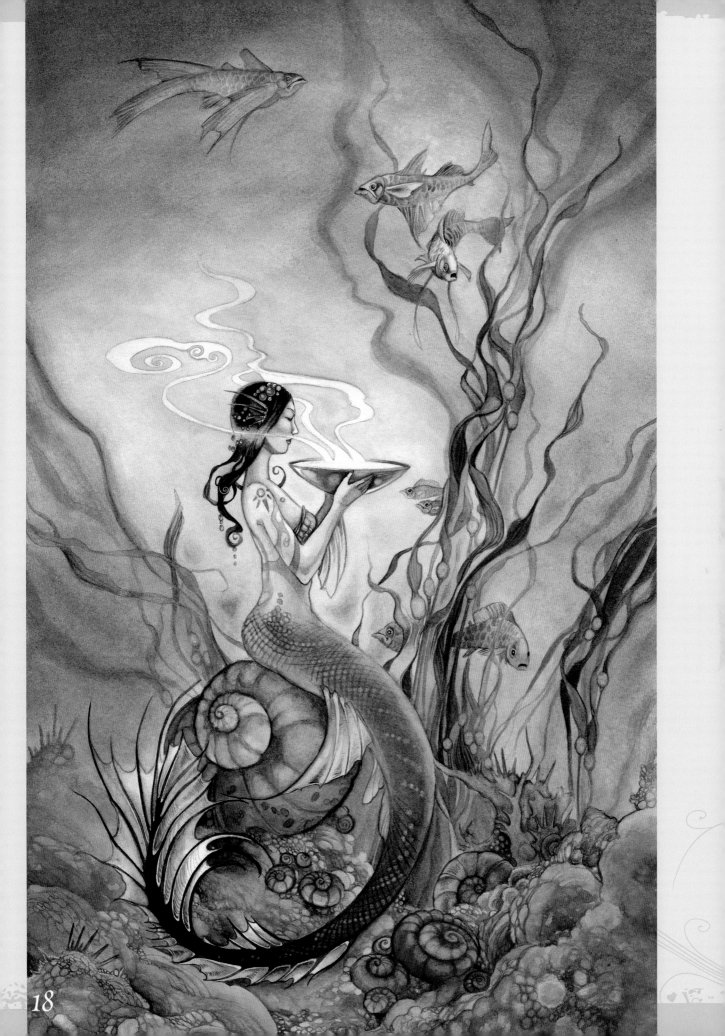

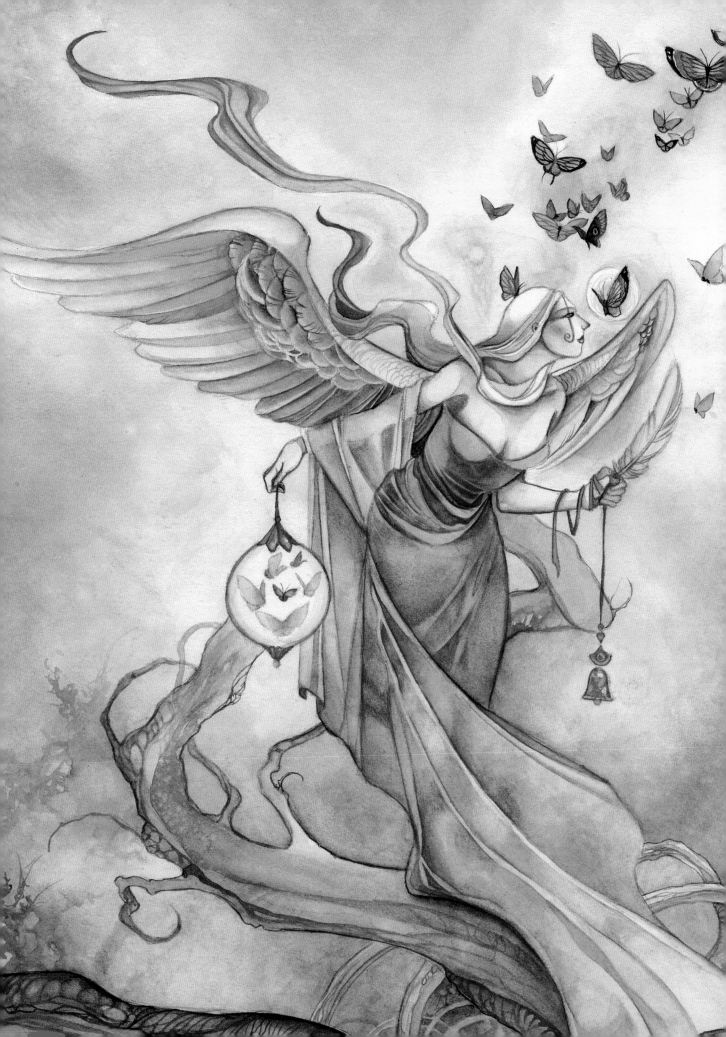

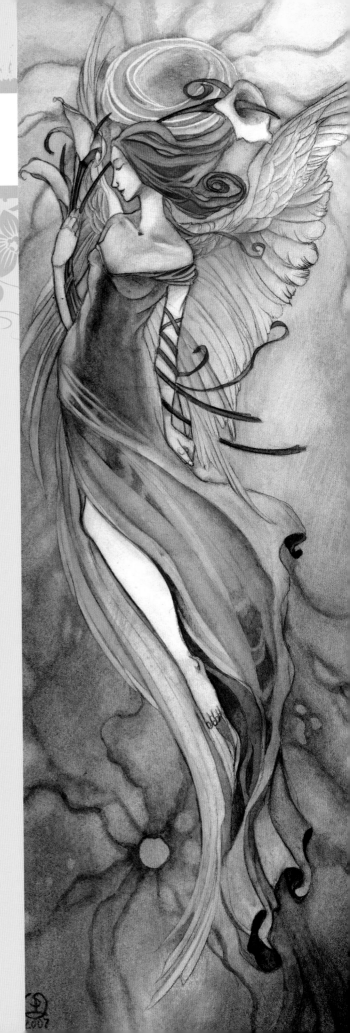

Part Four
ANGEL REALMS

There is a note that wavers through
the warp of weft of past and now
and quivers in a golden thread
stretched out towards future's bow.

A memory of divinity
deep-etched in blood and mind
that yearns for a perfection
beyond all earthly kind.

Angels are immortal beings that can be found in many religions.
They act as messengers, harbingers to the human plane. They act as
guardians. They are spiritual manifestations for divine intervention.
They are beings of light and fire and ineffable beauty. They are the
medium to enact God's will upon the world. As such, their beauty
can be a terrifying thing as well.

Wings and Feathers

BIRDS ARE A GREAT REFERENCE POINT FOR constructing angel wings. Birds are easy to observe because they're everywhere (although getting them to sit still can be difficult). Get a closer look at a pet parrot, birds in the zoo or even city-dwelling pigeons. Bring a digital camera with you to take some pictures of closed wings, of wings stretched open and of wings in flight. Remember that angel wings do not have to be limited to white, the plumage of colorful tropical birds are also a great source of inspiration.

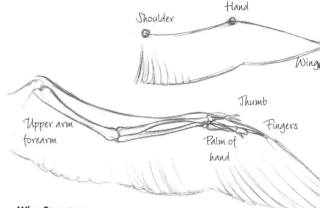

Shoulder · Hand · Wing · Thumb · Fingers · Upper arm forearm · Palm of hand

Wing Structure

Use a human arm as the underlying structure of a wing. Connect the muscles to make a smooth curve from the shoulder to the hand. Notice there isn't as much of a crease at the elbow as in the human arm, so the prominent angles are the shoulder, hand and wing tip (which extends far beyond where the fingers actually end). The feathers give a tapering triangular shape to the wing overall.

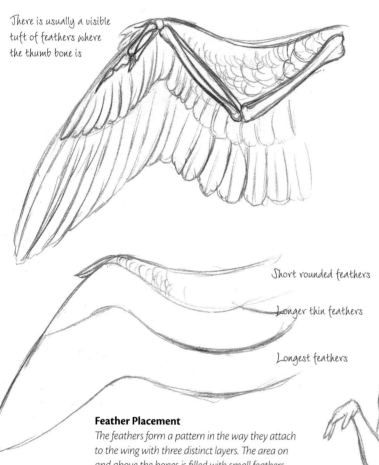

There is usually a visible tuft of feathers where the thumb bone is

Short rounded feathers

Longer thin feathers

Longest feathers

Feather Placement

The feathers form a pattern in the way they attach to the wing with three distinct layers. The area on and above the bones is filled with small feathers in a scale-like pattern. Below that, longer pinions follow the angles of the bones, followed by a layer of even longer feathers. The long primary plumes are those that are supported by and connected to the hand. The bone structure influences the overall shape of the wing, creating an arched curve of feathers below the arm area.

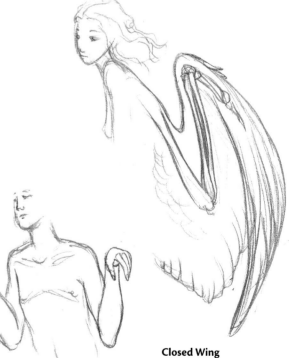

Closed Wing

Understanding how the bones move underneath the feathers can help you figure out how to draw wings. When the wings are closed, the "arm" is tucked up with a bent elbow and the hand curling back in.

124

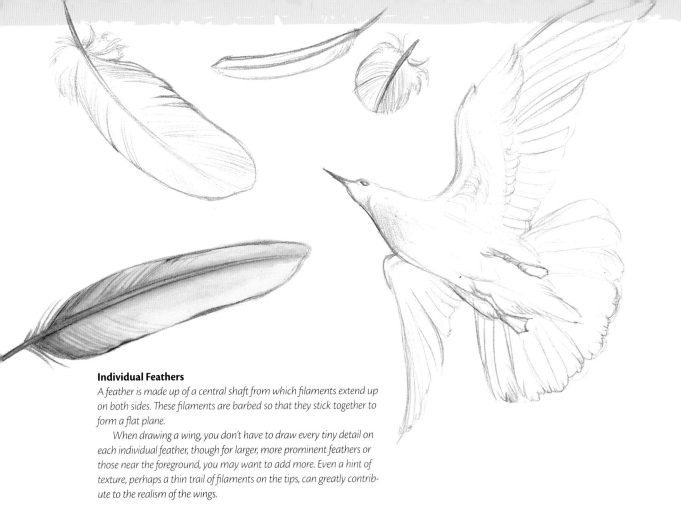

Individual Feathers

A feather is made up of a central shaft from which filaments extend up on both sides. These filaments are barbed so that they stick together to form a flat plane.

When drawing a wing, you don't have to draw every tiny detail on each individual feather, though for larger, more prominent feathers or those near the foreground, you may want to add more. Even a hint of texture, perhaps a thin trail of filaments on the tips, can greatly contribute to the realism of the wings.

Sketching Feathers

To create long, feathered wings, overlap elongated wing tip feathers. To form soft, downy feathers, overlap the smaller feathers by softening the round edges with a bit of a ruffled contour. This also works as a shortcut, but avoid hard edges to keep your finished wing from looking more like fish scales than feathers.

Long feathers

Short, downy feathers

Sketches of feathers

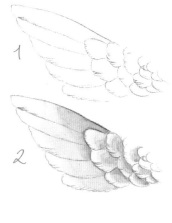

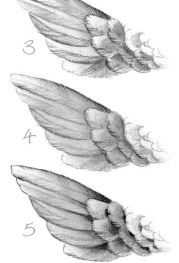

Painting Feathers

1 Sketch the feathers with a pencil.

2 Work wet-on-dry to paint the major shadows. Blend the color from the dark shadows to the edges of each feather by diluting the paint with water.

3 With a more concentrated version of the color from step 2, dry-brush texture on the feathers. Follow the contours of the filaments along each feather's shaft.

4 Smooth out the drybrushed texture with a wash of clean water over everything.

5 Go back and add a few more defining shadows with some contrasting color. If it starts to look too sharply defined, swipe with a clear wash of water.

Wing Proportions

YOU DO NOT HAVE TO CONFINE YOUR RENDITIONS to the limits of physical reality. After all, an angel is a being of spirit and its wings are symbolic. They are manifestations of an angel's celestial nature—they mark the angel as a creature not of this earth, but one that transcends mortal bounds and mortal gravity.

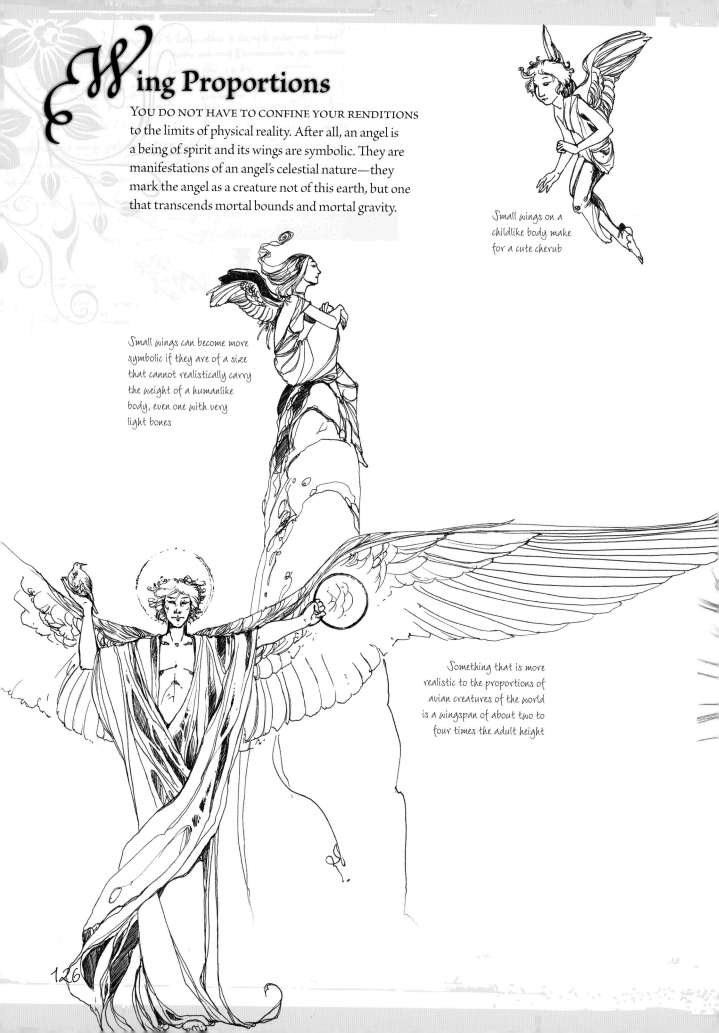

Small wings on a childlike body make for a cute cherub

Small wings can become more symbolic if they are of a size that cannot realistically carry the weight of a humanlike body, even one with very light bones

Something that is more realistic to the proportions of avian creatures of the world is a wingspan of about two to four times the adult height

Wing Placement

PLACEMENT OF FAERY AND ANGEL WINGS IS very similar. Use the shoulder blades as a guideline for the initial location. The muscles of the wings connect at the shoulders in a slight V-shape that angles toward the base of the spine. Place the wings along the curve of the shoulder blades from just below the shoulder and down, falling about three-quarters of the way down the back. Small, downy feathers can soften up the transition of the wing to the skin, covering up the area across the shoulders, the nape of the neck or even into the hair.

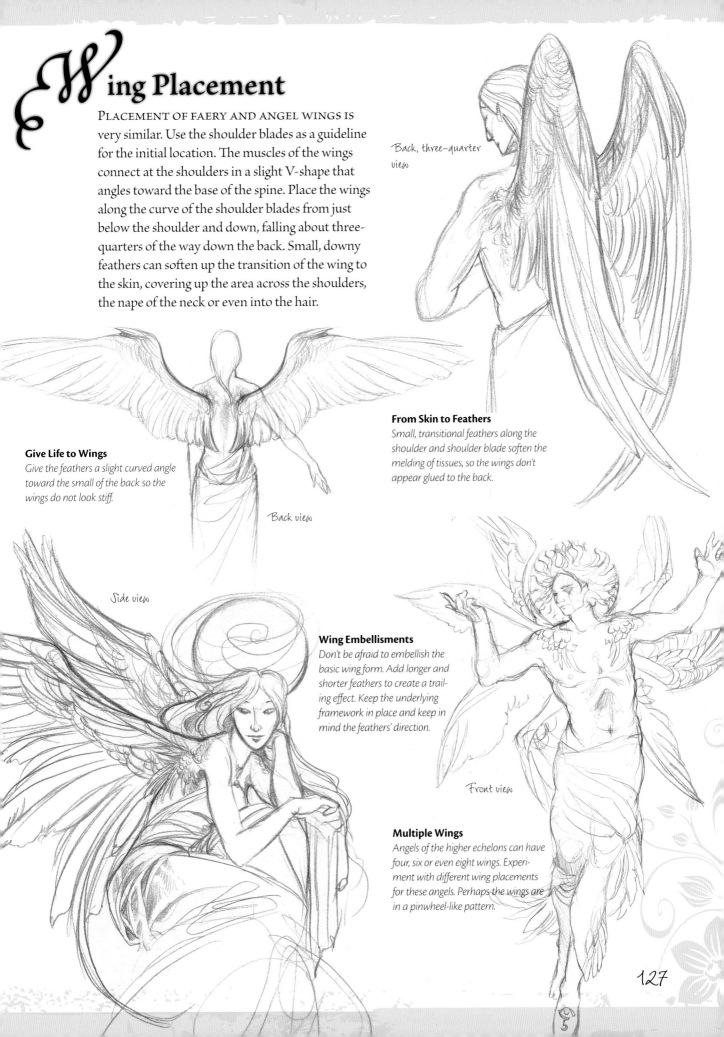

Back, three-quarter view

Give Life to Wings
Give the feathers a slight curved angle toward the small of the back so the wings do not look stiff.

Back view

From Skin to Feathers
Small, transitional feathers along the shoulder and shoulder blade soften the melding of tissues, so the wings don't appear glued to the back.

Side view

Wing Embellisments
Don't be afraid to embellish the basic wing form. Add longer and shorter feathers to create a trailing effect. Keep the underlying framework in place and keep in mind the feathers' direction.

Front view

Multiple Wings
Angels of the higher echelons can have four, six or even eight wings. Experiment with different wing placements for these angels. Perhaps the wings are in a pinwheel-like pattern.

127

Painting white wings
ANGEL OF BLESSINGS

White is the most difficult color to paint, especially in a transparent medium like watercolor. The absolute brightest white will be the surface of your paper around which you'll build highlights, shadows and reflected color. White is nothing if you don't define it by its surroundings.

In this demo, you will practice painting the different colors that surround the wings in order to define them.

PAINTS

Burnt Sienna, Burnt Umber, Cadmium Red, Dioxazine Violet, Naples Yellow, Payne's Gray, Prussian Blue, Raw Sienna, Ultramarine Blue, Ultramarine Violet

MATERIALS LIST

½-inch (12mm) flat, illustration board, nos. 0, 1 and 2 rounds, paper towels, pencil

1 Sketch the Composition
With a pencil draw the angel so the wings curve around her body, cradling it in an embrace. This is a more advanced angle to draw because, instead of both wings resting on a flat plane, her right wing comes straight out toward the viewer and her left wing recedes toward the back.

Since they curve inward, draw the wings' inside surface close to her body. Draw the outer surface of long, trailing feathers at the tip of her wingspan.

2 Add the Background Wash
With a ½-inch (12mm) flat, paint a wash of Raw Sienna in the background. Use a no. 2 round to get to the tight corners underneath her left wing. Keep the color diluted near the top of her head for a bit of a halo and darker toward the corners. If needed, do this in two or three layers of washes, letting each layer dry before applying the next.

3 Add a Basecoat to the Skin
With a no. 1 round, add an underlayer of Ultramarine Violet for the shadowy areas of her skin. Blend the shadows outward into the highlight areas. For delicate areas like her eyelashes and lips, use a very fine size no. 0 round and Dioxazine Violet.

4 Add the Skin Tones
Mix Cadmium Red and Burnt Umber and paint a wash over all of her skin with a no. 2 round. Save a few highlights on her cheekbones, nose, eyelids and the back of her hand. Add a mixture of concentrated Cadmium Red and Burnt Umber to her lips with a no. 0 round to give them color.

5 Add Shadows and Highlights
Finish her skin with a diluted Prussian Blue. Using a no. 0 round, lightly drybrush the deepest shadows along the left side of her hair and clothing, at her elbows and under her left wrist and palm. The Prussian Blue will produce the darkest shadows while adding a liveliness to the skin as it interacts with its orange complement.

Add some highlights to the top of her hair, tendrils and along the edges of her clothing with Naples Yellow working wet-on-dry with a no. 0 round.

6 Basecoat the Hair
Create a black by mixing Ultramarine Blue with Burnt Umber and apply as a basecoat to her hair with a no. 2 round. Let the color blend into the edges of the Naples Yellow highlights.

7 Add Shadows to the Hair
With a more concentrated mixed black and a no. 0 round, add texture and form to the hair by painting the shadows around the strands. For some extra dark areas, add some Payne's Gray to the mixture.

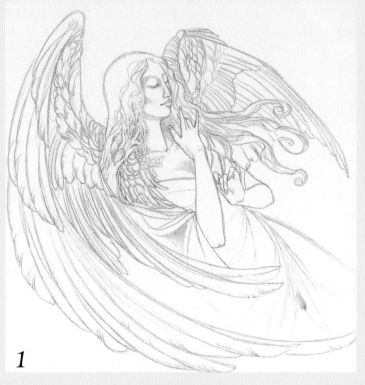

1

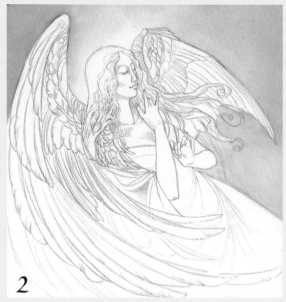

2

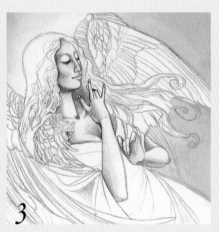

3

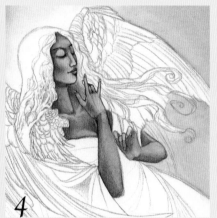

4

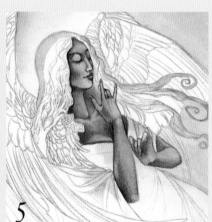

5

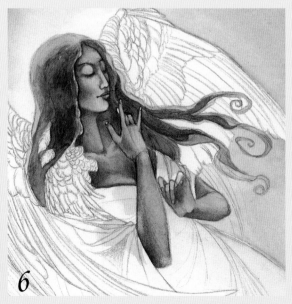

6

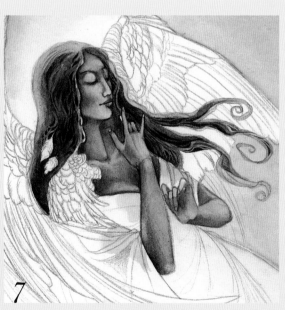

7

129

8 Add a Basecoat for the Clothing
Paint in the shadows of the folds and wrinkles on her robes with Ultramarine Violet and a no. 2 round.

9 Paint the Robes
Paint a wash of Cadmium Red over her robes with a no. 2 round. When that dries, darken the deepest folds (under her right elbow, along the edge of her right sleeve and in the creases at her waist) and corners with Burnt Umber and a no. 0 round.

10 Begin the Wings
With a no. 2 round, lay in a very pale wash of Burnt Sienna along all the shadowy edges of the feathers. This will reflect the dominant golden tones. Keep a lot of the white of the paper showing through for highlights.

11 Paint the Inner Side of the Wings
The feathers on her right shoulder are very tiny, some so small they're more like scales. Take a no. 0 round and drybrush variations of Ultramarine Violet mixed with Burnt Sienna along the inner edge of each feather. Let the brushstrokes follow the direction of each feather's filaments. Let the white of the paper show through the outer edge of each feather so that it overlaps the feather below.

Similarly drybrush the larger feathers of her extended wings, using Burnt Sienna on her left wing. For her right wing, mix in the darkest parts with Burnt Umber. Again, be careful to leave the white of the paper showing on the outer edge of the feathers.

If your drybrush strokes look too harsh or ragged, then take a slightly larger brush and swipe a wash of clean water over the whole area and then dab up the excess liquid with a paper towel.

12 Add Shadows to the Back of the Wings
Mix a bit of Ultramarine Blue with Ultramarine Violet and use a no. 2 round to apply washes of purple along the back of her wings. Using purple here lets you pick up the color of the shadows and basecoats. With a no. 0 round and a more concentrated paint, lightly drybrush some texture along the edges of the long trailing feathers. If the strokes become too ragged, wipe over them with clean water and dab up the excess liquid with a paper towel to smooth the edges.

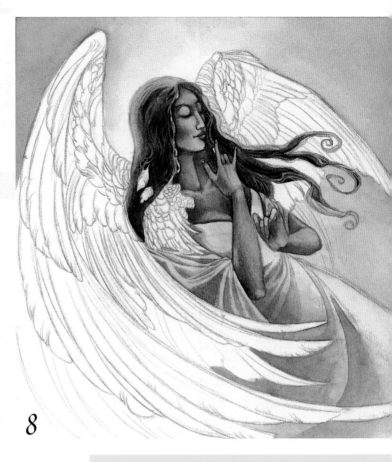

8

Wing Shadows
White objects still have shadows and highlights, but they aren't created by painting a dead gray tone. White shadows are a result of the reflected colors all around. This is why it's best to leave the wings for the last stage. The red of her robes, the brown of her skin and hair, the yellow of the background, the purple underlayers—all will affect the whiteness of her wings.

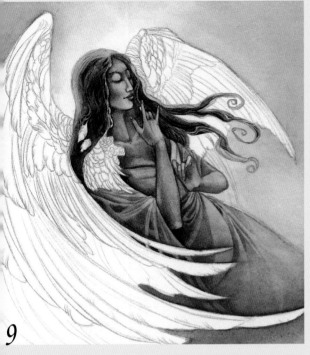

9

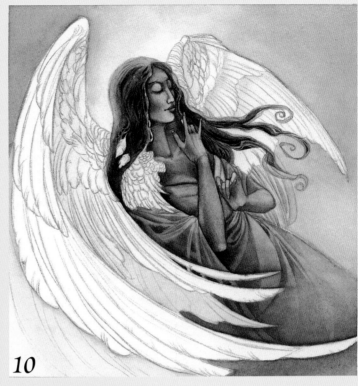

10

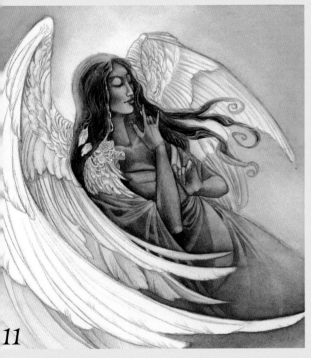

11

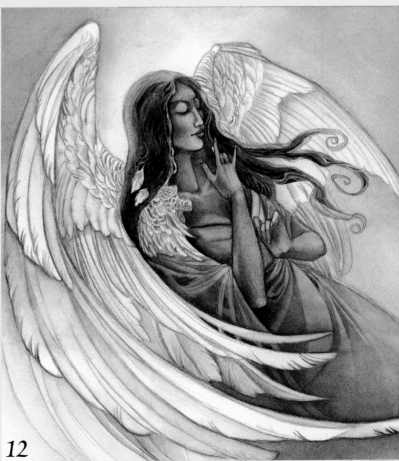

12

Composition Tip

By painting the back of her wing with yellow's complementary color, purple, you create a visual cup that focuses the viewer's eye on the central area of the angel's face and hands. In fact, the curve of all of the feathers serve this purpose because they all point toward her hands, which, in turn, bring the viewer's eye up to her face.

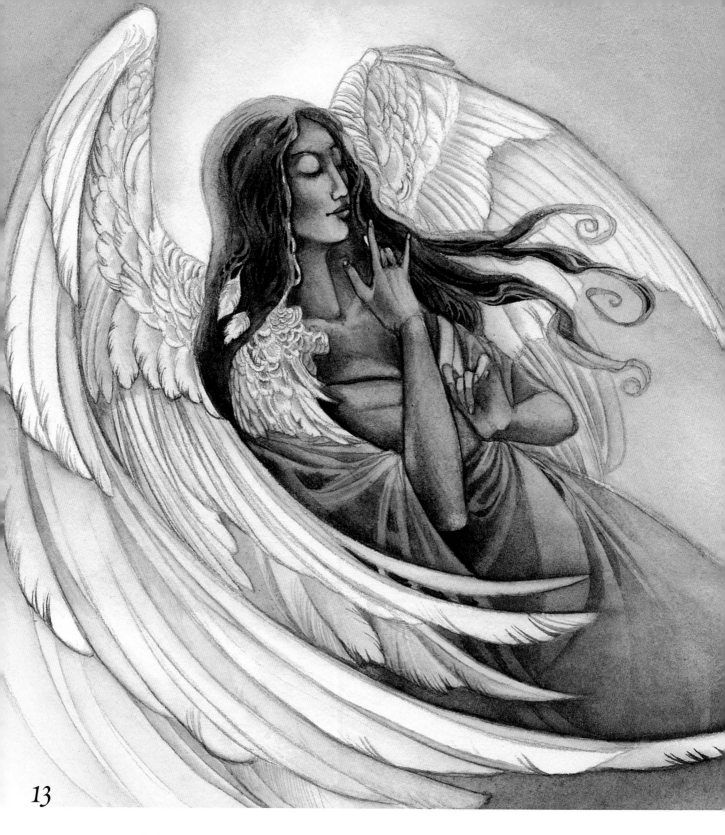

13

13 *Add the Finishing Touches*
Mix Burnt Umber and Cadmium Red like you did for her robes in step 9. Use a diluted hint of this color on some of the shadowy feathers, especially along the curve of the inner edge of her right wing. Use this mixture to define the texture along some of the inner feathers. As you work, make sure to keep a lot of the white paper showing through because this is the white of the wings!

Avoid Using Gray for White Shadows

It can be tempting to use gray for painting the shadows of white objects. If we had used gray instead of the reds, golds and purples we used for our angel of blessings, her wings would look like they were pasted into the painting and not a part of the scene. And, in a sense, they're not part of the scene because the wings don't actually contain the colors used in the image. It may seem an odd concept, but in order to paint white you have to use many colors. Doing so actually integrates the white objects into the scene.

The only time you might use gray for white shadows is if the surroundings are a grayish color. Even then, it is always more interesting to use warmer (brown) or colder (blue) approximations of gray than a very lifeless color like black or gray.

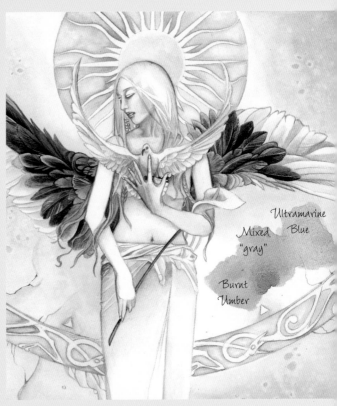

Ultramarine Blue

Mixed "gray"

Burnt Umber

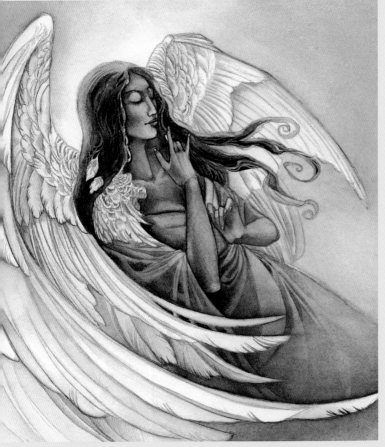

Use Lively Colors for Cold White Shadows
The surroundings in this painting are mostly white, with deep blue for the inner feathers on her wings and touches of Cadmium Orange for a bit of fire in her hair. Instead of using a tube gray for the highlights and shadows, use a very muted blue produced by mixing Ultramarine Blue and a little bit of Burnt Umber. You can also mix in more Burnt Umber if you want a warm sepia tone.

Notice the hint of reflected color from her orange hair along the edges of her skirt. Look for more reflections in the brownish tone compared to the shadows along the white feathers on the underside of her left wing. Although intuitively it might seem strange to "paint" white by adding orange, it actually is what defines the white, because the white is reflecting and absorbing the tones all around.

Gray Shadows for a Warm White? Bad Idea
Here the gray wings look like something outside of the image; they don't seem to relate to anything going on in the picture. The wings aren't part of the composition because they don't actually contain the colors of the image. Instead, the wings here look flat, unfinished and unpainted.

133

Body Types

ANGELS COME IN ALL SORTS OF SHAPES and sizes. They can be male or female, androgynous, wispy and delicate or muscular and powerful. Michaelangelo was known for using muscular male models in all his depictions of angels (whether male or female) because he wanted that physical power embodied in his divine messengers. Edward Burne-Jones, on the other hand, painted very effeminate angels with delicate features of indeterminate sex. The way you envision angels is up to you.

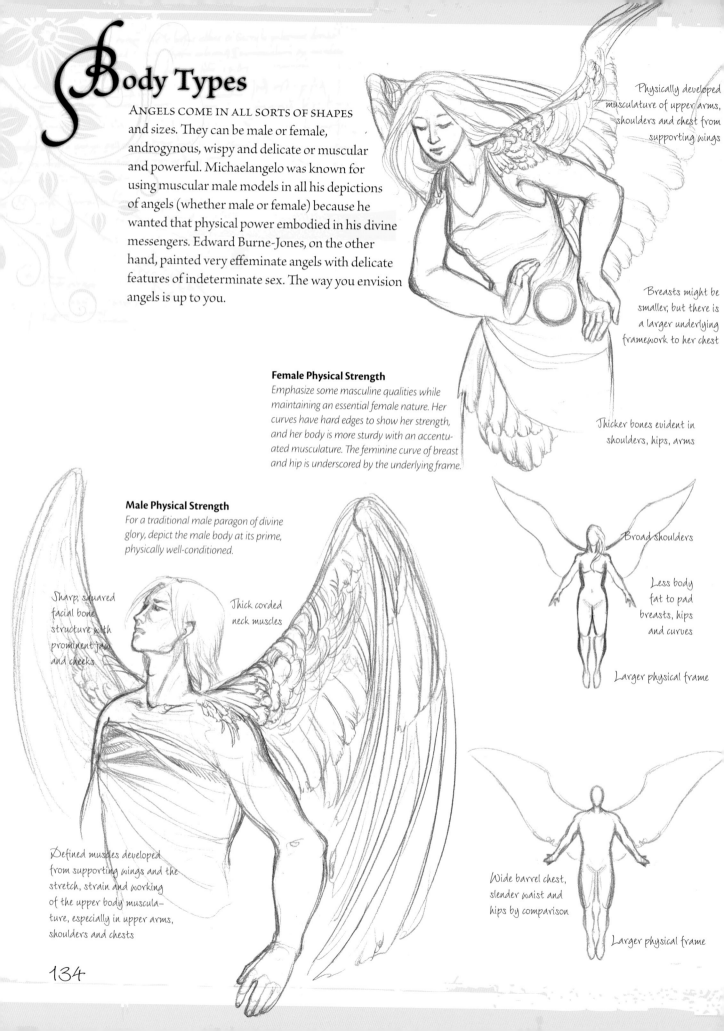

Physically developed musculature of upper arms, shoulders and chest from supporting wings

Breasts might be smaller, but there is a larger underlying framework to her chest

Thicker bones evident in shoulders, hips, arms

Female Physical Strength
Emphasize some masculine qualities while maintaining an essential female nature. Her curves have hard edges to show her strength, and her body is more sturdy with an accentu-ated musculature. The feminine curve of breast and hip is underscored by the underlying frame.

Male Physical Strength
For a traditional male paragon of divine glory, depict the male body at its prime, physically well-conditioned.

Sharp, squared facial bone structure with prominent jaw and cheeks

Thick corded neck muscles

Defined muscles developed from supporting wings and the stretch, strain and working of the upper body muscula-ture, especially in upper arms, shoulders and chests

Broad shoulders

Less body fat to pad breasts, hips and curves

Larger physical frame

Wide barrel chest, slender waist and hips by comparison

Larger physical frame

134

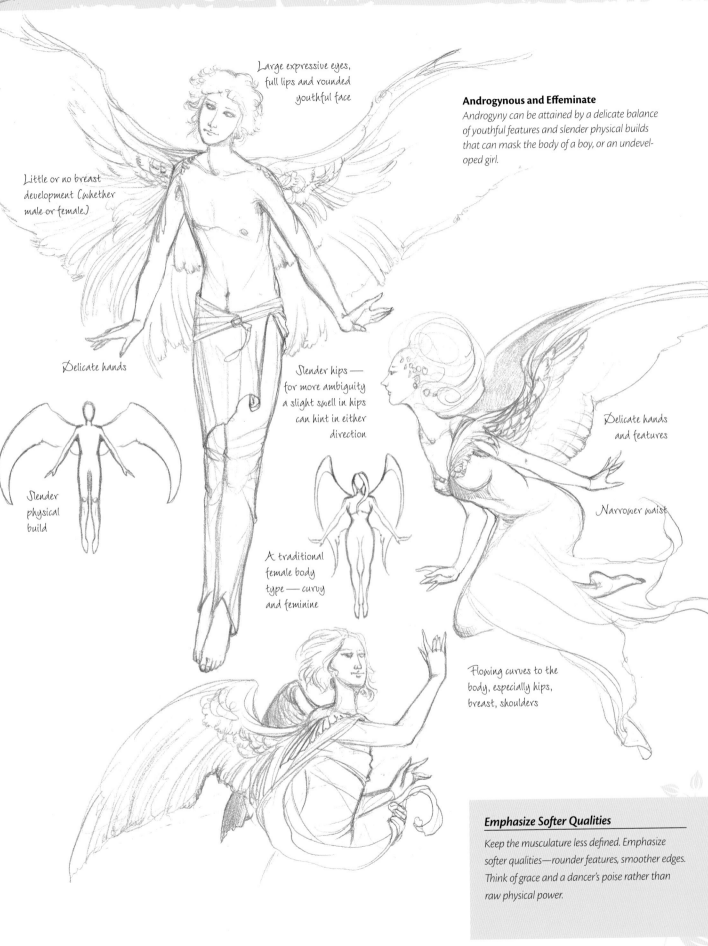

Large expressive eyes, full lips and rounded youthful face

Androgynous and Effeminate

Androgyny can be attained by a delicate balance of youthful features and slender physical builds that can mask the body of a boy, or an undeveloped girl.

Little or no breast development (whether male or female)

Delicate hands

Slender hips — for more ambiguity a slight swell in hips can hint in either direction

Slender physical build

Delicate hands and features

Narrower waist

A traditional female body type — curvy and feminine

Flowing curves to the body, especially hips, breast, shoulders

Emphasize Softer Qualities

Keep the musculature less defined. Emphasize softer qualities—rounder features, smoother edges. Think of grace and a dancer's poise rather than raw physical power.

Robes

IF YOU EVER PLAYED WITH PAPER dolls when you were young, think of them as you draw clothing—just because you can't see the legs and feet beneath a robe, does not mean they aren't there. Envisioning the body structure underneath a robe will help you draw the clothed form with more realism.

Drawing Fabric

Here's a common art class exercise that is a very useful and easy when learning how to draw fabric. Take a white bed sheet and drape it over a chair. Let the folds fall to the ground in a graceful pile. Sketch it.

A white sheet helps you to better see the shadows and the line of the draping. It is an easy exercise to set up that allows you to study a variety of clothing folds with the simple shake of the sheet. Even though a chair is not quite a human body, this exercise is good practice for learning to draw fabric.

Study how gravity pulls the folds into graceful curves. Look at the shadows and notice there are no truly flat surfaces, merely subtle ripples. The folds are not just a meeting of lines to a point, but an interaction of highlights and uniquely shaped bits of shadow.

Although your brain might tell you the folds are just lines of cloth draping from one point to the next, this is not the case. Though some creases might seem at sharp angles, look at the fabric's gentle arc and you'll see it's not just a straight line.

Basic Form

Though the arms and legs of your subject will eventually be obscured by cloth, starting with the basic figure is a good way to map the subtle interplay of the body's contours with the folds of material. This is what gives the final image realism. Art Nouveau painter Alphonse Mucha's figures are often garbed in form-hiding robes. Yet the hint of a foot pressing against the cloth, or the jutting of a hip hint at the pose and give structure to the lines of cloth. For starters, trace this figure lightly and then we will move on to drawing her clothing.

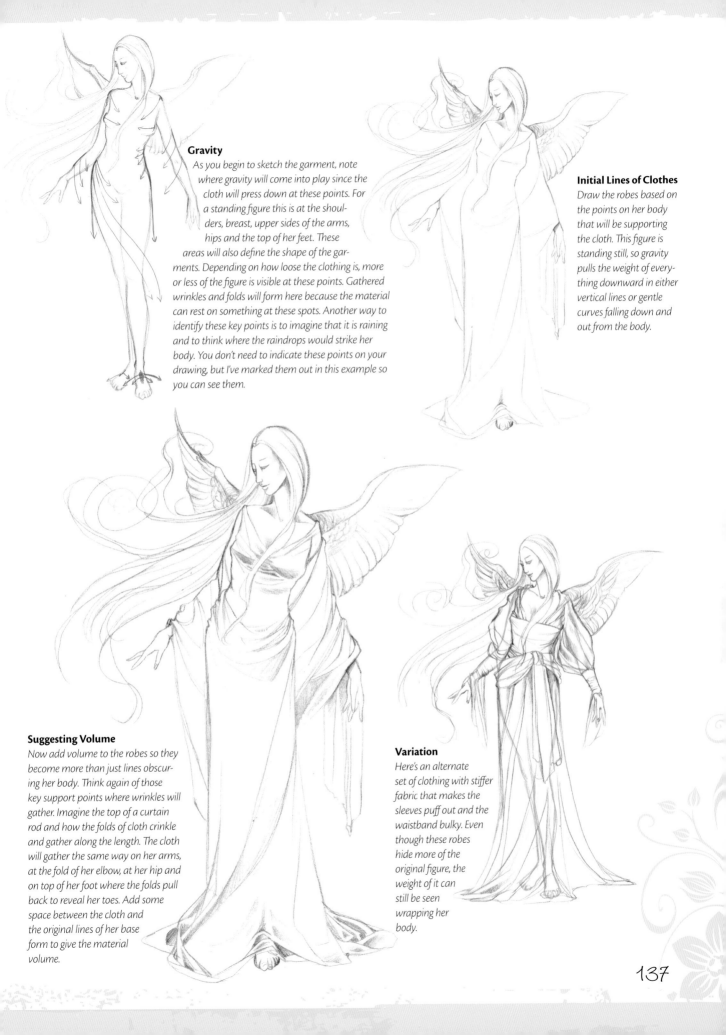

Gravity

As you begin to sketch the garment, note where gravity will come into play since the cloth will press down at these points. For a standing figure this is at the shoulders, breast, upper sides of the arms, hips and the top of her feet. These areas will also define the shape of the garments. Depending on how loose the clothing is, more or less of the figure is visible at these points. Gathered wrinkles and folds will form here because the material can rest on something at these spots. Another way to identify these key points is to imagine that it is raining and to think where the raindrops would strike her body. You don't need to indicate these points on your drawing, but I've marked them out in this example so you can see them.

Initial Lines of Clothes

Draw the robes based on the points on her body that will be supporting the cloth. This figure is standing still, so gravity pulls the weight of everything downward in either vertical lines or gentle curves falling down and out from the body.

Suggesting Volume

Now add volume to the robes so they become more than just lines obscuring her body. Think again of those key support points where wrinkles will gather. Imagine the top of a curtain rod and how the folds of cloth crinkle and gather along the length. The cloth will gather the same way on her arms, at the fold of her elbow, at her hip and on top of her foot where the folds pull back to reveal her toes. Add some space between the cloth and the original lines of her base form to give the material volume.

Variation

Here's an alternate set of clothing with stiffer fabric that makes the sleeves puff out and the waistband bulky. Even though these robes hide more of the original figure, the weight of it can still be seen wrapping her body.

137

Painting robes
ANGEL OF GRACE

She is the voice within that councils reason and sight, relenting and forgiveness, graceful acceptance and giving.

PAINTS

Brown Madder, Burnt Umber, Cadmium Red, Cadmium Yellow, Naples Yellow, Prussian Blue, Sap Green, Ultramarine Violet

MATERIALS LIST

½-inch (12mm) flat, illustration board, nos. 0, 1, 2, 3 and 4 rounds, pencil

1 Sketch and Add the Background
Sketch the drawing. Paint a background wash of Prussian Blue with a ½-inch (12mm) flat. Use a no. 4 round in the smaller corners. After that dries, add three to four layers of a graded wash using Prussian Blue at the top quarter and Ultramarine Violet at the bottom quarter with a ½-inch (12mm) flat. Let the layers dry between washes. Paint over the bottom part of the sketch since this will be in shadow. With a no. 1 round, add texture to the areas around her wings and head by drybrushing around them with fiery streaks of Ultramarine Violet. Soften the edges by swiping the areas with a ½-inch (12mm) flat full of clean water.

2 Establish the Skin's Shadows
Paint a basecoat of Sap Green to the shadow areas on her skin using a no. 1 round.

3 Add the Skin Tones
Mix Cadmium Red and Cadmium Yellow and paint a wash over all her skin areas with a no. 2 round. In the deepest shadows—around the scoop of her neckline and along the side of her cheek where her hair covers her face—use some Brown Madder to deepen the shadows. Paint the details of her facial features with a no. 0 round and Cadmium Red for her lips and Burnt Umber for her eyes and eyebrows.

4 Paint the Hair and Wings
Start with a basecoat of Naples Yellow applied with a no. 1 round. After that dries, add texture by painting shadowy strands with Brown Madder and a no. 0 round. In the dark areas near her neck, use Brown Madder mixed with Ultramarine Violet.

Paint shadows on the wings' feathers by drybrushing Ultramarine Violet near the center of each feather with a no. 0 round. Keep the tips of each feather white. Paint a layer of very diluted Naples Yellow on the wing tips to give a slight warm hint to the edges with a no. 1 round. If the drybrushed shadows look too harsh, take a no. 3 round and apply a wash of clean water over the wings to soften.

5 Add the Robes Underlayer
Using a no. 4 round, paint in washes of Prussian Blue mixed with Ultramarine Violet along the undersides of her sleeves, along the center of her body and in the background sleeve draping off her right arm. Block in some of the large shadowy folds in her lower skirt.

6 Add More Shadows
With a no. 2 round, add more shadows with a mixture of Ultramarine Violet, Prussian Blue and Burnt Umber. Soften the edges of the folds by blending and lifting the color into the light areas with a clean brush and water. Keep the edges of her arms and the sides of her body light, almost white.

1

2

3

4

5

6

139

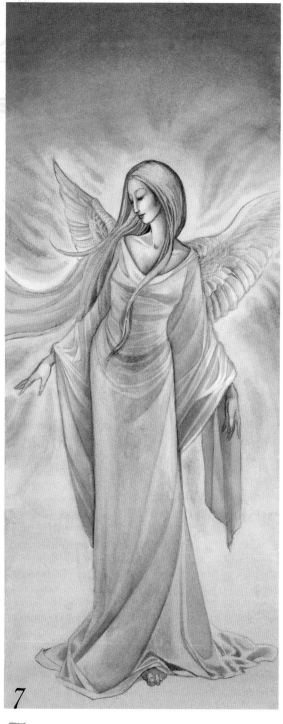

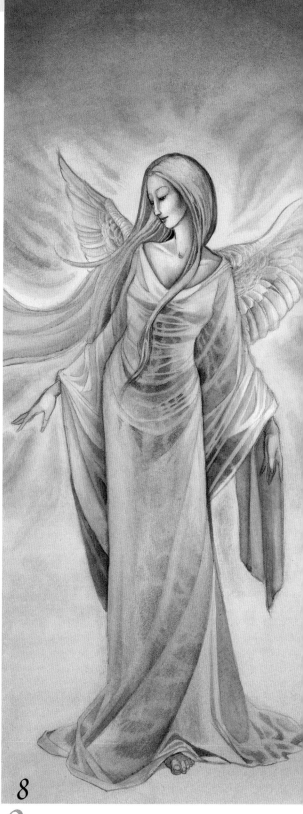

7

8

7 Darken Shadows and Add Highlights

Mix Ultramarine Violet and Prussian Blue. With a no. 3 round, apply a wash along the base shadows, down the pillar of her body and the undersides of her sleeves. This darkens those areas while smoothing and blending the shadows of the smaller folds from the previous steps. For highlights, apply a wash of Naples Yellow across her upper arms, along the sides of her body and upper chest.

8 Add Texture to the Fabric

Add texture to the fabric by creating crinkles and fine wrinkles. Mix Brown Madder and Ultramarine Violet and drybrush this along the darkest folds for crinkles. Wipe clean water over this area with a no. 1 round to smooth out the roughness. Paint a more concentrated wash of Naples Yellow with a no. 1 round over the back edges of her robes, including the trailing ends of her sleeves and the sides of the folds on the floor. This adds a bit of reflected golden color to the shadows.

Clothing and Movement

So what happens with cloth when the body is moving, in flight or when the wind is blowing? Instead of hanging straight down, the cloth will billow and flow. Gravity will still pull the clothing downward, but, instead of pulling it taut on the body's upper surfaces, the tightness will be dictated by the direction of movement. If your figure is moving to the left, the clothing will flow and be pulled to the right.

Basic Form
Keep your marks very light because you will have to erase the bits that are hidden by clothing.

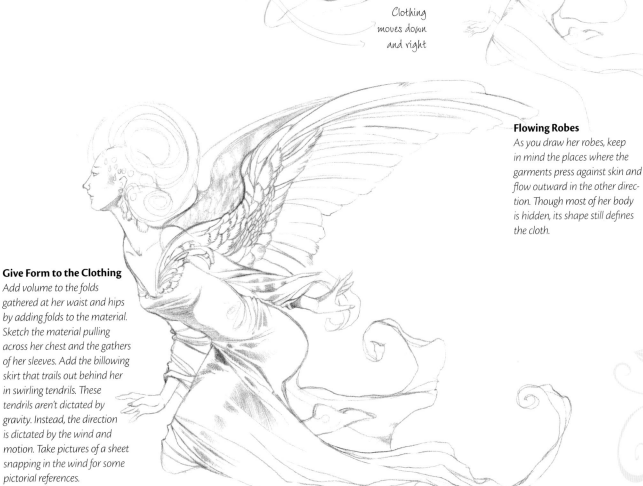

Analyze Movement
As before, lightly sketch in the entire figure. Make a mental note of all the key points highlighted with arrows. She is flying in an upward swooping movement to the left, so her clothing is pulled down and to the right. The left side of her body is where the garments will be pulled taut.

Figure is flying up and left

Clothing moves down and right

Flowing Robes
As you draw her robes, keep in mind the places where the garments press against skin and flow outward in the other direction. Though most of her body is hidden, its shape still defines the cloth.

Give Form to the Clothing
Add volume to the folds gathered at her waist and hips by adding folds to the material. Sketch the material pulling across her chest and the gathers of her sleeves. Add the billowing skirt that trails out behind her in swirling tendrils. These tendrils aren't dictated by gravity. Instead, the direction is dictated by the wind and motion. Take pictures of a sheet snapping in the wind for some pictorial references.

*I*ndicating Movement

PORTRAYING MOVEMENT IN A FIGURE IS A combination of many elements in a drawing. Balance, torque (twisting of the body), wing placement, clothing and hair all help indicate where and how a figure is moving.

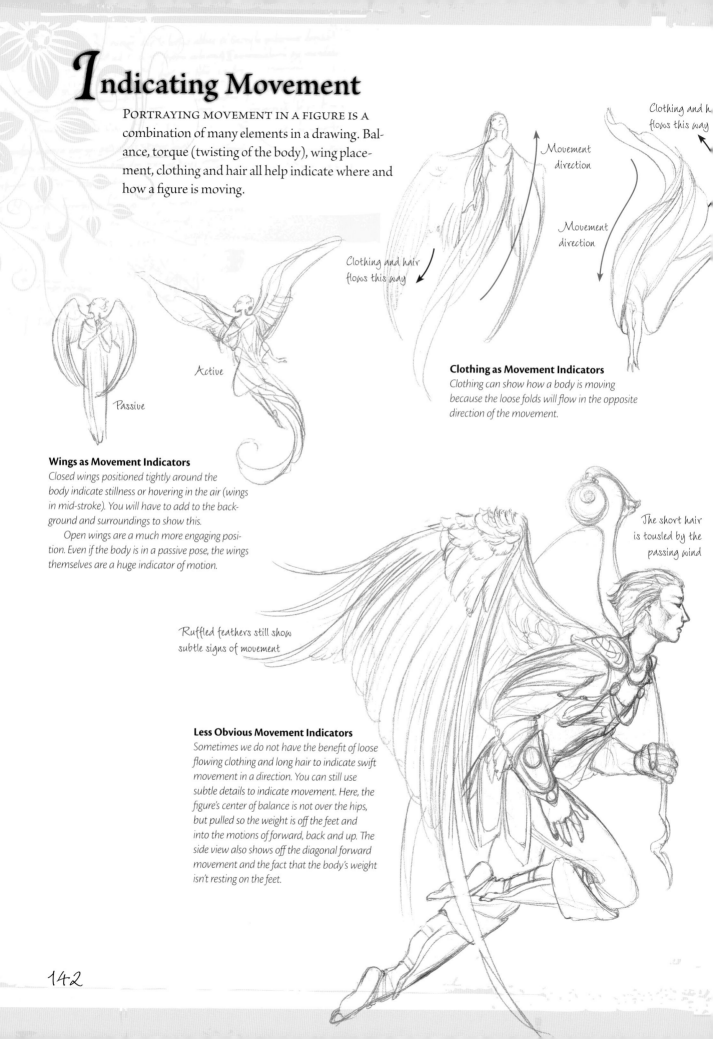

Movement direction

Clothing and hair flows this way

Movement direction

Clothing and hair flows this way

Clothing and hair flows this way

Active

Passive

Clothing as Movement Indicators
Clothing can show how a body is moving because the loose folds will flow in the opposite direction of the movement.

Wings as Movement Indicators
Closed wings positioned tightly around the body indicate stillness or hovering in the air (wings in mid-stroke). You will have to add to the background and surroundings to show this.
Open wings are a much more engaging position. Even if the body is in a passive pose, the wings themselves are a huge indicator of motion.

The short hair is tousled by the passing wind

Ruffled feathers still show subtle signs of movement

Less Obvious Movement Indicators
Sometimes we do not have the benefit of loose flowing clothing and long hair to indicate swift movement in a direction. You can still use subtle details to indicate movement. Here, the figure's center of balance is not over the hips, but pulled so the weight is off the feet and into the motions of forward, back and up. The side view also shows off the diagonal forward movement and the fact that the body's weight isn't resting on the feet.

142

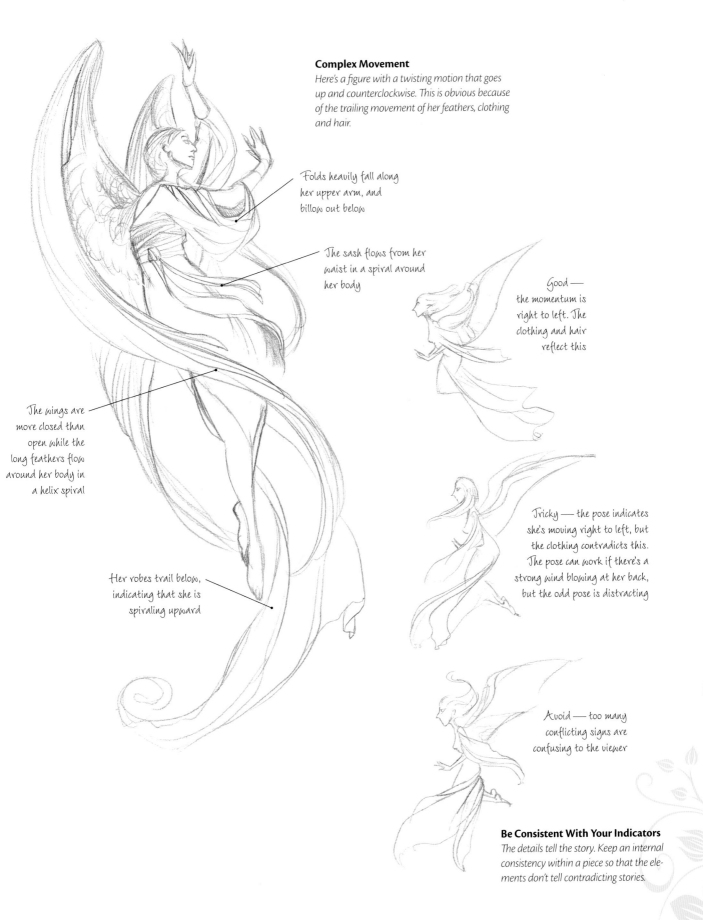

Complex Movement

Here's a figure with a twisting motion that goes up and counterclockwise. This is obvious because of the trailing movement of her feathers, clothing and hair.

Folds heavily fall along her upper arm, and billow out below

The sash flows from her waist in a spiral around her body

The wings are more closed than open while the long feathers flow around her body in a helix spiral

Her robes trail below, indicating that she is spiraling upward

Good — the momentum is right to left. The clothing and hair reflect this

Tricky — the pose indicates she's moving right to left, but the clothing contradicts this. The pose can work if there's a strong wind blowing at her back, but the odd pose is distracting

Avoid — too many conflicting signs are confusing to the viewer

Be Consistent With Your Indicators

The details tell the story. Keep an internal consistency within a piece so that the elements don't tell contradicting stories.

143

Angel in flight
VANGUARD

He flies in the vanguard of the angelic hosts. His voice is raised in the Summoning Song and the lantern he carries streaks like a star across the sky.

PAINTS

Brown Madder, Burnt Umber, Cadmium Orange, Cadmium Red, Cadmium Yellow, Cobalt Violet, Dioxazine Violet, Lamp Black, Lemon Yellow, Naples Yellow, Payne's Gray, Prussian Blue, Sap Green, Ultramarine Violet, Viridian

MATERIALS LIST

½-inch (12mm) flat, craft knife, illustration board, nos. 0, 1, 2, 3 and 4 rounds, pencil, rubbing alcohol, toothbrush

1 Sketch the Angel and Add the Glow of Light
Sketch in the subject with a pencil. With a no. 4 round paint a soft glow of Lemon Yellow around the lantern and the angel's wings. Also paint over the far wing since the light of the lantern falls on it.

2 Apply a Background Wash
Paint washes of Ultramarine Violet in the corners with a ½-inch (12mm) flat. Dilute with water to fade the color toward the center so the edges are darkest. Use a toothbrush to spray some rubbing alcohol in the corners to add texture. Layer many washes to build up the color.

3 Add Transition Colors
Add a mixture of Brown Madder and Cadmium Yellow to the background, drybrushing around the yellow areas with a ½-inch (12mm) flat. This helps to transition the vibrant purple hues to the softer yellow glow of the lantern. Smooth out the mixture with a wash of clean water.

4 Deepen the Sky
Add more layered washes of Ultramarine Violet mixed with some Prussian Blue towards the corners, deepening the contrast to the warm glow with a ½-inch (12mm) flat. Lend a sense of motion by creating trails of light from his wing tips; drybrush with a ½-inch (12mm) flat very diluted darker shades of the Ultramarine Violet and Prussian Blue mixture in streaks, following the movement of the feathers. Brush clean water over this area with a ½-inch (12mm) flat to soften and blend.

5 Shade the Skin and Hair
Apply a basecoat of Ultramarine Violet in the shadows of the skin and hair with a no. 2 round.

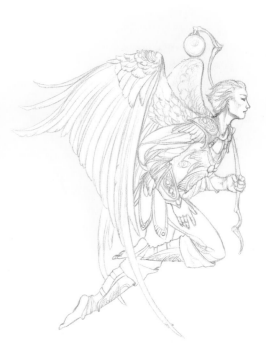

1

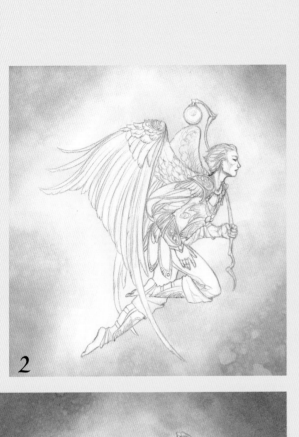

2

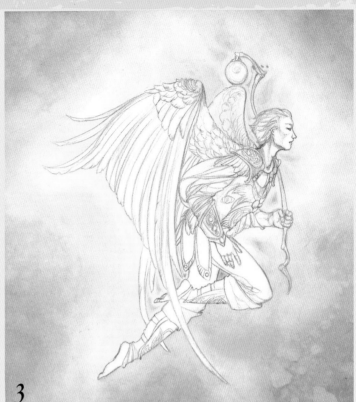

3

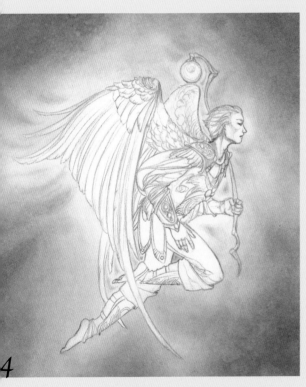

4

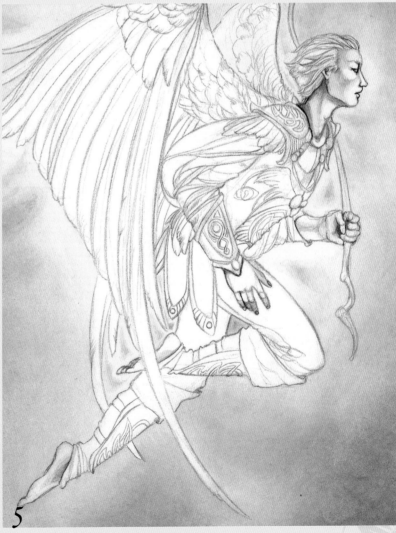

5

145

6 Bring the Skin and Hair to Life

Paint a Cobalt Violet and Lemon Yellow layer for the skin with a no. 1 round. For the hair, paint a layer of Cadmium Orange, Cadmium Yellow and Brown Madder with a no. 1 round. For highlights, lift out color from the strands at the top of his head and near the temples with a no. 0 round.

7 Basecoat the Areas of Golden Armor

Since his armor will be a gleaming gold, use a no. 2 round to apply a basecoat of Cadmium Red, working wet-on-dry over the armor. Leave a lot of white paper showing through for reflections and highlights.

8 Create the Golden Tones

Blend some of the harsher edges of the Cadmium Red wash by rubbing the edges with a no. 1 round and water, lifting some of the color. Add a wash of a mixture of Cadmium Yellow and Lemon Yellow. Remember to leave some white areas for highlights.

9 Add Shadows to the Clothing

With a no. 0 round, add Burnt Umber to the shadows emphasizing the embossed patterns of his armor. Using the same brush, shade the areas under his right arm, along his back and under his wings.

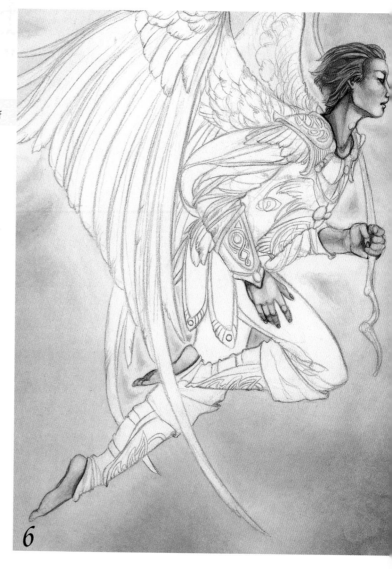

6

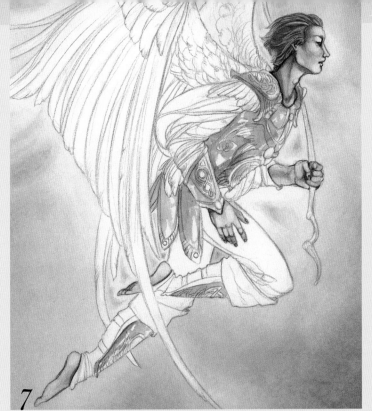

7

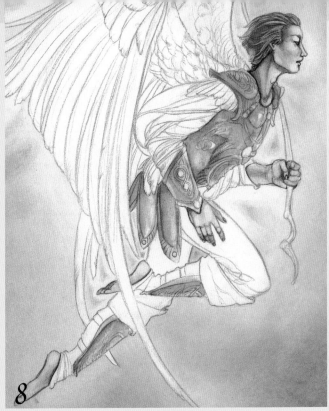

8

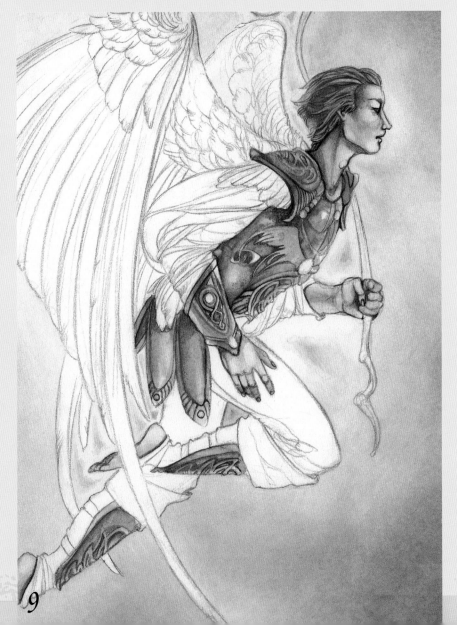

9

10 Add Reflections and Sparkles

Emphasize polished highlights in the armor by scrubbing the area with a small round and water to gently lift the color. To create highlights, take a craft knife and very delicately scrape the surface to reveal the white paper beneath. Paint the gemstones in his armor with Sap Green and Viridian with a no. 0 round. Keep a bright point of a white highlight sparkle for each stone. Drybrush Sap Green and Viridian reflections with a no. 0 round to create mottled textures in the darker areas of the armor. Smooth out the roughness of the drybrushed areas with a wash of water.

11 Create the Black Cloth

To create the black clothing, apply a basecoat of Viridian with a no. 3 round. This may seem strange, but the Viridian will give the black cloth an iridescent greenish sheen like a crow's black feathers in sunlight. When subsequent layers are lifted, some of the Viridian will show through.

Mix Payne's Gray with Dioxazine Violet and paint a wash over the Viridian basecoat with a no. 1 round. Add successive layers to darken the folds of the sleeves and the far leg. Lift to soften edges and create highlights.

12 Deepen the Folds

For the deepest shadows at the center of his right arm, his upper thighs and in the creases at his knees, apply a sparing amount of Lamp Black with nos. 0 and 1 rounds. Lightly drybrush the black in the folds in these areas, then blend with a no. 1 round and clean water. Keep the clothing along the outer edges of his body highlighted, maintaining the nimbus of light around him granted by the lantern.

10

148

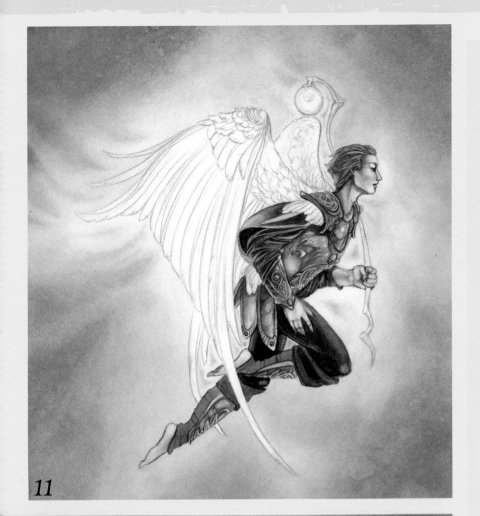

11

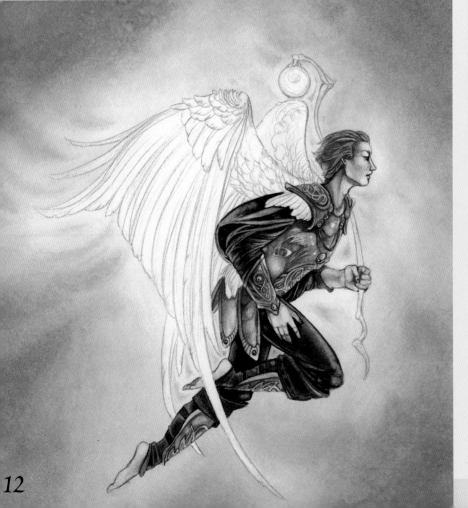

12

Painting Different Types of Material

Materials fall in varying ways depending on the texture and weight. Something lightweight like cotton or linen has a coarse texture and doesn't cling to the body. It has a lot of airy space in the folds and can get quite bulky when it gathers (at the waist, arms, shoulders and feet). More delicate materials like silk or chiffon have a smooth and slippery texture. The weight pulls down and creates elegant curving lines of drapery without hard angles because there is not so much air between the skin and the cloth.

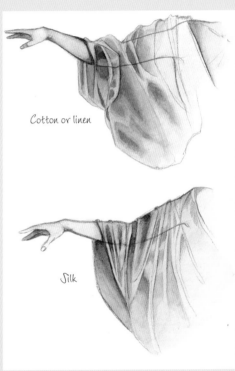

Cotton or linen

Silk

13 Define the Feathers

Start with a layer of Ultramarine Violet on the upper parts of the longer wing feathers with a no. 1 round. Let this fade to white at the edges. Add Ultramarine Violet on the curved inner parts of his wings and on the small feathers along his shoulder and hip with nos. 0 and 1 rounds.

Paint the upper layer of feathers with Cadmium Yellow using a no. 0 round. Keep the color more concentrated toward the inner shaft of each feather and white along the edges. For the curved inner area that's shadowed by the arc of his wing, add a little bit of Naples Yellow to the Cadmium Yellow with a no. 0 round.

14 Soften the Edges

Mix Burnt Umber with Ultramarine Violet and add more shadows along the longer feathers with a no. 1 round. For the golden feathers, use a no. 2 round to soften the edges by painting a very diluted wash of Cadmium Yellow over the entire area (except for the top of his left wing where the glow of the lantern hits).

15 Add the Finishing Details

Finish the feathers by adding detailed filaments to the edges of some feathers with a no. 0 round. You do not have to paint every feather, just enough to hint at details. On the longer white feathers, use a mixture of Burnt Umber and Ultramarine Violet. For the short, golden feathers, use Burnt Umber.

Paint the handle of the lantern with Burnt Umber and a no. 1 round. Add details inside the globe of light by drybrushing Cadmium Yellow with a no. 1 round, then soften it with a wash of water.

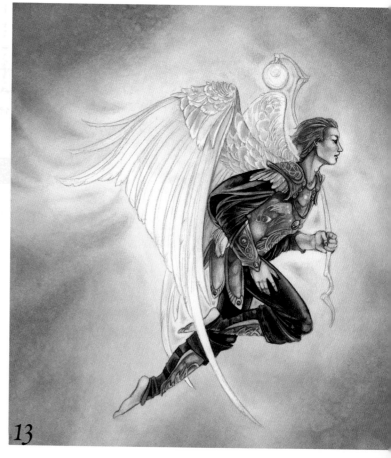

13

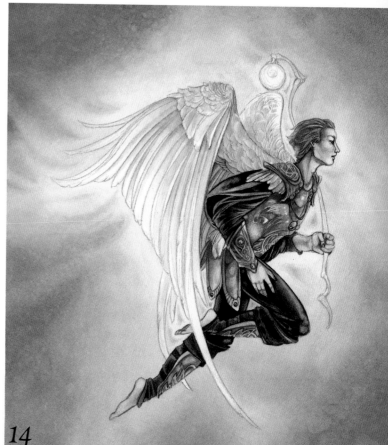

14

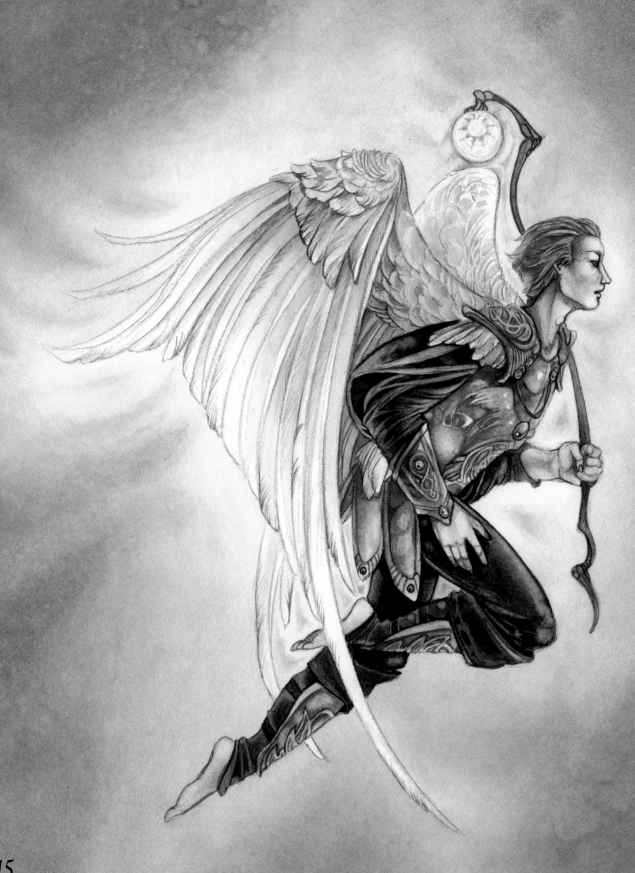

15

Backgrounds
CLOUDS

How you approach the environs is as important as the central figures in a painting. Even in a cloudless blue sky, a flat blue tone flattens the whole piece. If you hint at light from the east or the faint glow of dawn at the horizon, the image suddenly exists in a specific time of day and not just in a square of blue paint.

PAINTS

Cerulean Blue, Dioxazine Violet, Payne's Gray, Ultramarine Blue

MATERIALS LIST

½-inch (12mm) flat, illustration board, nos. 0 and 2 rounds, rubbing alcohol, toothbrush

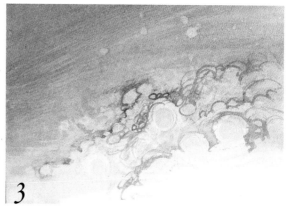

1 Initial Wash
Wash Cerulean Blue over the surface with a ½-inch (12mm) flat. Splatter rubbing alcohol with a toothbrush where you would like a pile of cumulus clouds. Using the toothbrush, sprinkle a finer spray of rubbing alcohol toward the upper edges of the cloud bank.

2 Refine the Sky
With the ½-inch (12mm) flat, darken the upper portion of the sky with another wash of Cerulean Blue. Do some drybrushing to create horizontal streaks of a slightly darker blue for a look of wispy distant cirrus clouds.

3 Define the Clouds
Emphasize the bubble texture from the rubbing alcohol by using a no. 0 round to define the clumps of cumulus clouds with Ultramarine Blue using short, arced strokes. Blend some of the paint into the surrounding areas by diluting it with water.

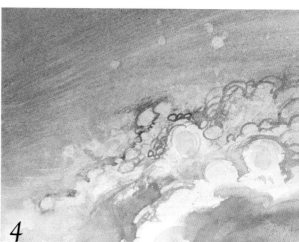

4 Add the Shadows
Mix Dioxazine Violet with Payne's Gray. With a no. 2 round, paint shadows on the undersides of the larger cloud masses.

Backgrounds
STARRY SKY AT DUSK

Dusk, when the light is fading in a heavenly display of colored glory, the first stars start to twinkle in the velvet textured dome of the sky.

PAINTS

Dioxazine Violet, Naples Yellow, Permanent Gouache White, Prussian Blue

MATERIALS LIST

1-inch (25mm) flat, illustration board, masking fluid, nos. 0 and 1 rounds, old brush, paper towels, pencil, salt

1 Start the Sky and Land
Sketch the landscape. With an old brush, add masking fluid dots in various sizes to the upper area of the sky. Let this dry. Wash in Naples Yellow near the horizon with a 1-inch (25mm) flat.

2 Add the Sky's Color
Paint a wash of Prussian Blue fading from darkest at the top to lightest near the yellow. Overlap the yellow a little bit. While this is wet, sprinkle salt at the top for extra texture and a hint of distant celestial bodies.

3 Darken the Sky
Paint a wash of Prussian Blue mixed with Dioxazine Violet, fading out about midway down from the top. Sprinkle salt at the top again. Repeat these graded washes until the sky is dark enough, then remove the masking fluid.

4 Add the Final Details
With a no. 1 round, gently rub the largest stars with clean water, then dab with a paper towel, lifting some of the pigment and softening the harsh edges. Dot in tiny stars with a no. 0 round and Permanent Gouache White.

Finish off the sleeping hills below with a wash of Prussian Blue.

Pigments and Lifting

Certain pigments lift easier than others. For example, Ultramarine Blue lifts very easily. If you paint a wash of Ultramarine Blue and let it dry, you will be able to take a wet brush, run it over your wash and easily lift the color. This can be frustrating if you are layering colors to intensify the darks. You can take advantage of this, however, when painting sparkles or a starry sky. It can make achieving your desired effects much easier.

2

3

1

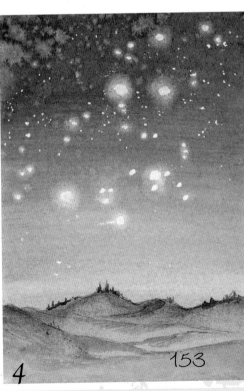
4

Backgrounds
STONE WALLS

Weathered halls that have seen the passage of aeons; age-scarred walls can carry a sense of dignity and a silent grace.

PAINTS

Burnt Umber, Lamp Black, Ultramarine Violet

MATERIALS LIST

½-inch (12mm) flat, illustration board, nos. 0 and 1 rounds, pencil

1 Sketch and Apply a Wash

With a pencil, lightly sketch the cracked texture of the wall. Mix Ultramarine Violet with Burnt Umber and use a ½-inch (12mm) flat to lay a wash over the entire area. The wash doesn't have to be perfectly smooth. In fact, after it dries, you can enhance any irregularities for more texture.

2 Darken the Walls

Working wet-on-dry, darken the areas around the cracks with a no. 1 round and the Ultramarine Violet and Burnt Umber mixture. Leave a thin area unpainted surrounding the lines for a faint highlight around the cracks. Any irregularities or pools of pigment will only enhance the rugged appearance.

3 Smooth Out the Surface

With a ½-inch (12mm) flat, paint a very diluted wash of the Ultramarine Violet and Burnt Umber mixture over everything. If the cracks blur, repeat this and the previous step as many times as needed to get the color intensity you need.

4 Refine the Cracks

Take a small no. 0 round and paint the cracks with a concentrated mixture of Ultra-marine Violet and Burnt Umber. Use a touch of Lamp Black in the deepest and widest cracks.

1

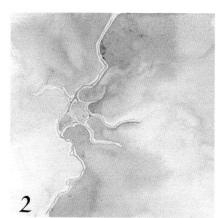

3

For the hairline cracks that radiate out, keep the line very delicate and pale, almost fading out into the surrounding color

2

A little bit of black to emphasize the crack

4

Getting Inspiration

With its majesty of elaborate cathedrals and castles, a trip through Europe might be the best way to gather inspiration for stone structures. Alas, this isn't always a readily available option. In that case, the Internet can easily supply you with many types of reference images.

Books of ancient art history from the library also have plenty of photos of classical structures. Look for examples in the pillared temples of Rome, the flying buttresses of Gothic cathedrals and the elegant arched chambers in palaces and churches.

Or you can even look to the present for ideas because many aesthetics of the past live in the architecture of today. Take a trip to the nearest city and use your camera for reference photos. Look skyward for statues that might crown rooftops or doorway arches that often have an ancient aesthetic.

More Stone Textures

Here are some additional ideas for stony textures
and backgrounds.

Rough Rocks

*Apply a wash of Naples Yellow.
While this is wet, take a damp
sponge and lightly press the
surface to lift out some of the
pigment, leaving a spongy
texture that looks like rocks.*

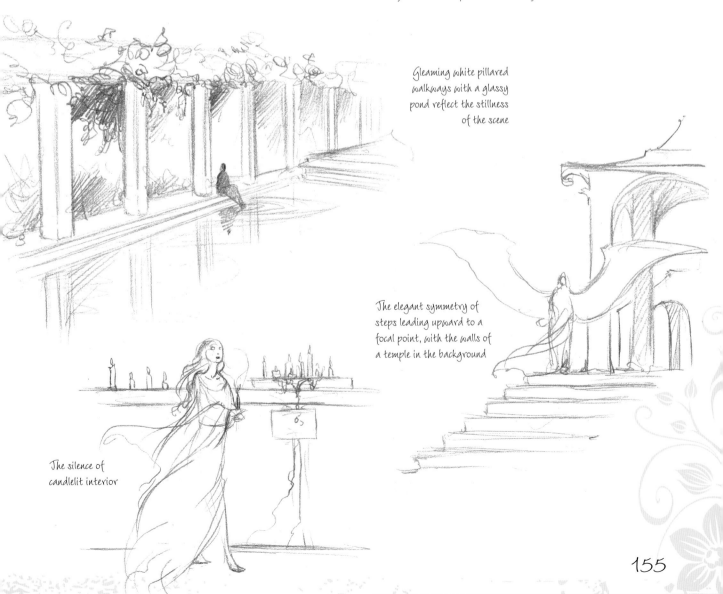

Smooth Marble

*Mix Ultramarine Violet with Burnt Umber and
apply a flat wash. While this is wet, take a small
round and paint wet-into-wet streaks of diluted
Burnt Umber for marble-like veins. After it all dries,
drybrush in little spots and streaks of white.*

Background Ideas

Gleaming white pillared
walkways with a glassy
pond reflect the stillness
of the scene

The elegant symmetry of
steps leading upward to a
focal point, with the walls of
a temple in the background

The silence of
candlelit interior

Backgrounds
STAINED GLASS WINDOWS

The magical quality that light has when it shines through colored glass hints of hallowed grounds, meditation and loving craftsmanship. The beauty of the jewel-like colors can add a great deal to an image's composition and bring a painting to life.

Using a combination of techniques on the panes will create effects of glowing light through jewel-colored glass.

PAINTS

Alizarin Crimson, Cadmium Orange, Cadmium Red, Cadmium Yellow, Lamp Black, Lemon Yellow, Sap Green, Ultramarine Violet, Viridian

MATERIALS LIST

illustration board, nos. 0, 1 and 4 rounds, pencil, plastic wrap, salt

1 Sketch the Shape of the Glass

Begin with a pencil sketch of the panes of glass. You can trace this design or experiment with a simple one of your own. The painting part of this is a bit like using a coloring book—just stay within the lines using bright colors.

2 Add the Yellow Areas

With a no. 4 round, drybrush some Cadmium Yellow. Over the yellow, drybrush Cadmium Orange with a no. 1 round to create some darker streaks and ripples in the glass's texture. Add a touch of very diluted Viridian at the edges for some color variation. Further darken the Cadmium Orange streaks where necessary.

3 Add the Green Areas

Apply a basecoat of Sap Green with a no. 4 round. You can leave gaps of white paper showing through. Working wet-into-wet, dot in some Viridian with a no. 4 round. Sprinkle some salt into the wet paint and let this dry. Brush away the salt and add in more concentrated Viridian to emphasize the bubbles and streaks. Retain the white sparkle of the salt spots.

4 Vary the Colors

Not every glass pane should be elaborately textured—a few panes with flat washes give the eye somewhere to rest. Vary the shades within nearby secondary and tertiary tones (see the color wheel on page 16) for a set of panes that are supposed to be the same color. For reddish panes, for example, use reddish, warm colors such as Cadmium Orange, Cadmium Red, Alizarin Crimson and Ultramarine Violet. Apply any of these colors wet-into-wet with a no. 4 round. Sparingly add colors from adjacent panes working wet-into-wet to bleed colors into other shades. Add some texture with little pieces of plastic wrap stretched across wet paint. Define the texture further by drybrushing a darker color over the striations created by the plastic wrap.

5 Add the Smaller Panes

For smaller areas, you cannot get as elaborate with the texture. Drybrushing and working wet-into-wet works the best. Let some of the Ultramarine Violet and Alizarin Crimson bleed into the yellow panes. You don't have to be completely neat with the separation of all colors and panels.

6 Piece It Together

Take a no. 0 or 1 round and paint in the lead holding the panes together with Lamp Black.

Colors of Light

One thing to keep in mind when painting stained glass is to keep your colors pure. The glass should glow with the light that comes through from behind. In order to get that incandescent glowing effect the colors need to be clean and unmixed.

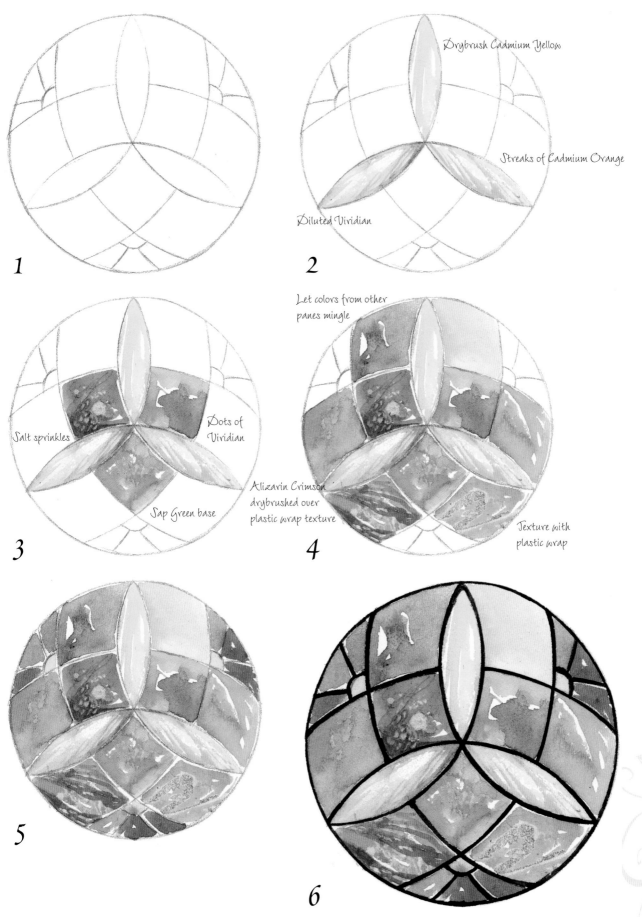

1

2

Drybrush Cadmium Yellow

Streaks of Cadmium Orange

Diluted Viridian

3

Salt sprinkles

Dots of Viridian

Sap Green base

4

Let colors from other panes mingle

Alizarin Crimson drybrushed over plastic wrap texture

Texture with plastic wrap

5

6

Angel with background
GUARDIAN OF OFFERINGS

Let's try an angel in an indoor setting of alabaster white walls with the glow of a stained glass window.

In hallowed halls, she waits within
the pillars of smoky incense offerings.
She dances in the airy arches
where whispered prayers linger.

1. Sketch and Add Shadows and Light

Sketch your composition with a pencil. Mix Dioxazine Violet with Payne's Gray and with a no. 8 round paint the shadows along the walls. The darkest areas will be on the ledge underneath her hips, behind the offering bowl, along the wall underneath her skirts and around the cracks in the lower wall. Smooth out the shadows into the surrounding areas with a wash of water. If the paint becomes mottled, it will only add to the wall's texture.

Paint a nimbus of Lemon Yellow around her head with a no. 8 round.

2. Darken the Background

Mix Ultramarine Violet with Burnt Umber and paint a diluted wash over the entire background with a no. 8 round. Keep it lightest around the stained glass window since you'll later add reflected colors. The darkest areas should be in the upper and lower right corners and underneath the ledge on the left. Spray some rubbing alcohol with a toothbrush into the wet paint for a mottled texture. Working wet-into-wet, add streaks of a more concentrated Ultramarine Violet and Burnt Umber mixture for some veined mineral textures in the marble.

3. Add the Cracks

Using a no. 0 round, paint in the cracks in the wall with a mixture of Payne's Gray and Burnt Umber.

PAINTS

Brown Madder, Burnt Umber, Cadmium Orange, Cadmium Red, Cadmium Yellow, Cobalt Violet, Dioxazine Violet, Lamp Black, Lemon Yellow, Naples Yellow, Payne's Gray, Prussian Blue, Sap Green, Ultramarine Violet, Viridian

MATERIALS LIST

illustration board, nos. 0, 1, 2, 4, 6 and 8 rounds, paper towel, pencil, plastic wrap, rubbing alcohol, salt, toothbrush

4. Paint the Golden Bowl and Add the Lilies' Stems

Paint a layer of Cadmium Yellow on the lining of the ledge and on the bowl with a no. 0 round. Add shadows with Brown Madder.

Apply Sap Green to the lilies' stems with a no. 0 round and apply Viridian for the shadows. Add a touch of Viridian with a no. 0 round along the right side of the bowl for some streaked reflections.

5. Paint the Flowers and Birds

With a mixture of Cobalt Violet and Cadmium Yellow, add the details to the flower petals and buds using a no. 0 round. Leave some white areas for highlights.

Apply a basecoat of Payne's Gray for the doves with a no. 0 round. Detail the doves' tails with Burnt Umber. Apply Cadmium Red to their beaks and feet with a no. 0 round.

1

2

3

4

5

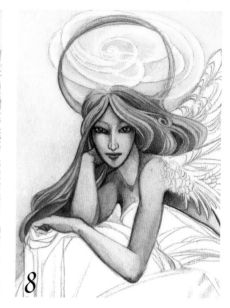

6 Basecoat the Skin and Hair

Mix Viridian with a bit of Ultramarine Violet and apply this to the shadows in her skin using a no. 0 round. In the hair, apply some Ultramarine Violet for the shadows with a no. 0 round.

7 Add the Skin and Hair Tones

Mix Cobalt Violet with Lemon Yellow for the fleshtone and apply a wash of this over her skin with a no. 2 round. For her hair, apply a layer of Cadmium Orange with a no. 2 round.

8 Add Shadows and Details

Drybrush shadows of Brown Madder on her skin with a no. 0 round. Soften and blend the areas with a wash of clean water. Add details to her lips with Ultramarine Violet and to her eyes with Viridian using a no. 0 round. Lift out some color to highlight her cheekbones. Detail strands of hair with Cadmium Orange and Brown Madder, deepening the shadows close to her face and shoulders with a no. 0 round.

9 Paint the Clothing and Wings

With various mixtures of Ultramarine Violet, Burnt Umber and Prussian Blue, paint the shadows on her clothing and wings using nos. 0, 1 and 2 rounds. Add a thin layer of Lemon Yellow over the upper parts of her wings to reflect the glow of her halo with a no. 6 round.

10 Tone the Clothing and Wings

Paint her dress with Sap Green, using Viridian in the upper areas. Add some Viridian to the the lower areas of cloth on the ledge to reflect some of the green of her dress. Add some Cadmium Orange along the upper parts of the cloth on the ledge to reflect her hair and halo.

Paint a wash of Viridian along the lower feathers of her wings to reflect the green of the dress. On the smaller feathers, add some details with Cadmium Yellow and Cadmium Orange. Mix Burnt Umber with Ultramarine Violet and paint detailed filaments on the feathers with a no. 0 round. Brush water over it to soften and blend.

11 Create the Texture of Fine Cloth

With a no. 0 round, drybrush in more texture to the cloth with Viridian, then smooth and blend it out with a wash of water. For the white drape, apply Payne's Gray to the deepest creases and the shadows under her arms with a no. 0 round. For her dress, mix Viridian with Ultramarine Violet and add some finer wrinkles by painting textured shadows.

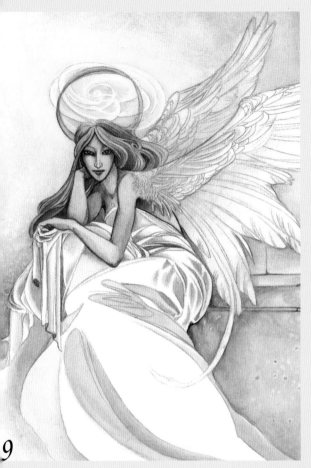

9

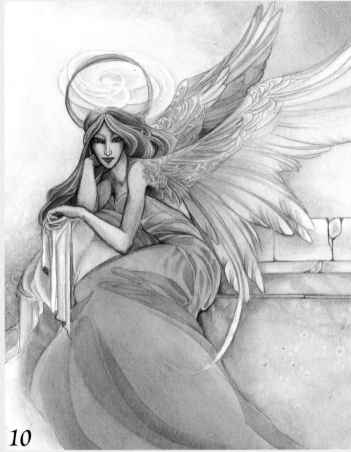

10

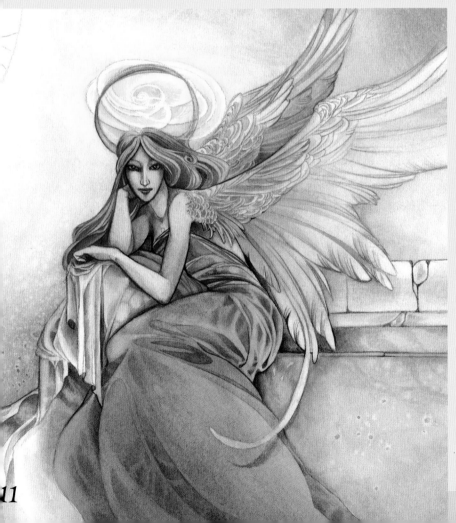

11

161

12 Paint the Stained Glass Window

It helps to paint all the areas of stained glass one color at a time, so go in this order:

Start by using variations of Cadmium Yellow and Lemon Yellow for the base of the small diamonds and the background of the large stars, painting with a no. 0 round. Add texture with Cadmium Orange and Naples Yellow as discussed in the techniques on pages 156 and 157. Mix the different techniques of salt, drybrushing, layering and plastic wrap to create a multi-textured window.

Use a range of colors for the panes surrounding the stars. Start on the left side with Ultramarine Violet, Prussian Blue and Cadmium Red. As you move along the curve toward the right side, paint some panes Viridian, some Naples Yellow and some Cobalt Violet. For each pane, modify the mixture you use slightly so that every glass looks slightly different from the others surrounding it.

Create the green leaves for the center circle with a mixture of Sap Green and Naples Yellow with a no. 0 round.

Mix Viridian with Sap Green and apply it to the areas of the inner circle that surround the flower with a no. 0 round. For darker streaks of texture, mix in a little bit of Ultramarine Violet.

Apply Cobalt Violet to the lily's center using a no. 0 round. Leave the center of the stars and the lily's petals white.

13 Add Lead to the Glass

With a no. 0 round, paint the lead holding the panes together with Lamp Black.

14 Add the Effects of Light

Anchor the window to the picture with the glow of colored light coming through the stained glass. With a no. 4 round, create streaming rays of color from the panes along the circumference of the circle and on the wall by dabbing in a little bit of color, then blending the edges into the background with water, dabbing away excess water with a paper towel. On the left, mostly use Ultramarine Violet and Cobalt Violet. As you move toward the pane's golden stars, use Lemon Yellow and Cadmium Yellow with a no. 0 round.

12

13

14

Bringing it all together
ANGEL OF DAWN

She sings of the sundry secrets of silence.
She weaves a webbing of whispered wonders,
Cloaking the cosmos and netherworld nights with
Words that have seen the dawning of time.

Dawn's colors have a particular quality to them. The upper sky lingers with receding darkness, while the glow of approaching day spreads tentative fingers through melting mists. In watercolor, this yields a delicate balance of blues and golds. To avoid painting a sickly greenish hue as a result of these two primary colors meshing, we have to mute the meeting areas of the two tones with purple and orange tones. There will be green colors that result regardless, but, though the eyes see green, by working with many layers we can build subtle illusions of a delicate golden light chasing away the night.

PAINTS

Cadmium Orange, Cadmium Red, Cadmium Yellow, Cerulean Blue, Cobalt Blue, Cobalt Violet, Lemon Yellow, Naples Yellow, Oxide of Chromium, Prussian Blue

MATERIALS LIST

½-inch (12mm) flat, illustration board, kneaded eraser, masking fluid, nos. 0, 1, 2, 4 and 8 rounds, old brush, pencil, rubbing alcohol, toothbrush

1 Sketch the Angel and Mask the Stars

Sketch the composition. Keep the pencil lines very light as you sketch in the star halo around her head. This will be a white nimbus, so you don't want hard pencil lines spoiling the ethereal glow. Splatter a few dots of masking fluid for stars in the lower half of the background with an old brush.

2 Apply a Background Wash

Add a wash of Lemon Yellow over the lower half of the background with a ½-inch (12mm) flat.

3 Create the Blue Sky

Using a mixture of Prussian Blue and Cobalt Violet, wash in the upper half of background with a ½-inch (12mm) flat.

2

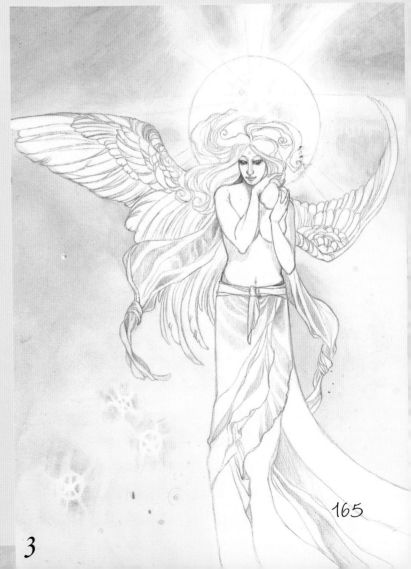

1

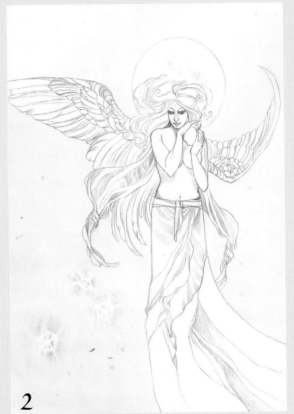

3

165

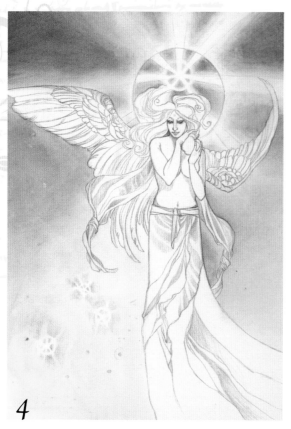

4

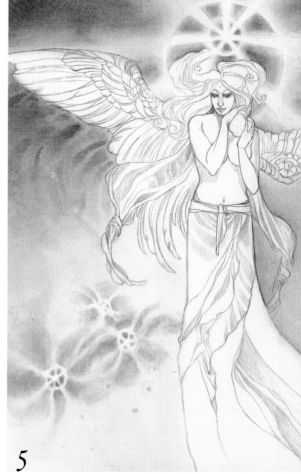

5

Darken the Blue Washes
With a mixture of Prussian Blue and Oxide of Chromium, paint a wash with a ½-inch (12mm) flat at the top to darken the areas around the star.

Darken the Background
Erase the pencil lines of the star halo around her head with a kneaded eraser. These guidelines are no longer needed now that the main color patches have been laid in. With a ½-inch (12mm) flat, keep layering more washes in the upper corners and the darkest parts of the halo. For rich tones, alternate a mixture of Prussian Blue and Oxide of Chromium with Cerulean Blue mixed with small amounts of Cobalt Violet. By applying these colors in thin alternating layered washes, you create subtle tonal variations and avoid creating mud.

Underneath the wing closest to the viewer, add texture to the background by drybrushing a Cerulean Blue pattern that extends the flow of the wing's feathers. Mix a small amount of Oxide of Chriomium with Naples Yellow and a touch of Cobalt Violet. With a no. 1 round, drybrush in the darker tones around the stars in the yellow portion. Keep the center showing the white of the paper.

Add Texture to the Background
Mix Cobalt Violet and Naples Yellow and apply some layered washes with a ½-inch (12mm) flat in the lower left corner and along the right side. Stay away from the center of the bright stars at the bottom, but you can let the washes cover the arms of the stars a bit to smooth out the drybrushed textures. With a toothbrush, splatter some rubbing alcohol into the washes to create a mottled texture. Drybrush more texture under her far wing with a no. 2 round. At this point, you are done with the washes on the background, so remove the speckled masking fluid to reveal spots of white stars.

Smooth the Stars' Edges
Wet a no. 2 round with clean water, then rub the white stars created by the masking fluid to soften the glow around the small stars.

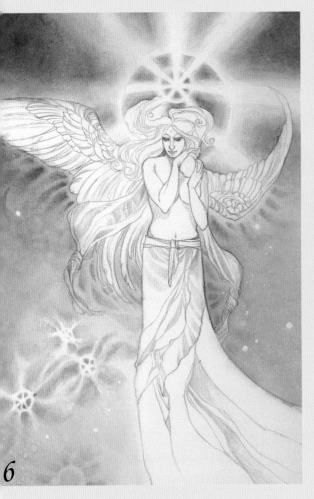

6

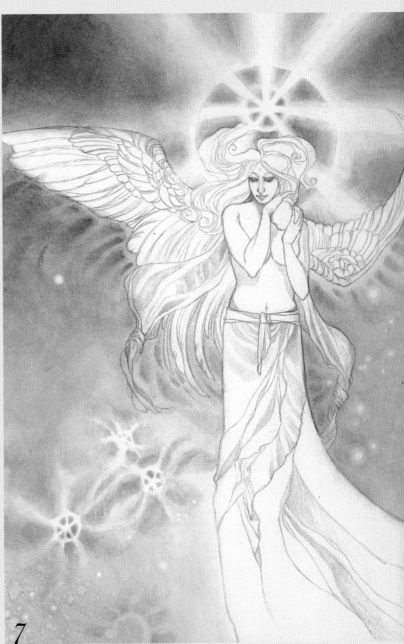

7

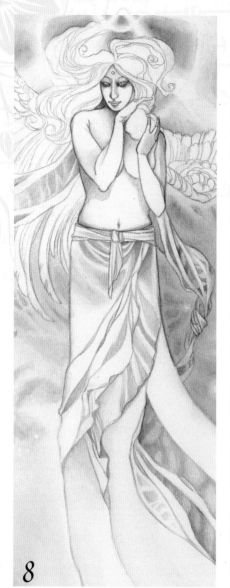

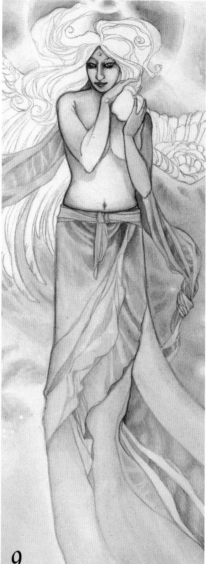

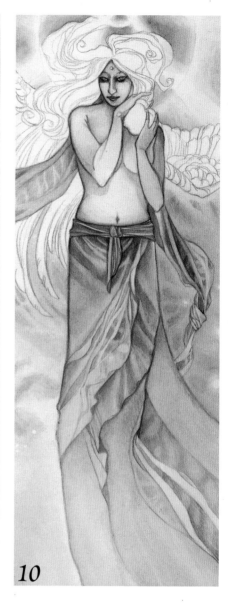

8 Establish Shadows on Her Skin and Clothing
Paint the shadows on her body with Cobalt Blue working wet-on-dry using a no. 2 round. For the shadows on her clothing, apply a mixture of Cobalt Blue and Cobalt Violet with a no. 2 round.

9 Build the Skin Tones
Use a mixture of Cadmium Yellow and Cobalt Violet with a no. 4 round for her skin. Apply a more concentrated version of this wash over her dress. Add a little bit of Lemon Yellow in the lower left side.

10 Finish Her Skin and Clothing
Layer more washes of Cadmium Orange over the shadows on her clothing to make the colors more vibrant with a no. 8 round.

11 Basecoat the Wings
Mix Cobalt Violet and Cobalt Blue and paint a layer of shadows on her wings with a no. 8 round.

12 Define the Feathers and Shadows
Mix Cobalt Violet and Cobalt Blue to detail shadows on individual feathers with a no. 1 round. Add a little bit of Cadmium Yellow to the feathers on the wing bent toward her body and add Lemon Yellow to the tips of the extended wing's feathers with a no. 1 round. Mix a little bit of Oxide of Chromium with Cobalt Blue and apply this to the shadow areas on the wing bent toward her body.

13 Begin Her Hair
Paint a base wash of Cadmium Orange on her hair with a no. 4 round.

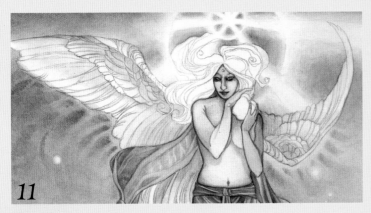

11

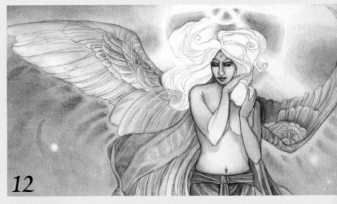

12

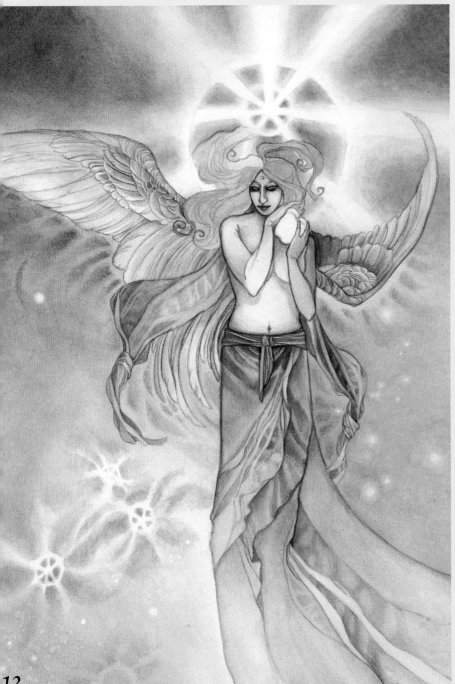

13

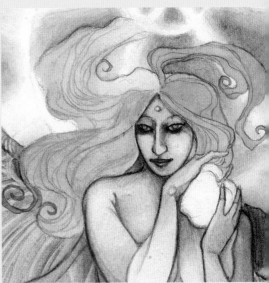

Detail of Initial Wash

14 Complete the Hair

Add details to her hair by painting shadows with Cadmium Red using nos. 0 and 1 rounds. Add a wash of Lemon Yellow highlights to the upper strands of her hair with a no. 4 round.

15 Add the Last Details

Paint the apple with Cadmium Red and a no. 1 round.

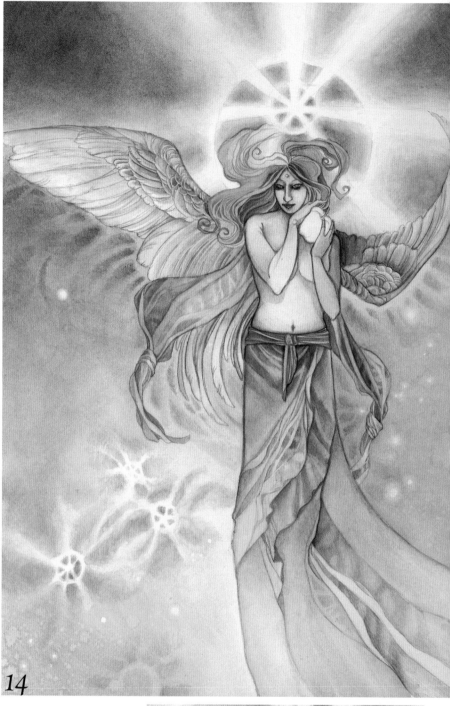

14

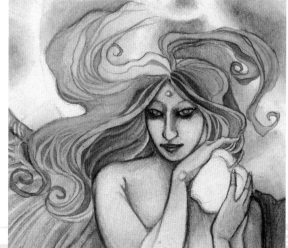

Detail of Hair

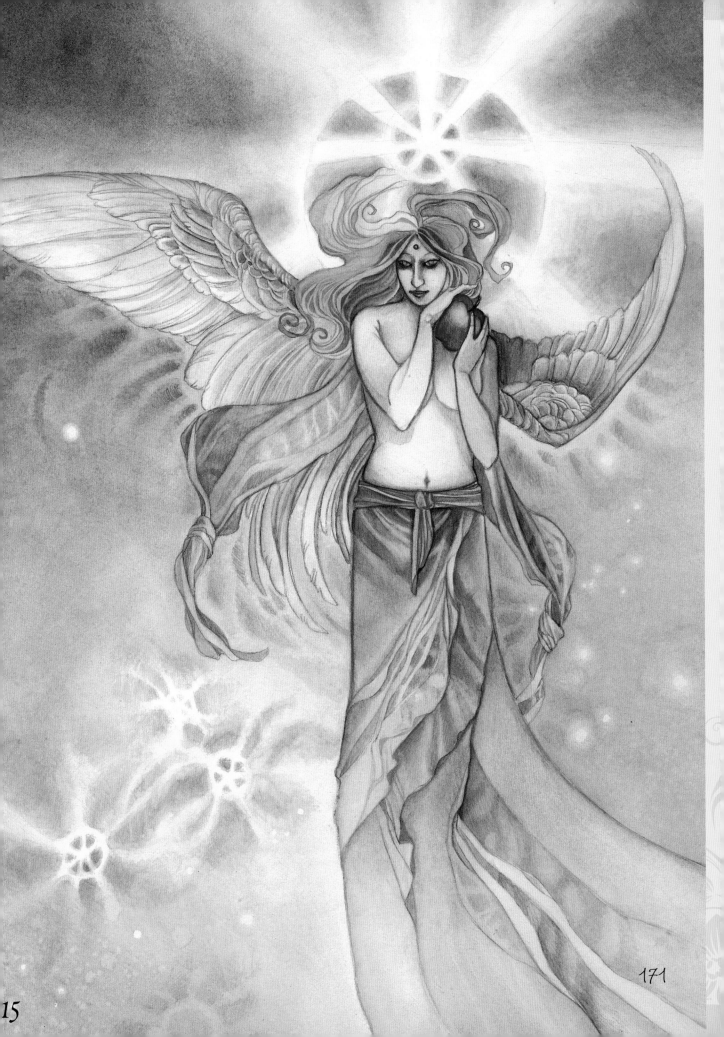

Index

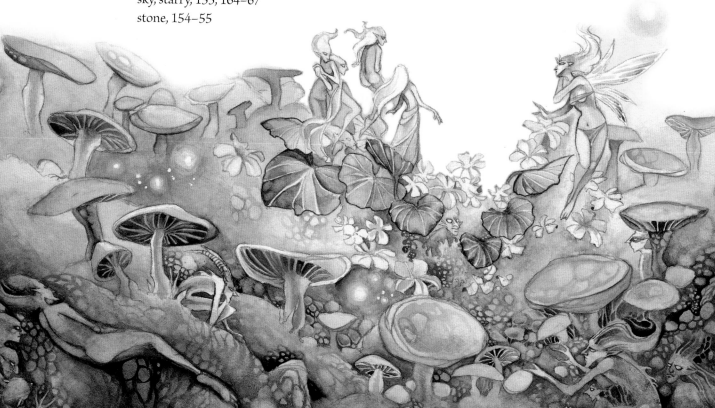

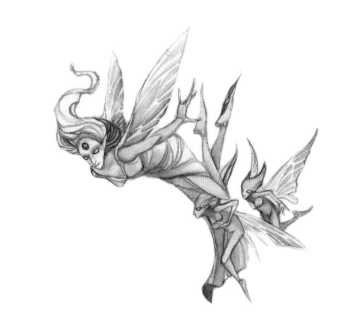

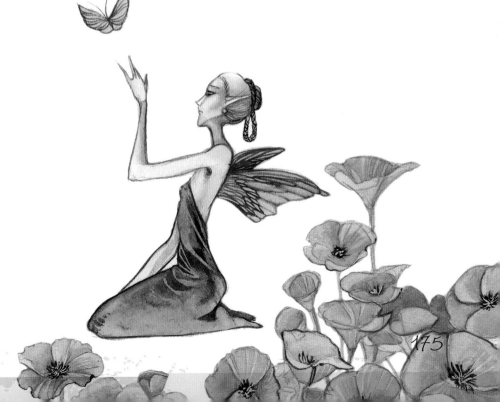